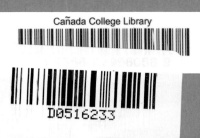

I do solemnly swear that I will
faithfully execute the office of
President of the United States,
and will to the best of my ability
preserve, protect, and defend the
Constitution of the United States.

UNITED STATES CONSTITUTION
ARTICLE II SECTION 1

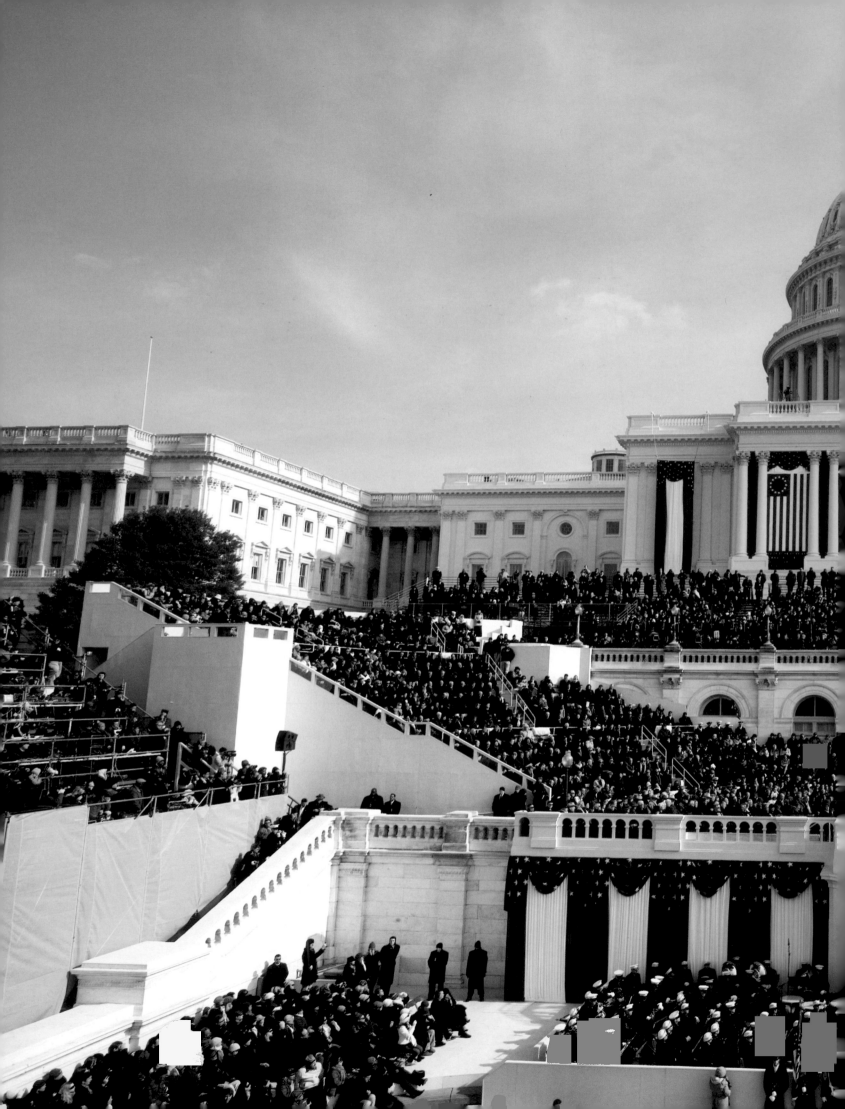

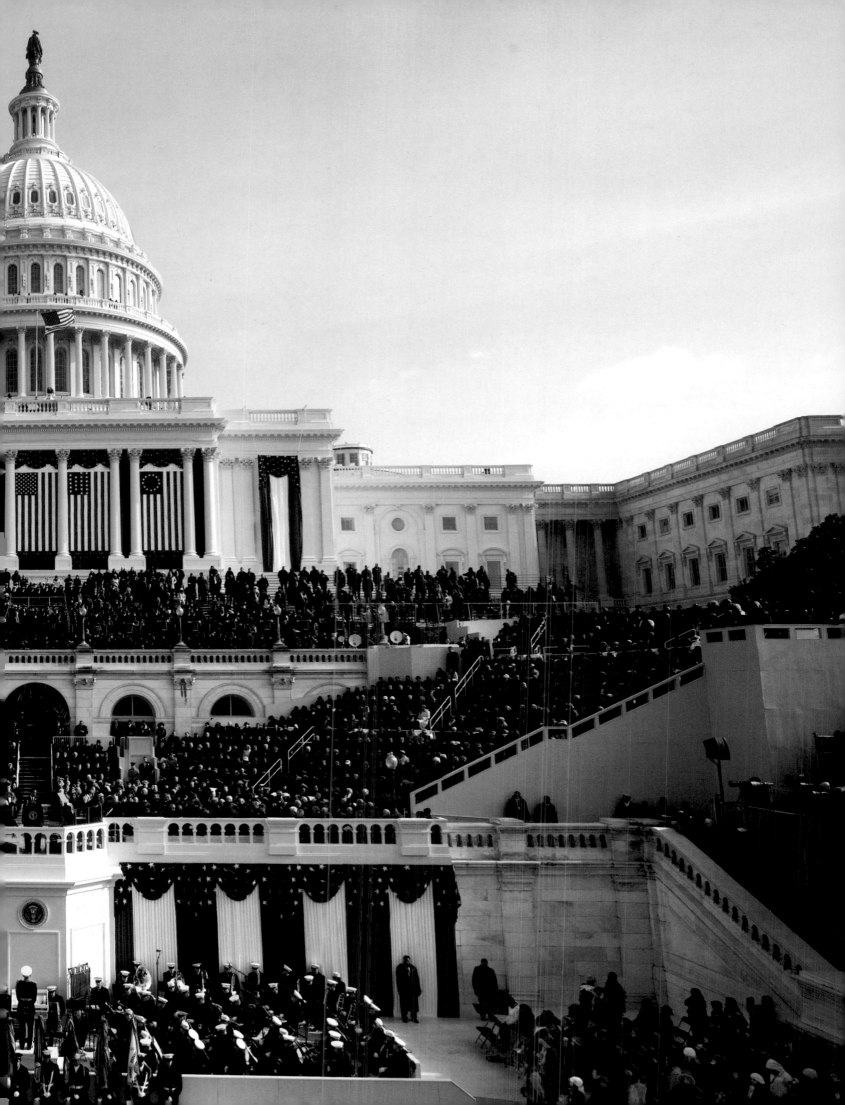

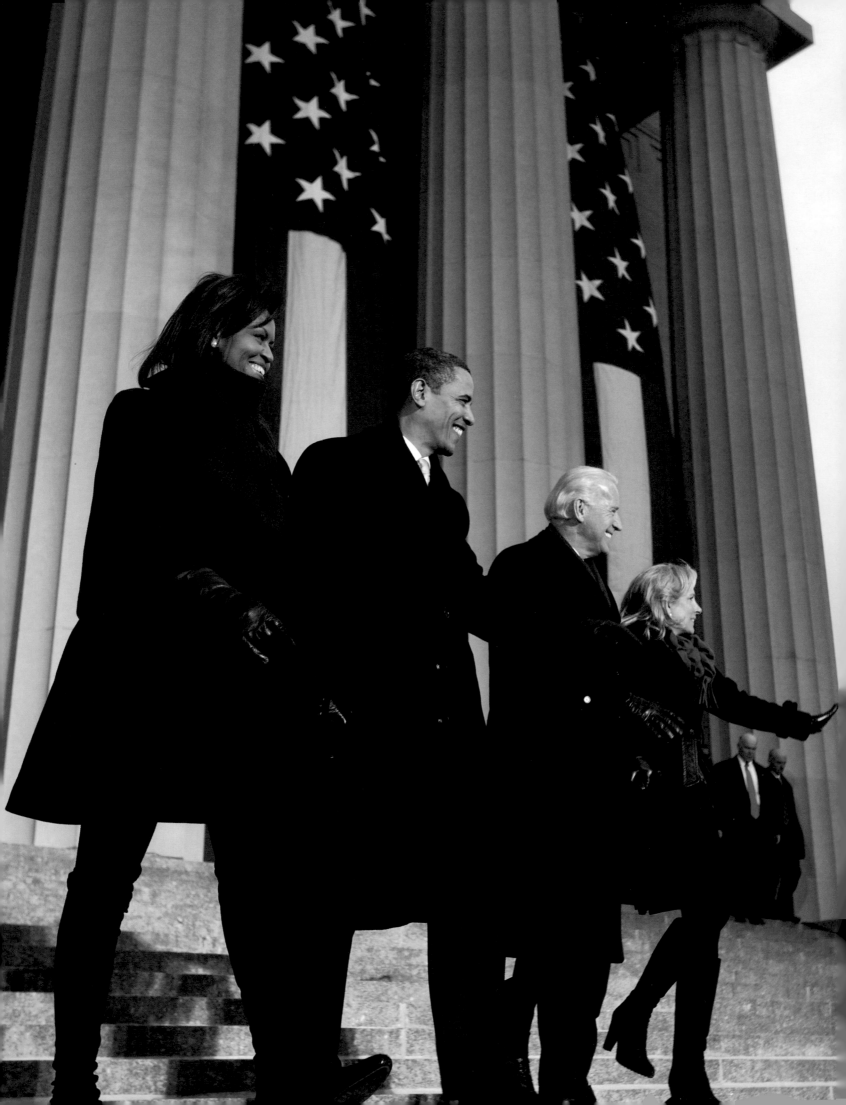

BARACK OBAMA

THE OFFICIAL INAUGURAL BOOK

PHOTOGRAPHS BY
DAVID HUME KENNERLY
ROBERT McNEELY
PETE SOUZA
A TEAM OF AMERICA'S
LEADING PHOTOJOURNALISTS
AND AMATEUR PHOTOGRAPHERS
FROM AROUND THE NATION

PREFACE
TOM BROKAW

FOREWORD
U.S. REPRESENTATIVE JOHN LEWIS

ESSAY
DOUGLAS BRINKLEY

CREATED AND PRODUCED BY
MATTHEW NAYTHONS
ROBERT McNEELY
DAVID HUME KENNERLY

fiveTIES

IN ASSOCIATION WITH
EP CENTER COMMUNICATIONS

PRODUCED BY
DAVID HUME KENNERLY
ROBERT MCNEELY
MATTHEW NAYTHONS
GARRETT WHITE

CREATIVE DIRECTOR
THOMAS K. WALKER

EDITORIAL DIRECTOR
DAWN SHEGGEBY

ONLINE DIRECTOR
PETER GOGGIN

PHOTOGRAPHS BY
KAREN BALLARD
ANDRÉ CHUNG
DANIEL CIMA
ANNE DAY
HECTOR EMANUEL
JOHN FRANCIS FICARA
GIL GARCETTI
JOHN HARRINGTON
DAVID HUME KENNERLY
SAM KITTNER
PETE MAROVICH
GREG MATHIESON
ROBERT MCNEELY
PAUL MORSE
MATTHEW NAYTHONS
DANIEL ROSENBAUM
MARK SENNET
PETE SOUZA
BRUCE TALAMON
THOMAS K. WALKER
CLARENCE WILLIAMS

PREVIOUS PAGES
PHOTOS BY KAREN BALLARD

CONTENTS

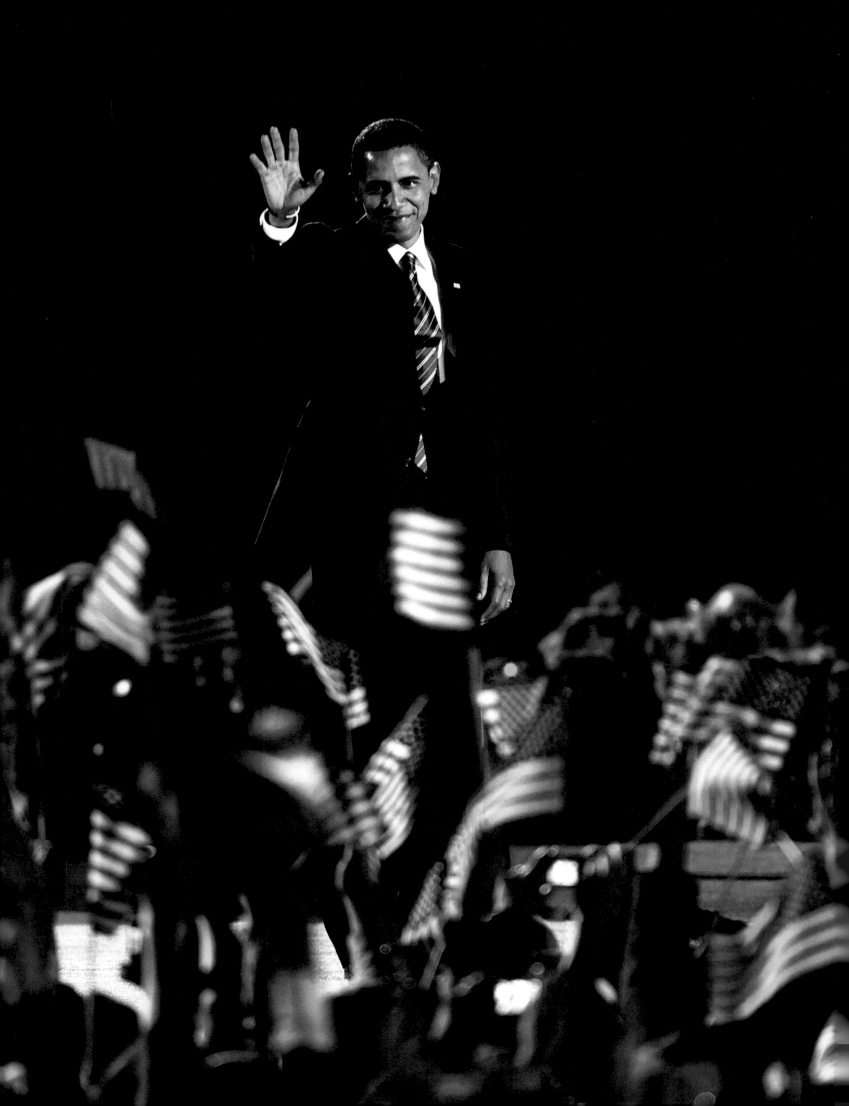

BARACK OBAMA

TOM BROKAW

"It was not in name and background alone that Barack Obama shattered conventional wisdom.... He symbolized a new America—more urban and more tolerant, impatient with the paralyzing effect of ideological gridlock, and longing for an authentic voice calling for hope in the face of fear."

WE'VE NEVER HAD an American president remotely like Barack Obama. We've had aristocrats and intellectuals, country lawyers and military heroes, adventurers and academics, knaves and fools—but none with the biography of the 44th president of the United States. His ancestry, name, childhood, and political career represent a striking change from the lives of the 42 white males who preceded him. His only shared characteristic is gender. Even his age, 47, is distinctive.

The average age of past presidents when elected was 55. President Obama is not the youngest, however. Theodore Roosevelt was 42; Ulysses S. Grant and John F. Kennedy were 43 when they took up residence in the White House.

This charismatic younger man with an African father, an Indonesian stepfather, and a white mother from the Great Plains spent his formative years on an odyssey that took him from the beaches of Hawaii to the South Pacific to the ivy-covered halls of Columbia University and Harvard Law School.

To his classmates he was known as Barry, but as a community organizer in Chicago and in the gauntlet of Illinois state politics he reverted to his given name, Barack, a counterintuitive move he later humorously explained by saying, "I got my name, Barack, from my father. And I got my middle name from someone who obviously never thought I'd run for president."

It was not in name and background alone that Barack Hussein Obama shattered conventional wisdom and created a new paradigm for running a presidential campaign. He symbolized a new America—more urban and more tolerant, impatient with the paralyzing effect of ideological gridlock, and longing for an authentic voice calling for hope in the face of fear. He looked to the future and quietly counseled those still stuck in the past to move on.

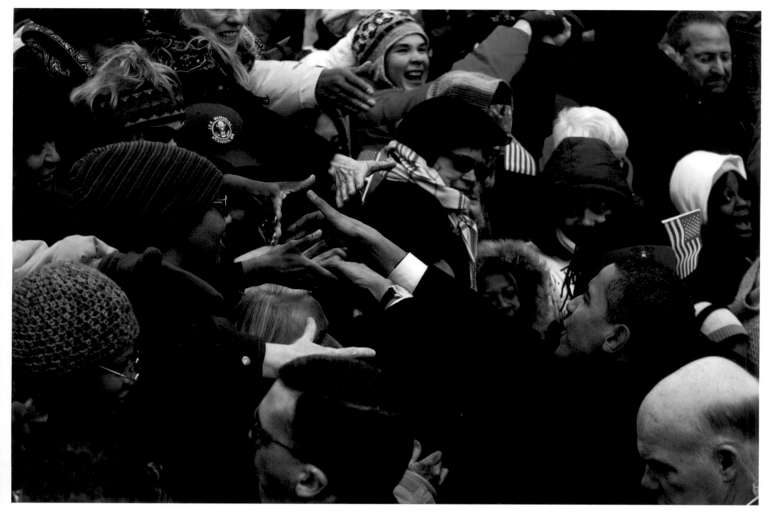

PHOTO BY KAREN BALLARD

This new president technically qualifies as a baby boomer, since he was born at the tag end of that fecund time between the end of World War II and the assassination of President Kennedy, but he grew up resisting the self-indulgence and narcissistic stains that compromised the accomplishments and possibilities of so many boomers.

Still, he understood that he was a conspicuous beneficiary of the heroic work of those generational brothers and sisters who marched with Martin Luther King, Jr., in the great nonviolent crusade for equal rights in practice and in law. Race, gender, and war were the defining causes of his earliest years, and he came to understand that a nation's moral center is not an intersection on Pennsylvania Avenue.

As an African-American, he chose not to embrace a life as victim, but instead to seize the new opportunities available to his generation of people of color. As Gwen Ifill explains in her seminal book, *The Breakthrough: Politics and Race in the Age of Obama*, older civil-rights leaders such as Andrew Young were at first skeptical of Obama and his chances because their lives had been defined only by limitations on their roles as citizens, employees, consumers, students, and politicians. "Every time one of those barriers fell," she writes, "it was power seized, not given."

Ifill reminds us that for Barack and Michelle Obama and other children of the movement, it was a different world. They walked freely down streets where their parents marched, and "Ivy League schools came looking

for them. They didn't grow up with Jim Crow laws or lynching trials, and they lived in a world shaped by access instead of denial."

That access became available for others as well—Asian-Americans and Hispanics—and as a result, Barack and Michelle Obama were surrounded by contemporaries who were not conditioned to see the world through the old black-and-white prisms.

When he first began his run for the presidency, there was a strong undercurrent of sotto voce conventional wisdom. "He's an attractive candidate," it was whispered. "But this country is not ready to elect a black man president."

Really? Not even a black candidate with two Ivy League degrees and a wife with a matching academic pedigree? A strong family man with a killer smile and the oratorical gifts to command great audiences who joined with him in the rising choruses of "Yes, we can!"?

This became an election in which the young taught their elders the new realities and expectations of America. How many times did you hear an older voter say, "Well, my kids forced me to take a look at Obama, and I must say, I am impressed"?

Those kids, whatever their color, knew him as one of them: smart, hip, urbane—a guy who played hoops, not golf. Most important, they knew he shared their frustration with a world gone awry and a political system fueled by blame instead of by possibilities.

They knew him as a man of the BlackBerry and iPod at the head of a campaign that left no email address unsolicited. He worked out every day and he was not afraid to say he had inhaled.

He wrote best-selling books about hope and dreams, and he never seemed to lose his cool. For a time, some of his most ardent supporters thought he was too cool. He didn't always like to mix it up in the old politics-as-a-bloody-brawl fashion. He kept his eye on the prize, even when he lost big states to Hillary Clinton in the primaries or got roughed up by conservatives in the summer months.

He emerged from those experiences a better candidate, tougher and more fully formed for the grueling test of the autumn campaign.

When he began his long-shot race to the Oval Office in 2007, he presented himself as the candidate who could end the war in Iraq and renew America's standing in the world.

Still, he understood that he was a conspicuous beneficiary of the heroic work of those generational brothers and sisters who marched with Martin Luther King, Jr.

By the fall of 2008, war and stature were still important, but voters were much more concerned about the terrifying state of the American economy. Obama proved to be a quick study of the complexities of the underlying causes, and he didn't hesitate to warn voters it would not be a quick or easy fix. It was the final test for the untested candidate, and the combination of his analytical skills and candor appealed to voters who heretofore had been skeptical.

AND SO WHEN he stepped out onto the platform at the Capitol to take the oath of office, surrounded by his poster-perfect family, he stood as the head of another family that surrounded him there and cheered him joyously from the far reaches of the Washington Mall: A family of young and old, from all points on the American compass, a family of every ethnic origin that makes up the multicolored quilt of this unique republic.

The torch was being passed once again, and the warmth of the day would be followed by a cold dawn of unsettling realities as America was being tested anew.

Barack Hussein Obama was ready to take that test.

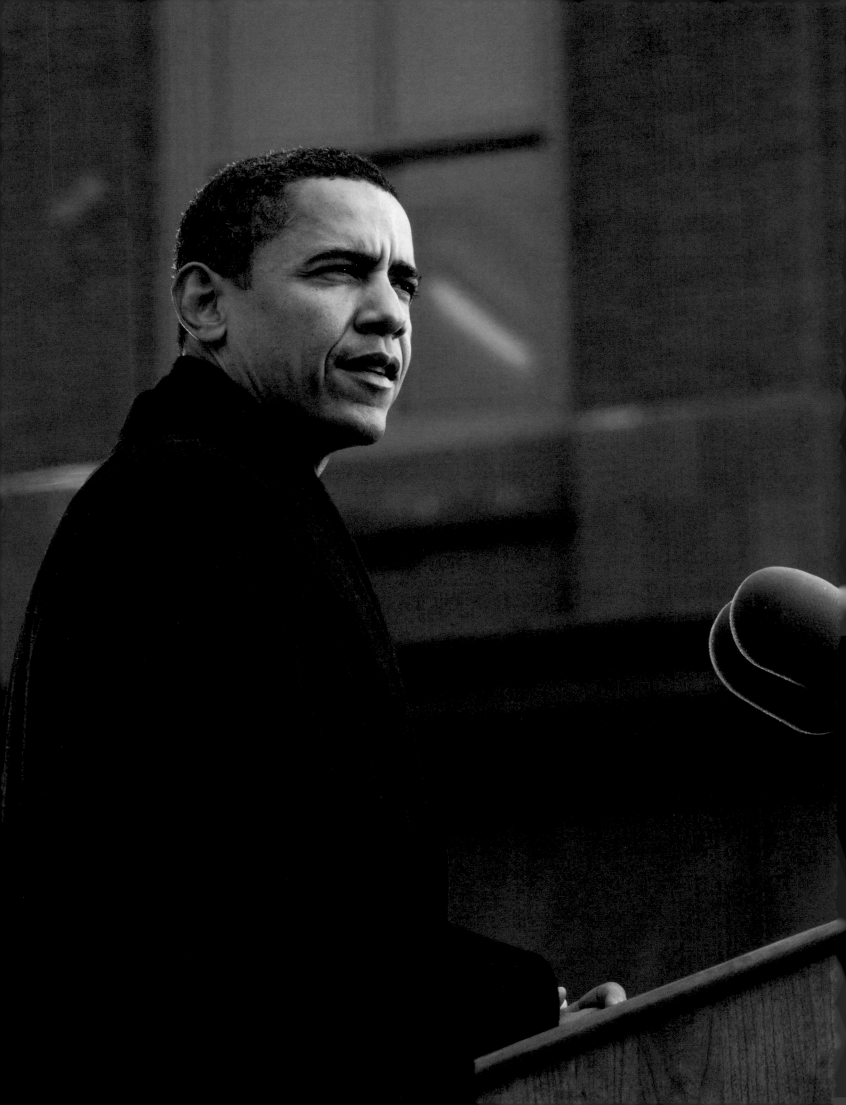

WE THE PEOPLE

U.S. REPRESENTATIVE JOHN LEWIS

"As Barack Obama said from the beginning, we are not blue states or red states; we are the United States of America. We are not just black or white, Latino, Asian-American, or Native-American.... We are one people, one family, the American family."

THE DAY OF Barack Obama's inauguration was a day of jubilee—an awesome, almost unbelievable day of joy. There was a profound sense of family and community moving through that vast sea of humanity. It was as if a great weight had been lifted, and we all became aware that maybe, just maybe, we were beginning to lay down the burden of race in America. You could almost hear Martin Luther King, Jr.'s words ringing out. "Free at last, free at last."

But without the nonviolent resistance to legalized segregation and racial discrimination, without the modern-day Civil Rights Movement and the action that took place in Selma, Alabama, in the early 1960s, there would be no Barack Obama. The march from Selma to Montgomery, Alabama, in 1965 gave us the Voting Rights Act, and that act liberated not only a people, it freed an entire nation. That legislation made it possible for people of color to become participants in the democratic process, and it created the environment for Barack Obama to emerge.

Before then, all across the American South, very few African-Americans were registered to vote—only 2.1 percent in Dallas County, where Selma is located. We could only attempt to register on the first and third Mondays of each month. People had to stand in what I called "unmovable lines," trying to go up the courthouse steps, through a set of double doors, to get a copy of the so-called "literacy test," a method of discrimination intended to prevent African-Americans from registering to vote.

In Selma, there was a sheriff. He was a big man; he was tall, and he was mean. His name was Jim Clark. He guarded the courthouse like it was his own home. He wore a gun on one side, and a nightstick on the other. He carried an electric cattle prodder in his hand, and he didn't use it on cows. He wore a button on his left lapel that said "Never."

I remember July 6, 1963, like it was yesterday, because it was my day to lead a group of people down to the courthouse to attempt to register to vote. Sheriff Clark met us at the top of the steps. He looked at me and said, "John Lewis, you are an outside agitator. You are the lowest form of humanity." And I said, "Sheriff, I may be an agitator, but I am not an outsider. We're going to stay here until these people are allowed to register to vote." He said, "You are under arrest," and he arrested me along with about 60 people. A few days later, Martin Luther King, Jr., and others came to Selma. We went back to the courthouse, and more than 300 were arrested.

Thirty miles from Selma, there is a little place called Marion, in Perry County, the heart of the Black Belt and home to Coretta Scott King, Juanita Abernathy, and the late Jean Young, the wife of Andrew Young. A march took place there on the evening of February 18, 1965, and a confrontation occurred when a young black man tried to protect his mother. His name was Jimmie Lee Jackson. He was shot in the stomach, and later died at the local hospital in Selma. And because of what happened to him, we made a decision to march from Selma to Montgomery on Sunday, March 7.

On that Sunday, 600 of us left Brown Chapel AME church and began walking through the streets of Selma. It was a silent walk, no one saying a word. We reached the edge of the Edmund Pettus Bridge, over the Alabama River, and continued to walk. At the highest point on the bridge we saw the water down below, and ahead of us, a sea of blue—Alabama state troopers. And behind the state troopers, we saw Sheriff Clark's posse on horseback. The Sheriff had requested that all white men over the age of 21 go to the courthouse to become deputized to be part of his posse to stop the march. When we came within earshot of the state troopers, one said, "I am Major John Cloud of the Alabama state troopers. This is an unlawful march. It will not be allowed to continue. I give you three minutes to disperse and return to your church."

In less than a minute and a half, the major said, "Troopers, advance!" and they came toward us, beating us with nightsticks, trampling us with horses, and releasing tear gas. A state trooper struck me in the head with a nightstick, giving me a concussion. I thought I was going to die—I thought I saw death.

I don't recall how I made it back across that bridge, through the streets of Selma, and back to that little church on that Sunday afternoon. But I do recall being asked to say something to those who had gathered there. I said, "I don't understand how President Johnson can send troops to Vietnam but cannot send troops to Selma, Alabama, to protect people whose only desire is to register to vote." And the next thing I knew I was admitted with 17 other people to the same hospital where Jimmie Lee Jackson had died a few days earlier.

That day became known as Bloody Sunday. It sparked righteous indignation all around America and demonstrations in more than 80 cities, at the Department of Justice, at the White House, at almost every major college campus. President Lyndon Johnson was so disturbed by what he saw that he invited Alabama governor George Wallace to meet him in Washington to get his assurance that he would protect us if we marched again. The governor could not assure the president, who went to federal court and got an injunction against the State of Alabama and the local police officials, prohibiting them from interfering with the march. A young judge named Frank M. Johnson granted us everything we wanted. He said that if we wanted to march, we had a right to march.

On March 15, 1965, eight days after Bloody Sunday, President Johnson made one of the most meaningful speeches that any American president has made in modern times on the question of voting rights and civil rights. He spoke to a joint session of Congress; he spoke to the nation. He began, "I speak tonight for the dignity of man and for the destiny of democracy...At times history and fate meet at a single time and a single place to shape a turning point in man's unending search for freedom. So it was at Lexington and Concord. So it was a century ago at Appomattox. So it was last week in Selma, Alabama." The most powerful nation on the face

of the earth had heard the cries of pain and the hymns and protests of an oppressed people, and this government was prepared to act.

That night, I sat next to Martin Luther King, Jr., in the home of a family in Selma. Before the president concluded his speech, he said, "And we shall overcome." I looked at Dr. King, and he began to cry, tears came down his face. We all started crying at hearing the president of the United States use the theme song of the Civil Rights Movement. Dr. King said, "We will make it from Selma to Montgomery, and the Voting Rights Act will be passed."

We set out on March 21, 10,000 of us, people from all over America walking across that bridge. By the time we reached Montgomery five days later, more than 25,000 people were marching toward the state capital. Congress debated the Voting Rights Act, passed it, and President Johnson signed it into law on August 6, 1965.

People asked me on Inauguration Day, "Is this the fulfillment of Dr. King's dream?" And I said, "No, this is a major down payment toward the fulfillment of that dream." From where I sat on the platform as President Obama spoke, I could see past the podium to the Lincoln Memorial. I imagined Dr. King standing there, 45 years ago, and tears came to my eyes. I wished that he was here. To me, that day was perhaps the beginning of the final chapter in the making of the Beloved Community, the making of a truly multiracial democracy in America. We were witnesses to a great drama, and this was, I believe, one of the finest hours of our democracy.

When Dr. King was assassinated, and then Robert Kennedy, something died in all of us. Something died in America. I had friends in the Civil Rights Movement, in the peace movement. who dropped out after the murder of those two young men. They were afraid to believe again, afraid to hope again. The campaign and election of Barack Obama gave us back that hope, and provided a real light where there had been so much darkness.

The discipline and philosophy of nonviolence is still so relevant, so powerful. It is an immutable principle from which we cannot deviate. And the vote is the most powerful nonviolent instrument that we can have in a democratic society We won the vote through nonviolent action. On January 20, we made a dramatic change in our society. But that power was transferred through a peaceful, nonviolent election. No gun was fired. No one fought or threatened to overthrow the government. It was an orderly transition. The assembly of that vast crowd on Inauguration Day was a nonviolent act, and in the undercurrent you could feel the spirit of the March on Washington in 1963. That is the power of nonviolence in action. People bear witness. They use their feet, their voices; they cast a vote. They bring change, and then they come to Washington to see what they have accomplished.

As Barack Obama said from the beginning, we are not blue states or red states; we are the United States of America. We are not just black or white, Latino, Asian-American, or Native-American. We are not Republicans, Democrats, or Independents. We are one people, one family, the American family. And Barack Obama is an all-inclusive president. I believe it is a part of his DNA, an aspect of his very being to lead us to a different place as a nation. He is daring, unafraid, and prepared to take us on a journey, and not just a road tread by the people of this nation, but by the people of the world. There may be setbacks and disappointments, but I believe we are on our way to a better place. The decision we made to elect Barack Obama President of the United States has helped to redeem the soul of America. Regardless of the outcome of politics or policies, I think when historians of this period look back they will have to pause and say that on January 20, 2009, the people of this nation made a difference. They will say that on this day we. the people, bore witness to a decision we made to leave this little piece of real estate we call America a little bit more peaceful, a little bit more just, a little bit more fair—a little better for all our citizens today and for generations yet unborn.

THE NATION PREPARES

IMAGINE AN AMERICA where ordinary citizens are so filled with pride and hope that they come to Washington in droves—in millions. Even if they don't have a seat at the ceremony, even if they don't have a ticket to the ball, they come to be a part of this moment in history.

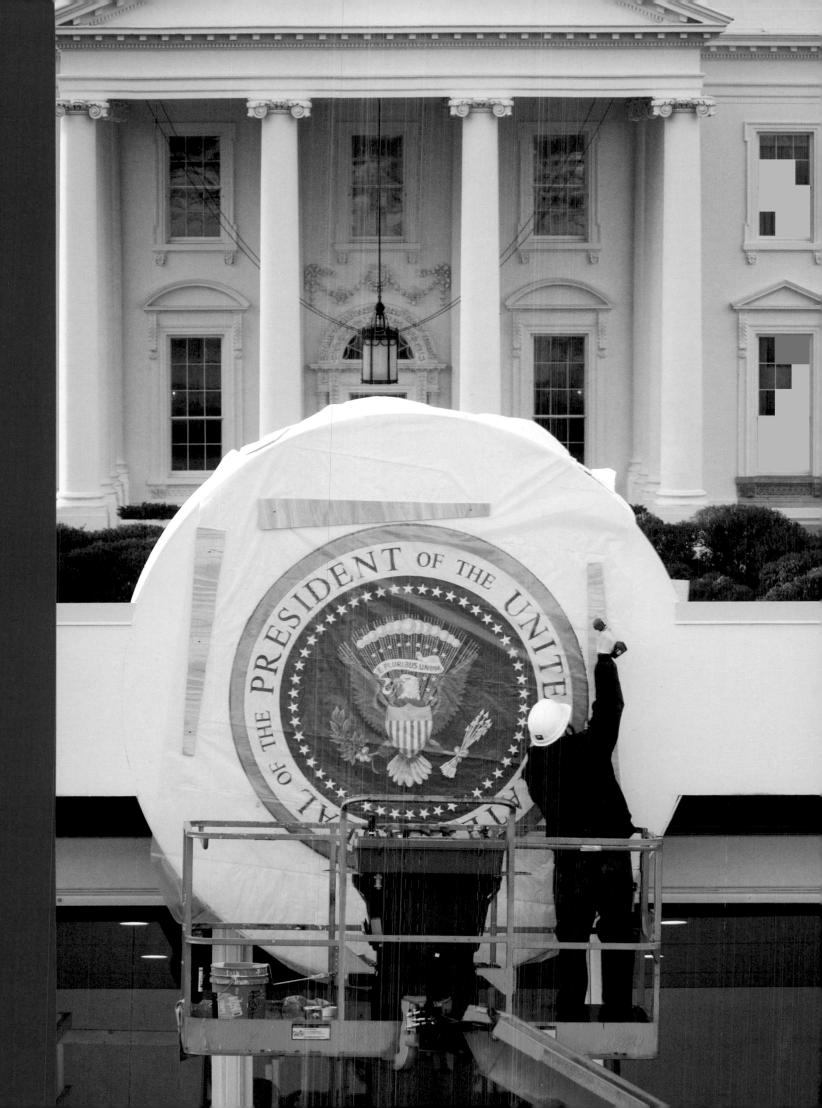

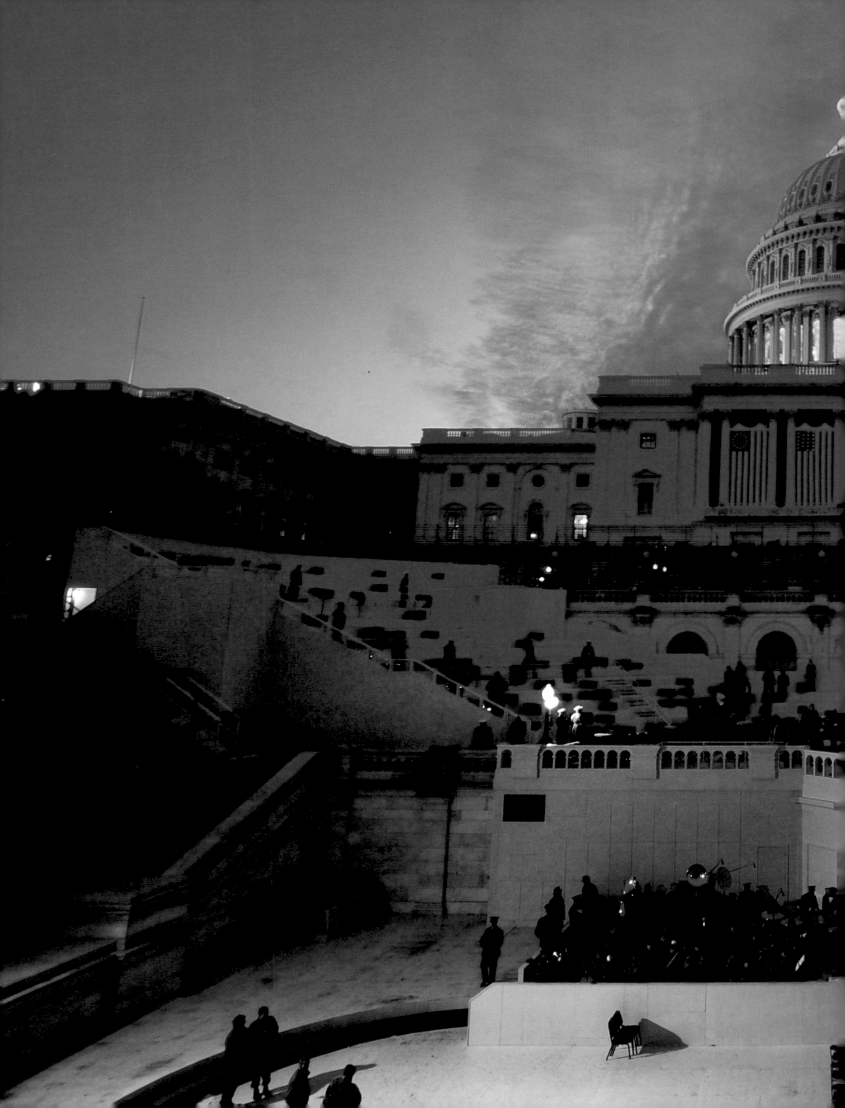

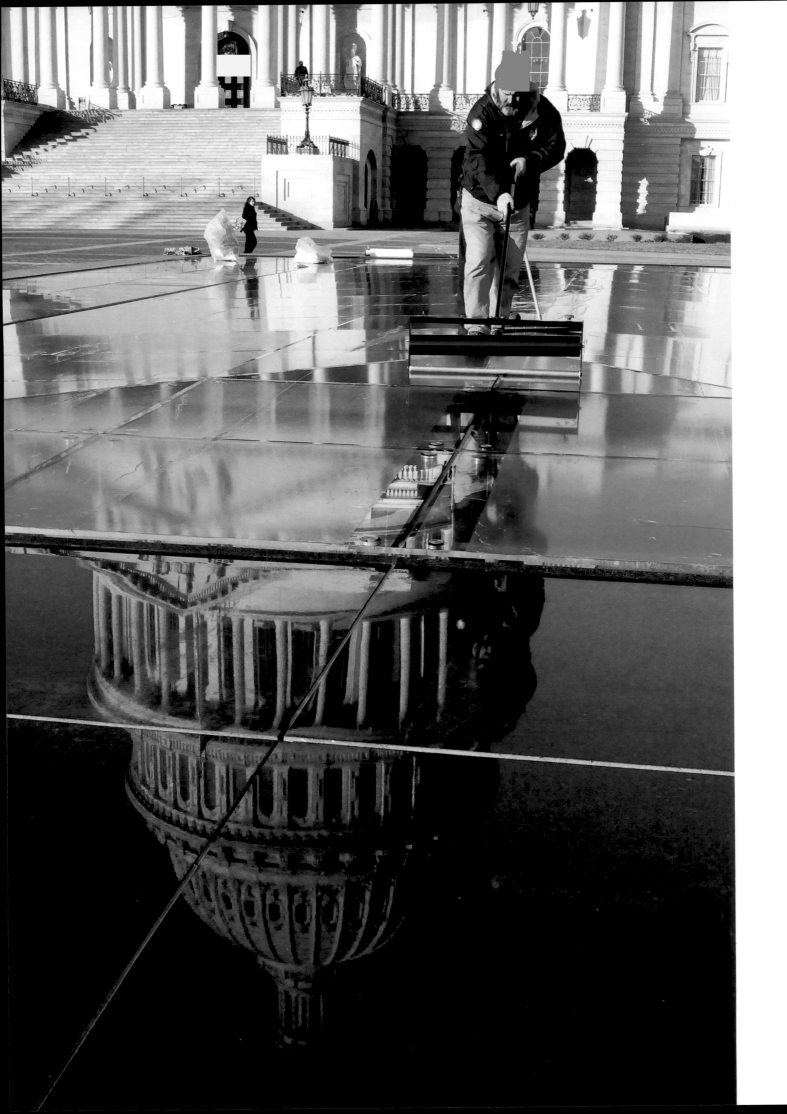

Preparations continue to the last minute, as a protective covering is applied to the glass skylights of the U.S. Capitol Visitor's Center (opposite) to protect it from the propeller wash of the incoming helicopters. In anticipation of the crowds, more than 7,000 portable toilets were deployed on and around the National Mall on Inauguration Day.

ABOVE
PHOTO BY PETE MAROVICH

OPPOSITE
**PHOTO BY CHIEF ELECTRONICS TECHNICIAN
JAMES CLARK, U.S. NAVY**

PREVIOUS PAGE
The west front of the U.S. Capitol building at dawn on Tuesday, January 20, 2009. In a few hours, the inauguration of Barack Obama as president will begin.

PHOTO BY MASTER SGT. CECILIA RICARDO, U.S. AIR FORCE

Preparations for the inauguration included both people and props. Members of the Armed Forces Inaugural Committee stand in for the inaugural participants during a rehearsal, including Army Staff Sergeant Derrick Brooks, taking the place of President-elect Obama.

**PHOTO BY
TECH. SGT. SUZANNE M. DAY,
U.S. AIR FORCE**

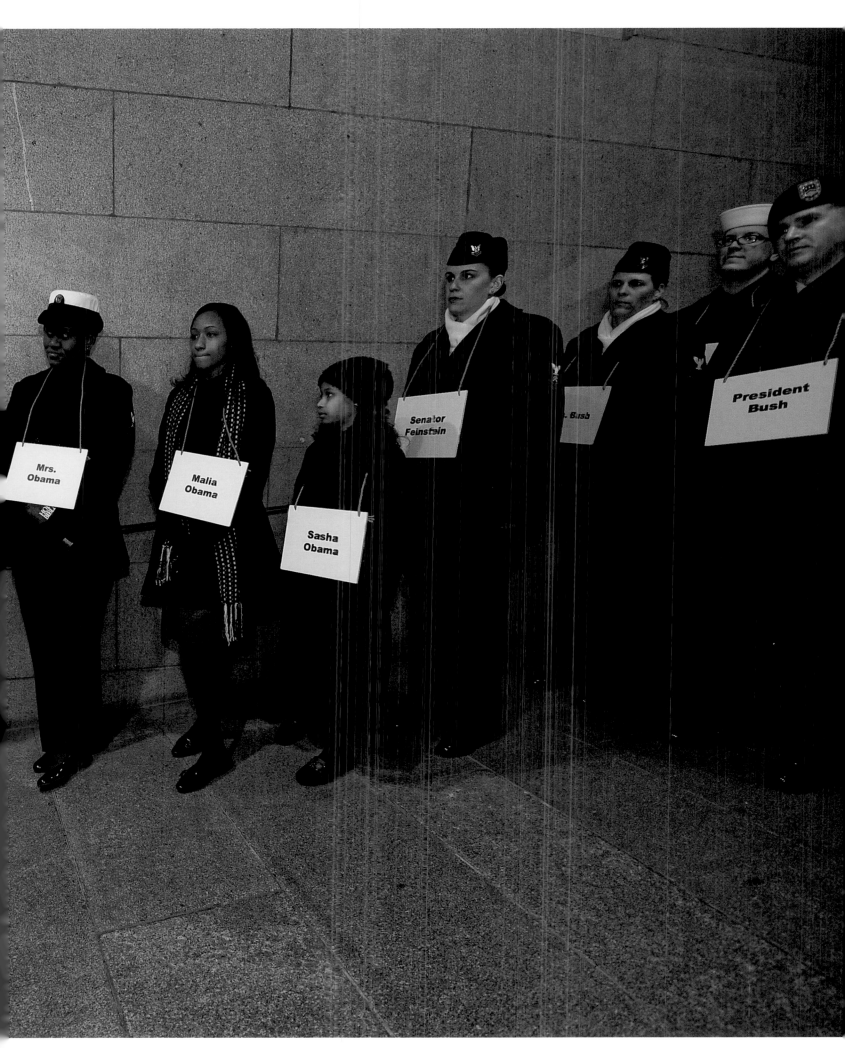

Barack and Michelle Obama travel to Washington by train, beginning at 30th Street Station in Philadelphia. They were later joined by Joe and Jill Biden in Wilmington, Delaware. The trip, dubbed the "Whistle-Stop Tour," was a conscious echo of Abraham Lincoln's own journey by rail to Washington for his inauguration in 1861.

PHOTO BY HECTOR EMANUEL

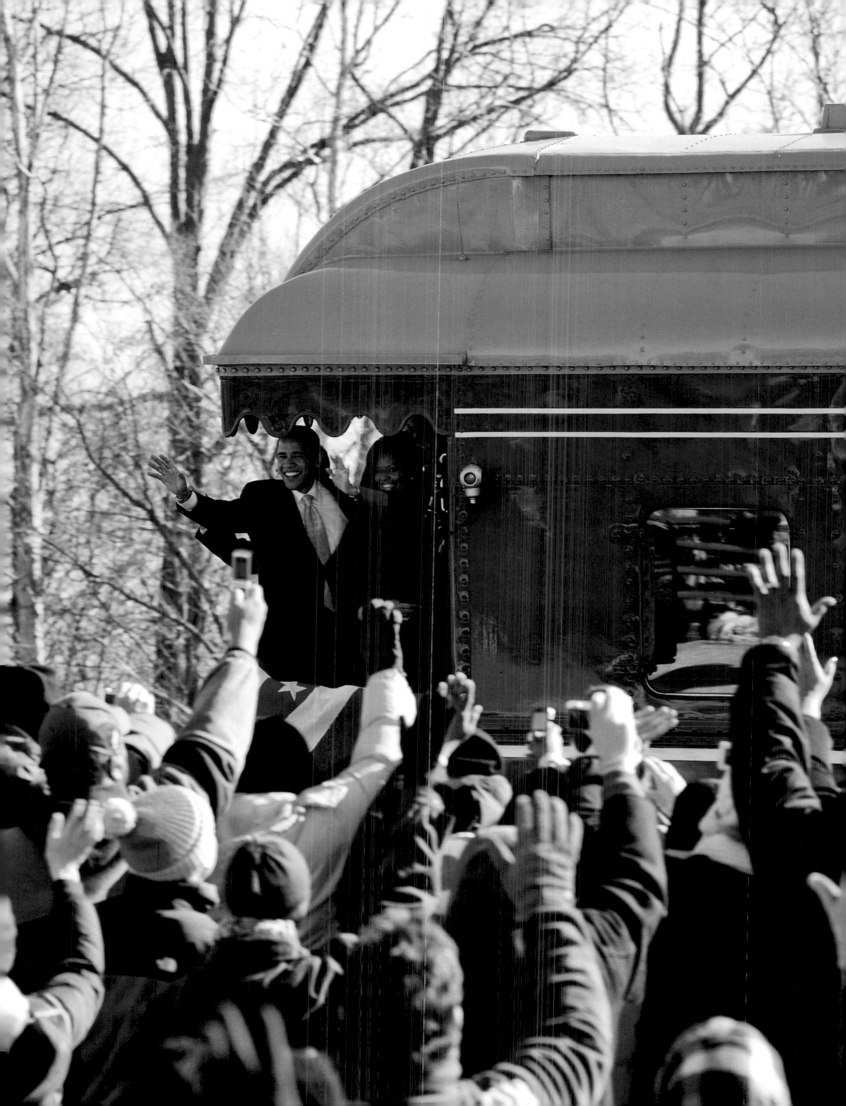

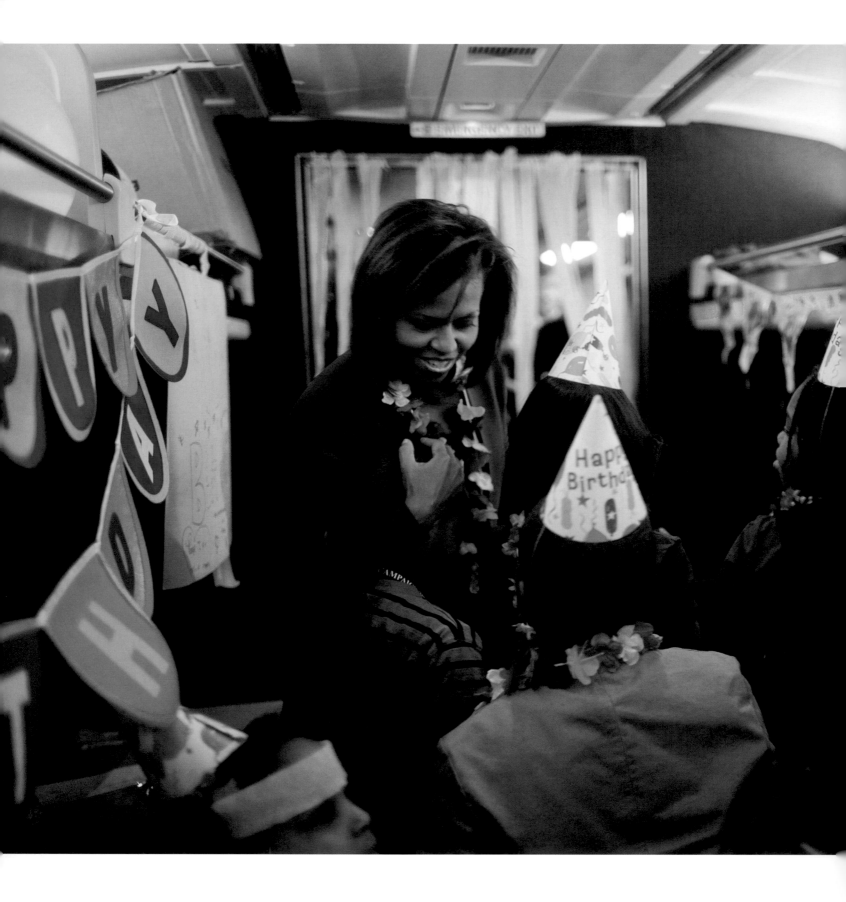

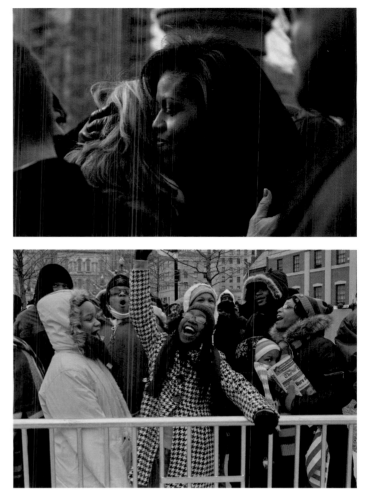

Michelle Obama celebrates her 45th birthday aboard the Whistle-Stop Tour en route to Washington with daughters Sasha and Malia and some of their friends. It's a breath of normalcy in a life that also includes greeting supporters while surrounded by Secret Service agents during a stop on the train trip in Baltimore (above).

LEFT
PHOTO BY ROBERT McNEELY

ABOVE TOP
PHOTO BY KAREN BALLARD

ABOVE BOTTOM
PHOTO BY ANDRÉ CHUNG

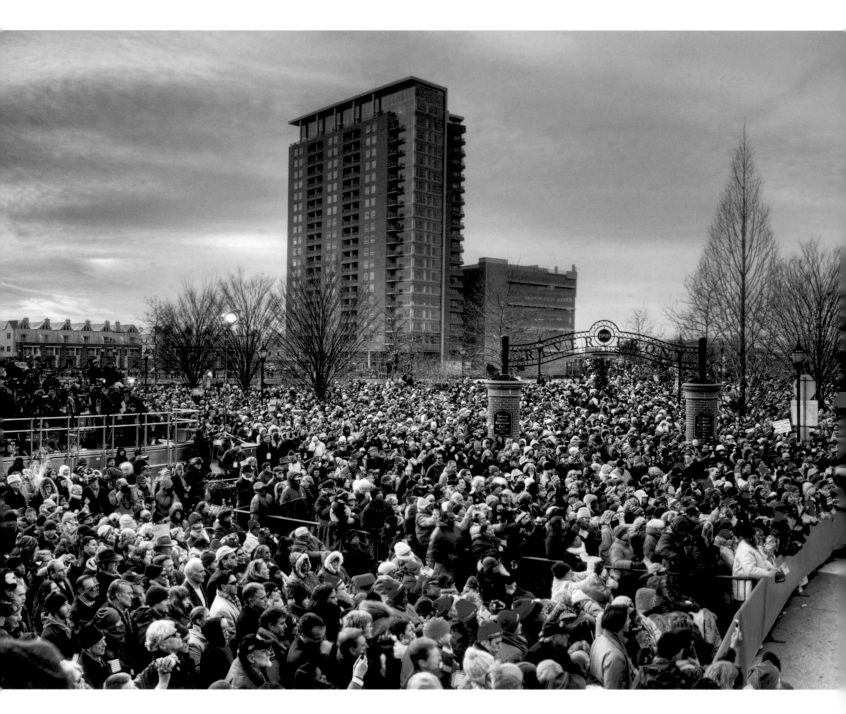

President-elect Barack Obama speaks to a rally of supporters during the Whistle-Stop Tour in Wilmington, Delaware, where he and Michelle stopped to pick up Vice President-elect Joe Biden and his wife, Jill. Thousands crowded around the stage in front of the Wilmington Amtrak station—a location familiar to Senator Biden, who commuted to Washington almost every day during his tenure in the Senate. Joining the Obamas and Bidens onstage was Gregg Weaver, the Amtrak conductor who became a close family friend over the course of Biden's many trips.

PHOTO BY JOHN HARRINGTON

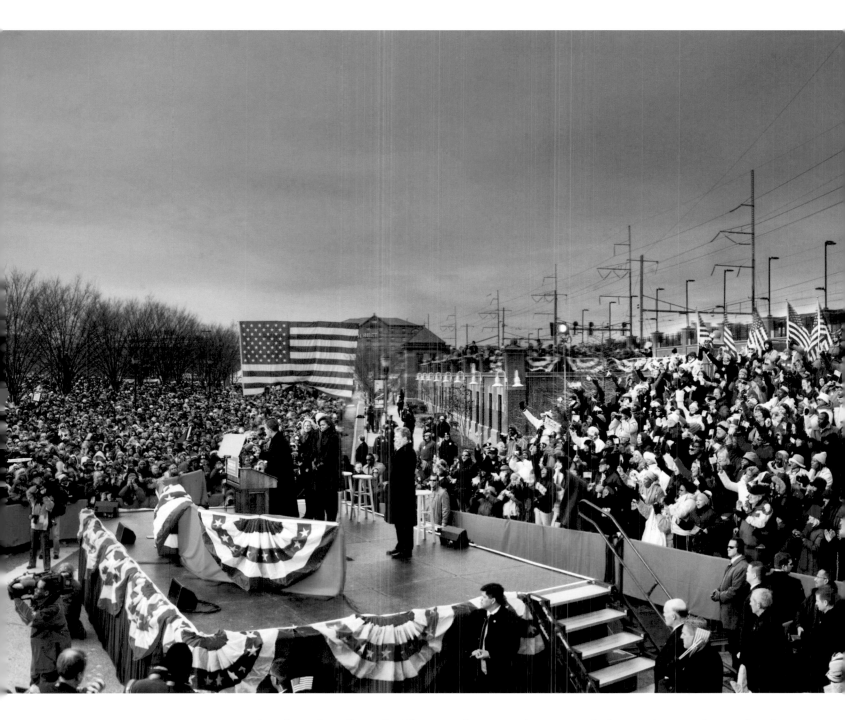

In choosing Barack Obama, the American people have chosen the path of change, openness, and optimism. At a time when the world is in torment and doubt, the American people—true to the values that have always been at the very core of America's identity—strongly expressed their faith in progress and in the future.

PRESIDENT NICOLAS SARKOZY
FRANCE

Barack Obama and Joe Biden pay their respects at the Tomb of the Unknown Soldier in Arlington National Cemetery on Sunday morning.

PHOTO BY ROBERT McNEELY

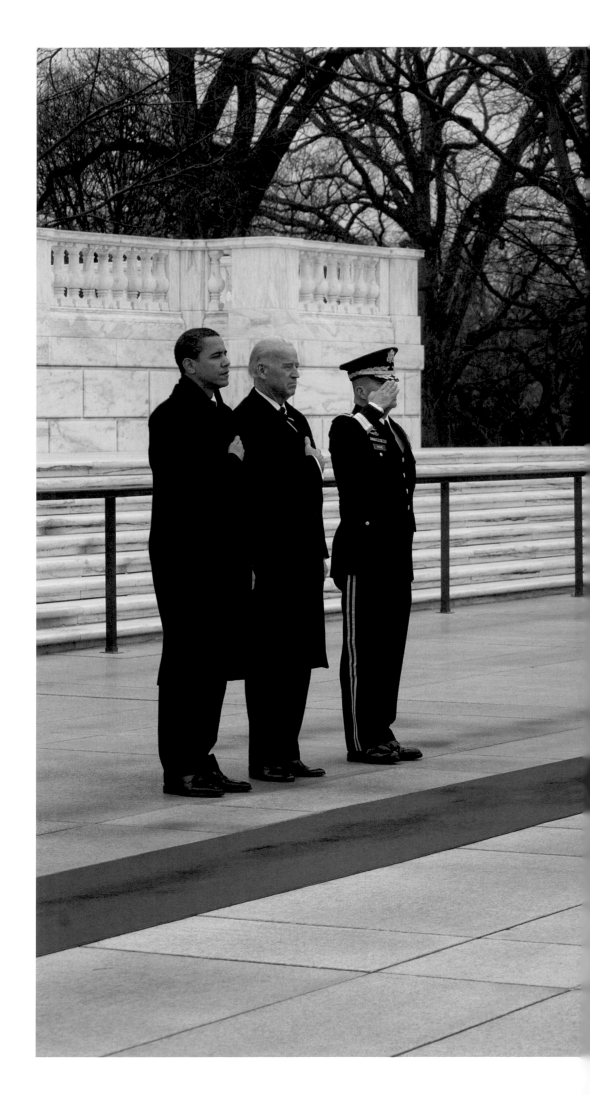

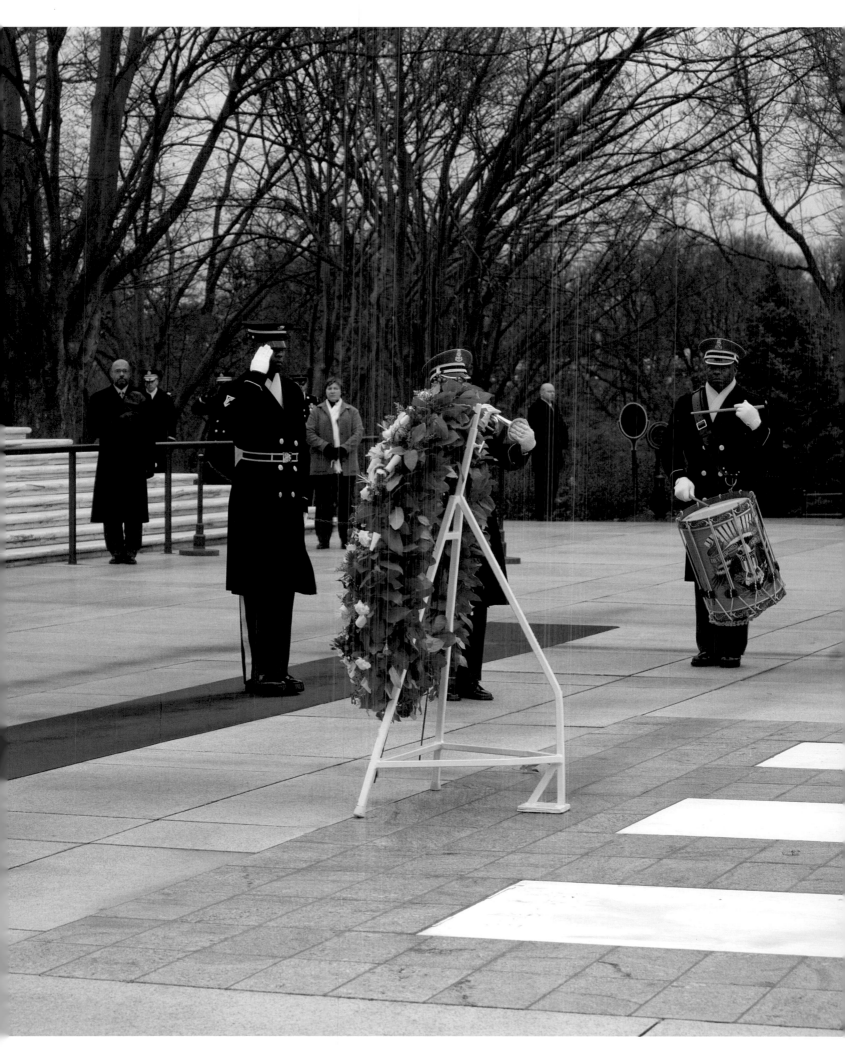

OPENING CELEBRATION

IMAGINE AN AMERICA where dozens of the world's most famous and beloved entertainers come together to celebrate democracy and hope in a free concert on the steps of the Lincoln Memorial.

PHOTO BY KAREN BALLARD

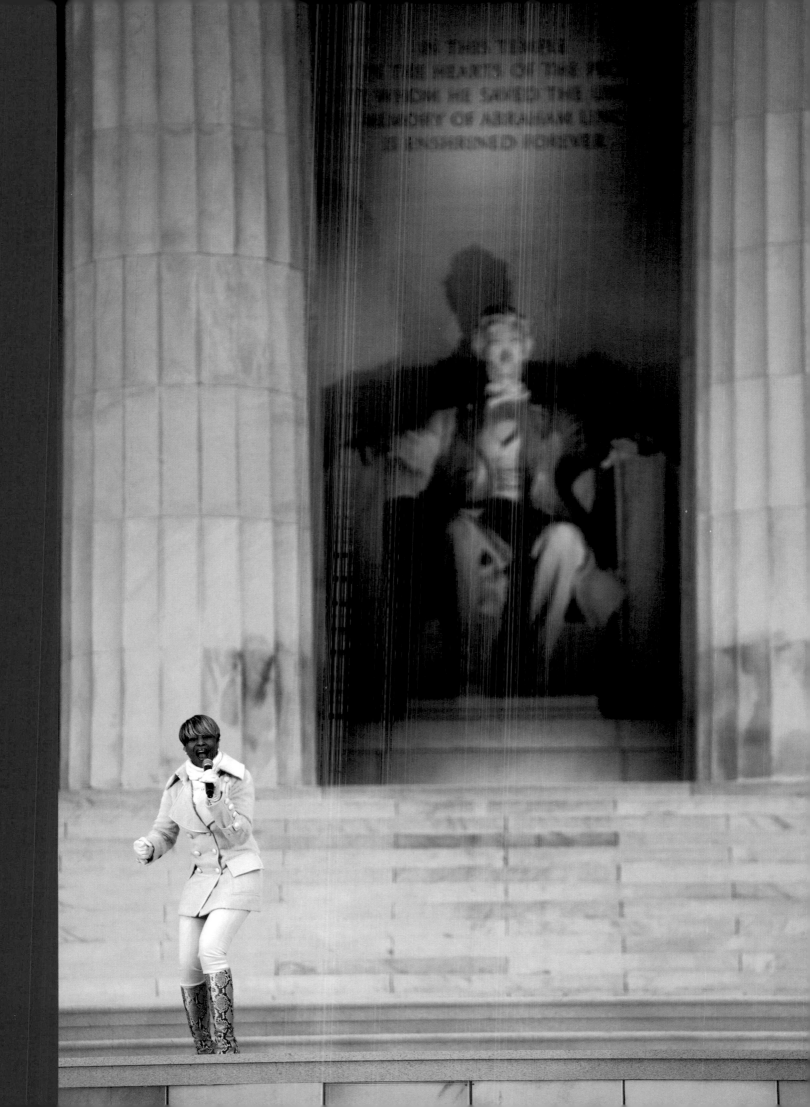

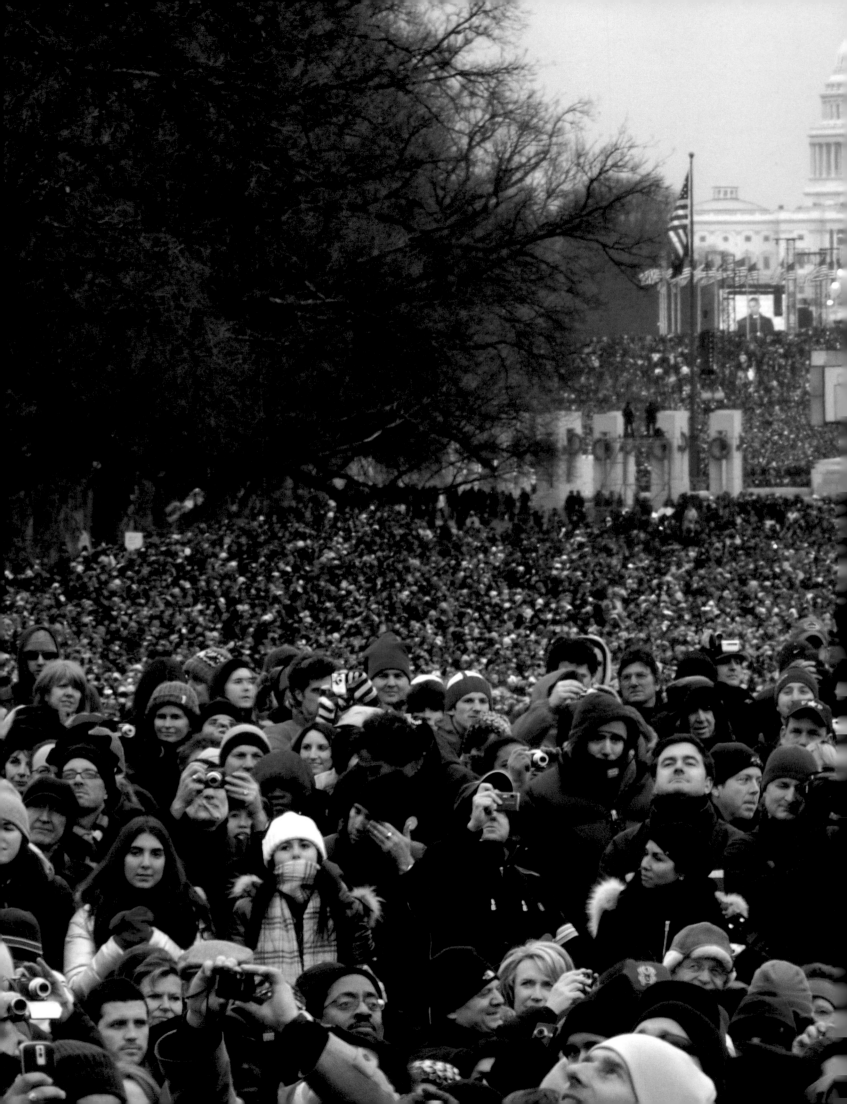

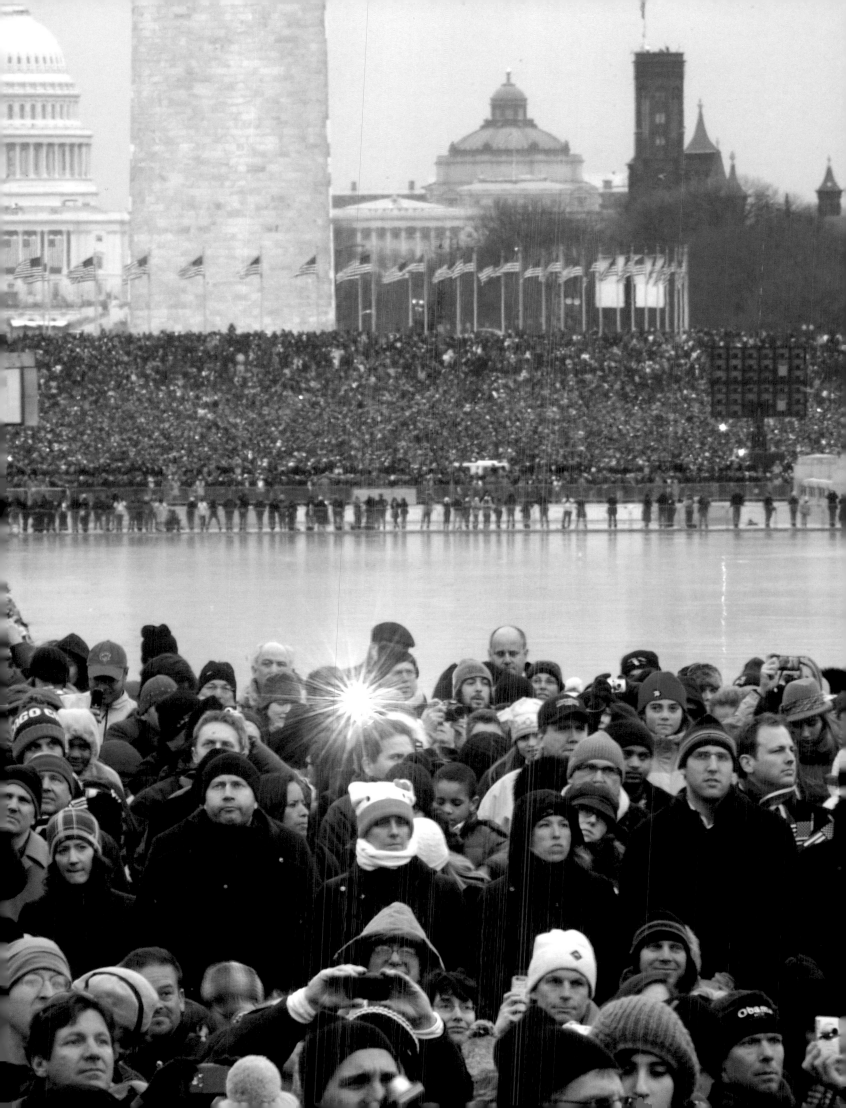

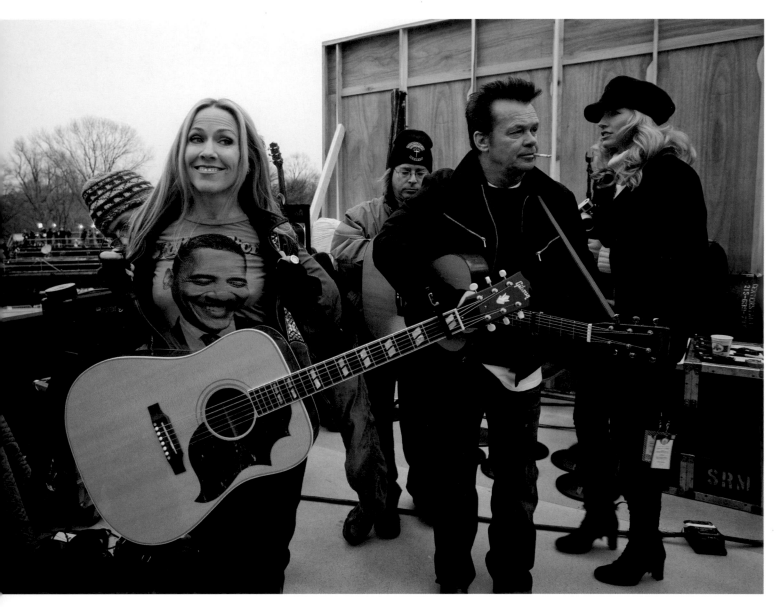

PREVIOUS PAGE
An estimated 400,000 people pack the western end of the National
Mall for the historic "We Are One" concert on Sunday. Staged on the
steps of the Lincoln Memorial, the superstar-studded show marked
the official start of the inaugural celebrations.

PHOTO BY DANIEL CIMA

Backstage at the concert, Sheryl Crow—showing off her Obama pride—and John Mellencamp (opposite) get ready to take the stage. Above, Tom Hanks prepares for his turn as a speaker narrating composer Aaron Copeland's "Lincoln Portrait," an orchestral work written in 1942 that excerpts portions of Lincoln's great documents and speeches.

OPPOSITE
PHOTO BY DAVID HUME KENNERLY

ABOVE
PHOTO BY CLARENCE WILLIAMS

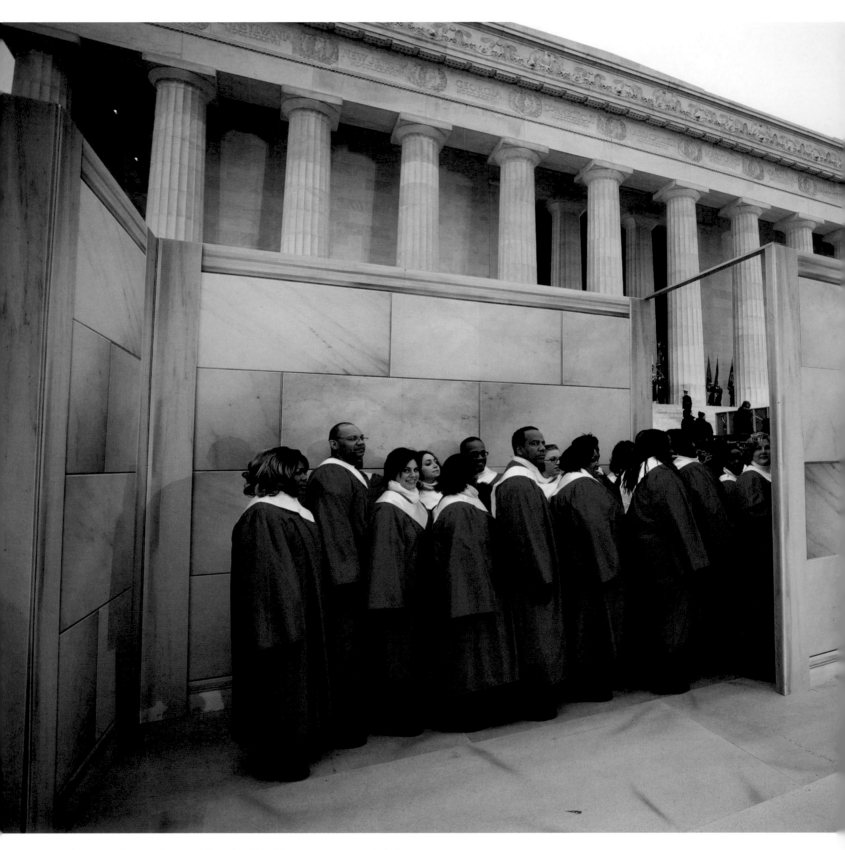

The Joyce Garrett Singers (above), a Washington-area gospel choir formed especially for the occasion, file in for their set backing Bruce Springsteen, while members of the Gay Men's Chorus of Washington, DC, ham it up backstage (opposite).

ABOVE
PHOTO BY DAVID HUME KENNERLY

OPPOSITE
PHOTO BY ROBERT McNEELY

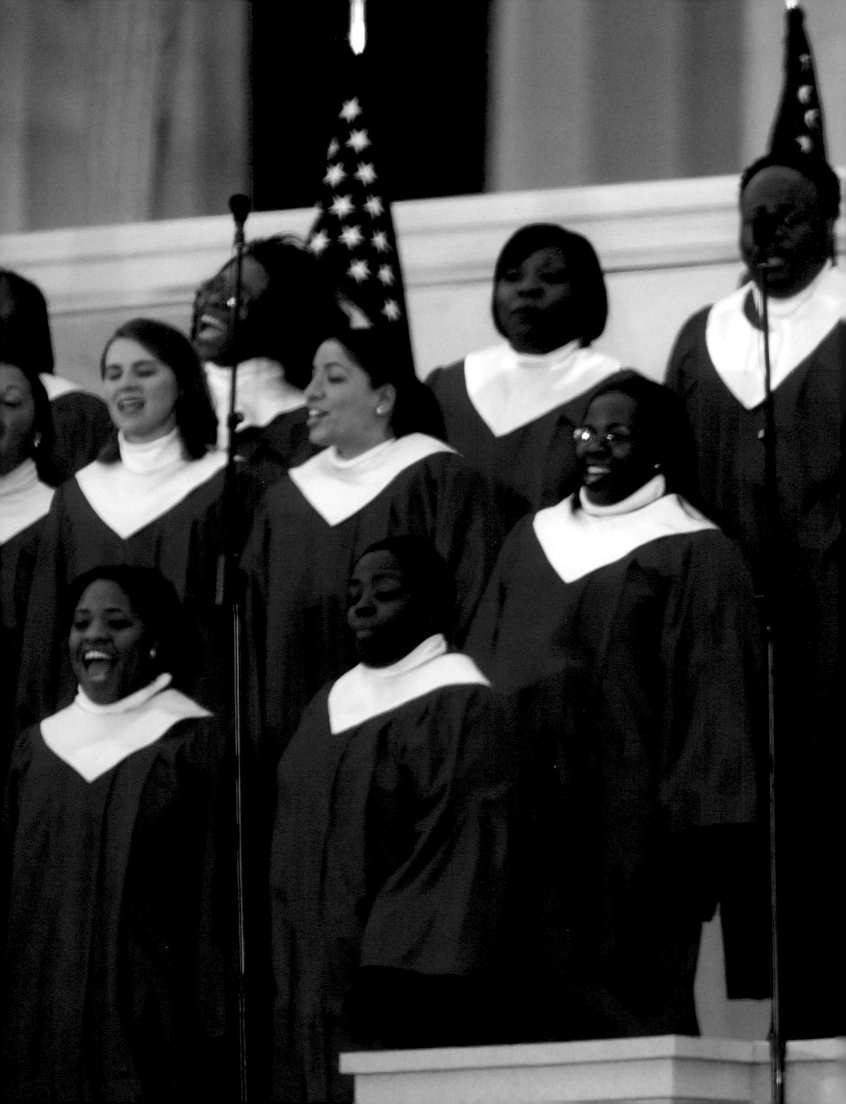

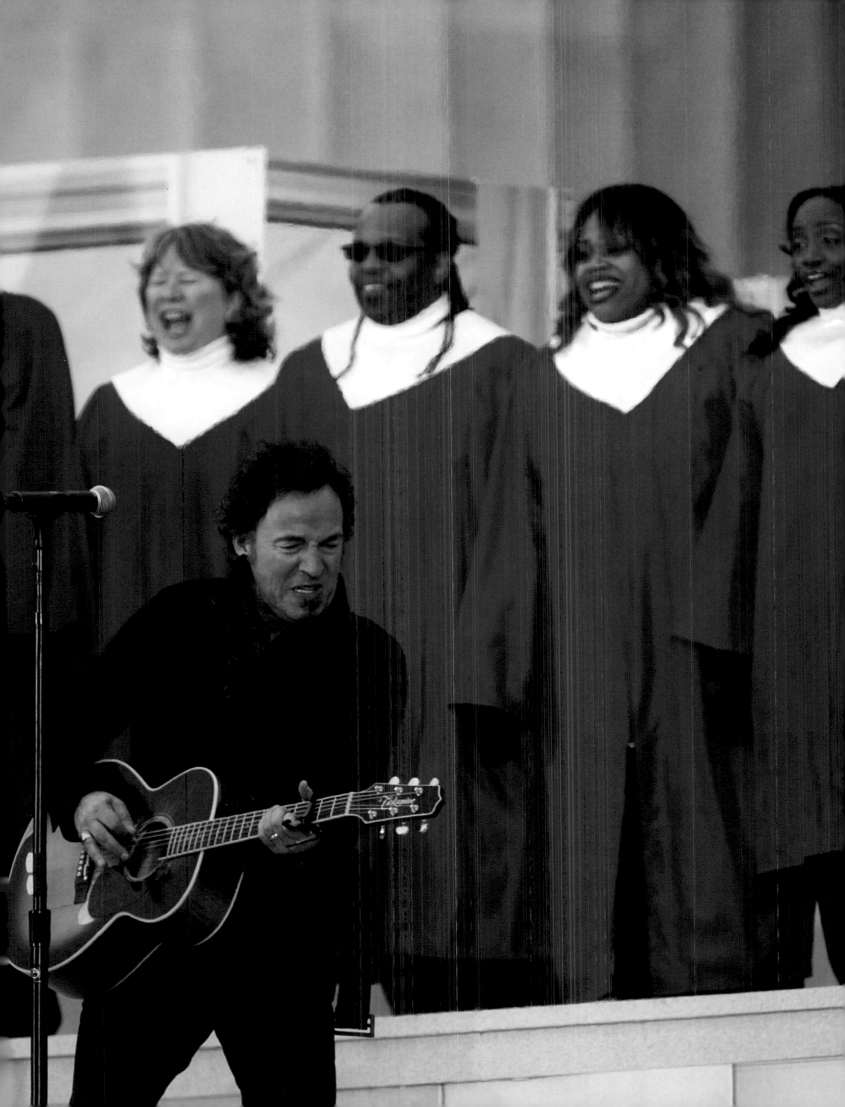

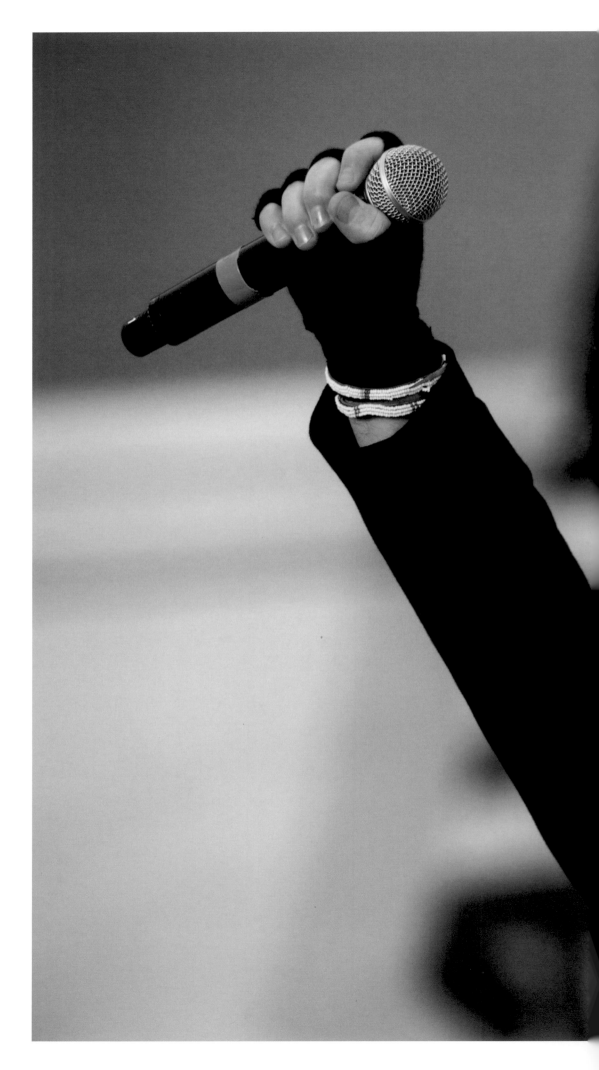

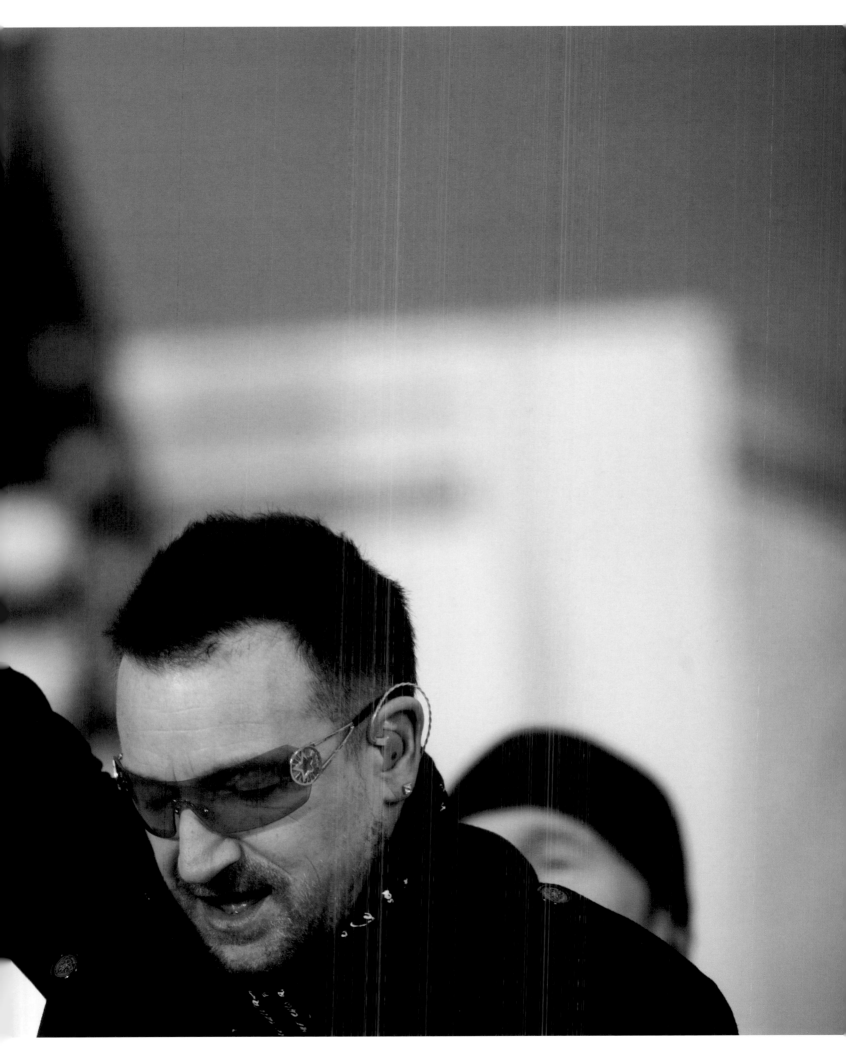

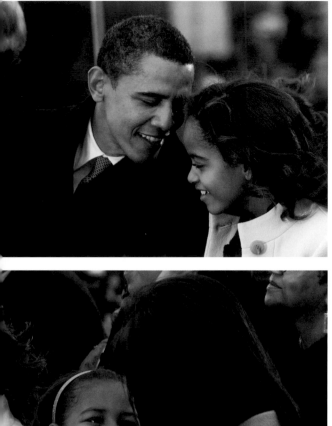

The Obamas, the Bidens, and family members enjoy the show from a special glass-protected viewing stand onstage. Actor Denzel Washington watches from the wings.

PHOTOS BY DAVID HUME KENNERLY

When Obama was elected I cried happy tears, because for me, as an African-American woman, to live to see a day like this was amazing. It was bigger than just an election, and it was bigger than just being an African-American, it was about change. It was about a transformation in America...

MARY J. BLIGE

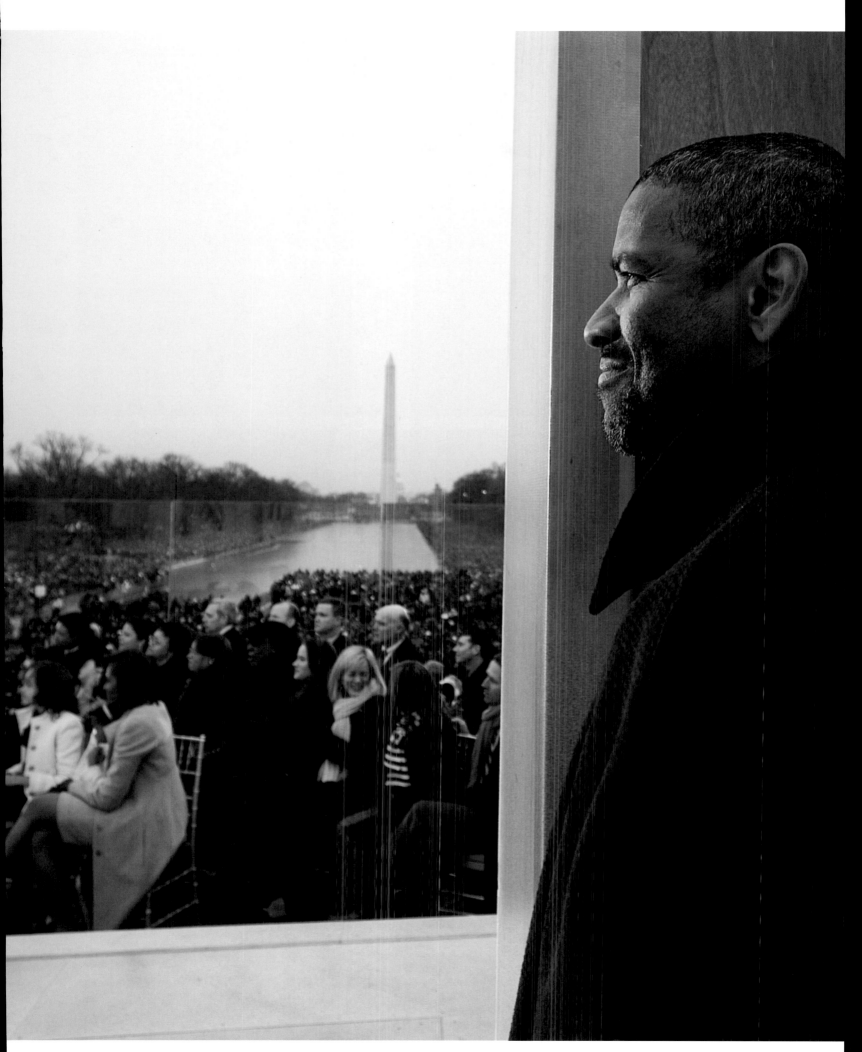

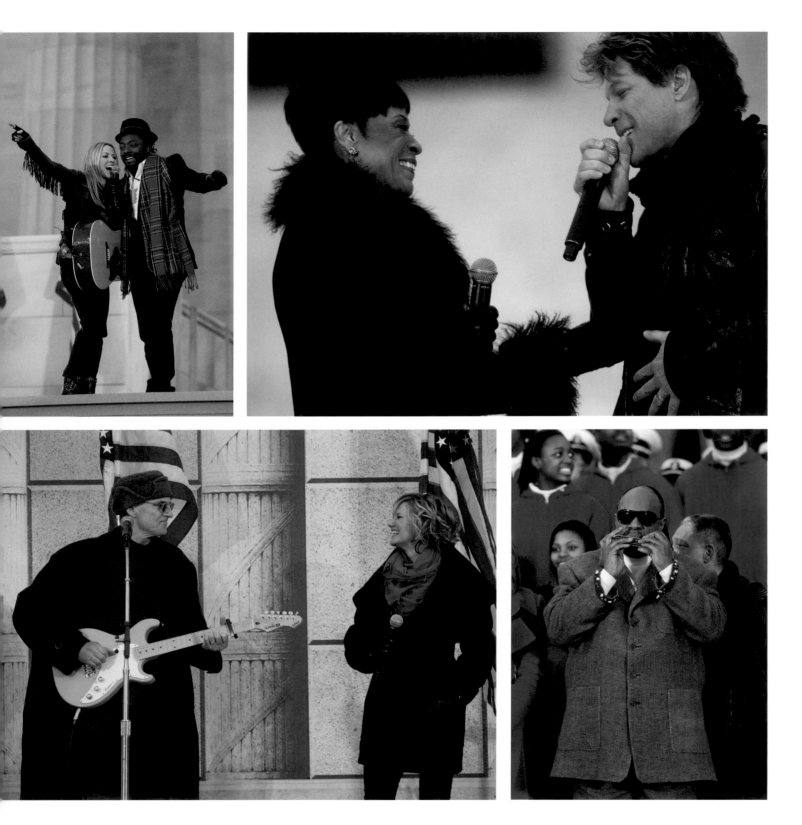

CLOCKWISE FROM TOP LEFT
Performing at the "We Are One" concert above are: Sheryl Crow and Will.i.am; Bettye Lavette and Jon Bon Jovi; Stevie Wonder; and James Taylor and Jennifer Nettles.

PHOTOS BY ROBERT McNEELY; KAREN BALLARD; KAREN BALLARD; PAUL MORSE

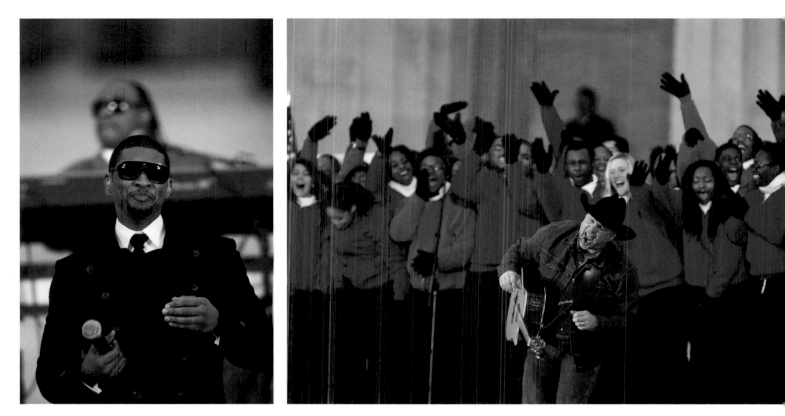

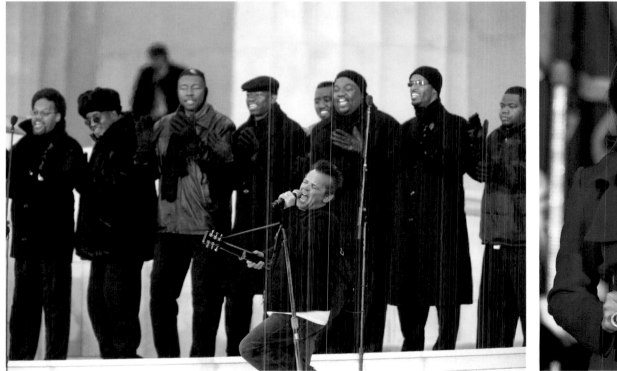

CLOCKWISE FROM TOP LEFT
Above are: Usher (with Stevie Wonder); Garth Brooks, backed
by the Washington Youth Choir; opera superstar Renée Fleming;
and John Mellencamp, singing his classic hit "Little Pink Houses"
with members of the Brookland Baptist Choir.

**PHOTOS BY KAREN BALLARD; PAUL MORSE;
KAREN BALLARD; PAUL MORSE**

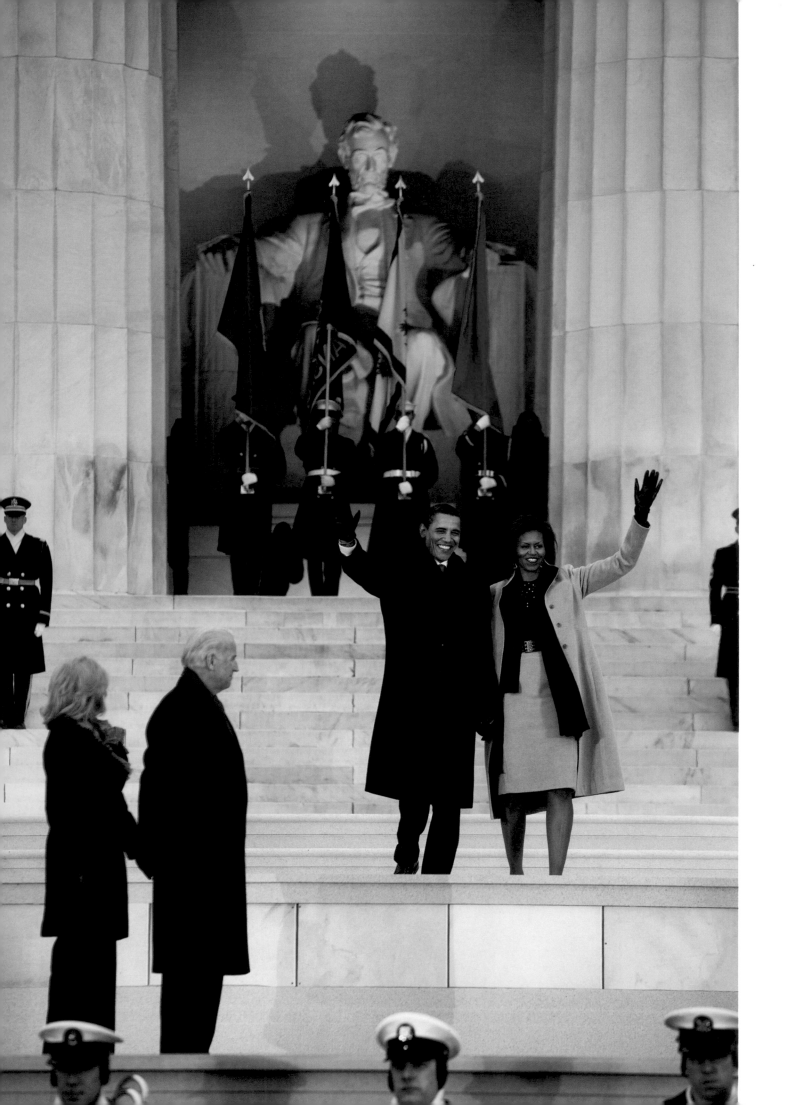

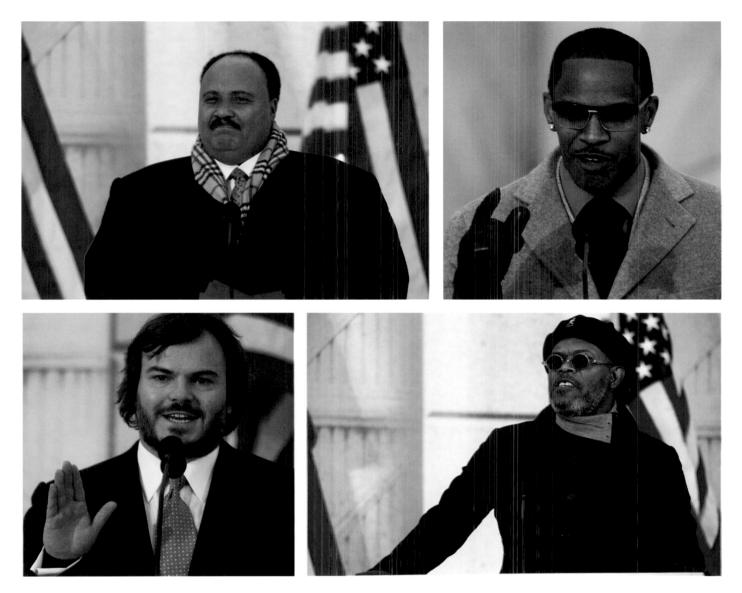

Onstage at the Lincoln Memorial, the Obamas and the Bidens greet the crowd. Speakers include Martin Luther King III (top left); Jamie Foxx (doing a droll impression of President-elect Obama); Samuel L. Jackson; and Jack Black, who read a passage honoring President Lincoln's protection of what would become Yosemite National Park in 1864.

PHOTOS BY KAREN BALLARD

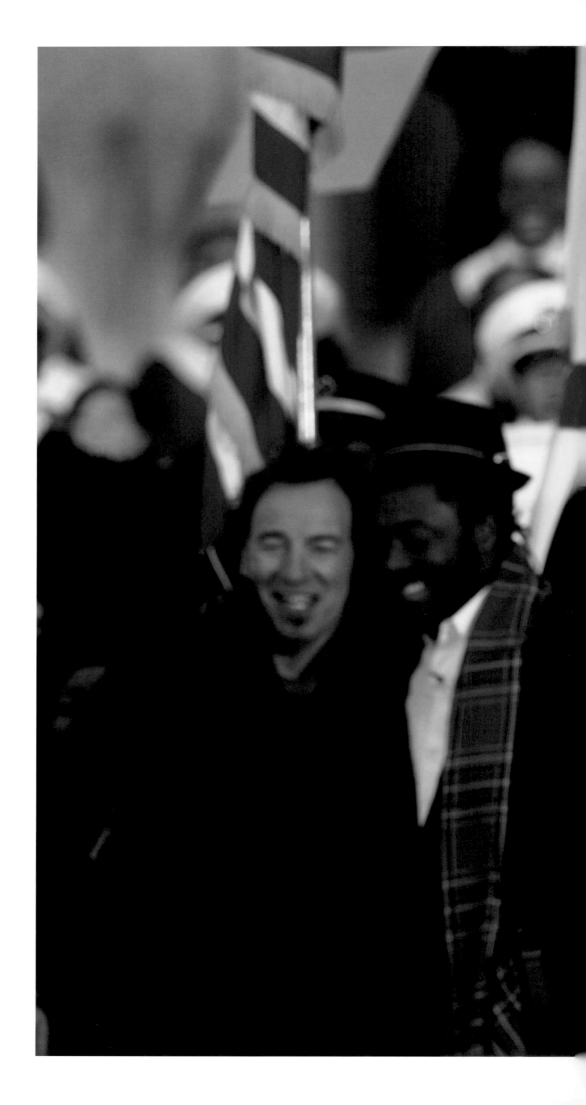

Beyoncé leads an all-star cast including Bruce Springsteen, Will.i.am, and Samuel L. Jackson in a finale of "America the Beautiful."

PHOTO BY KAREN BALLARD

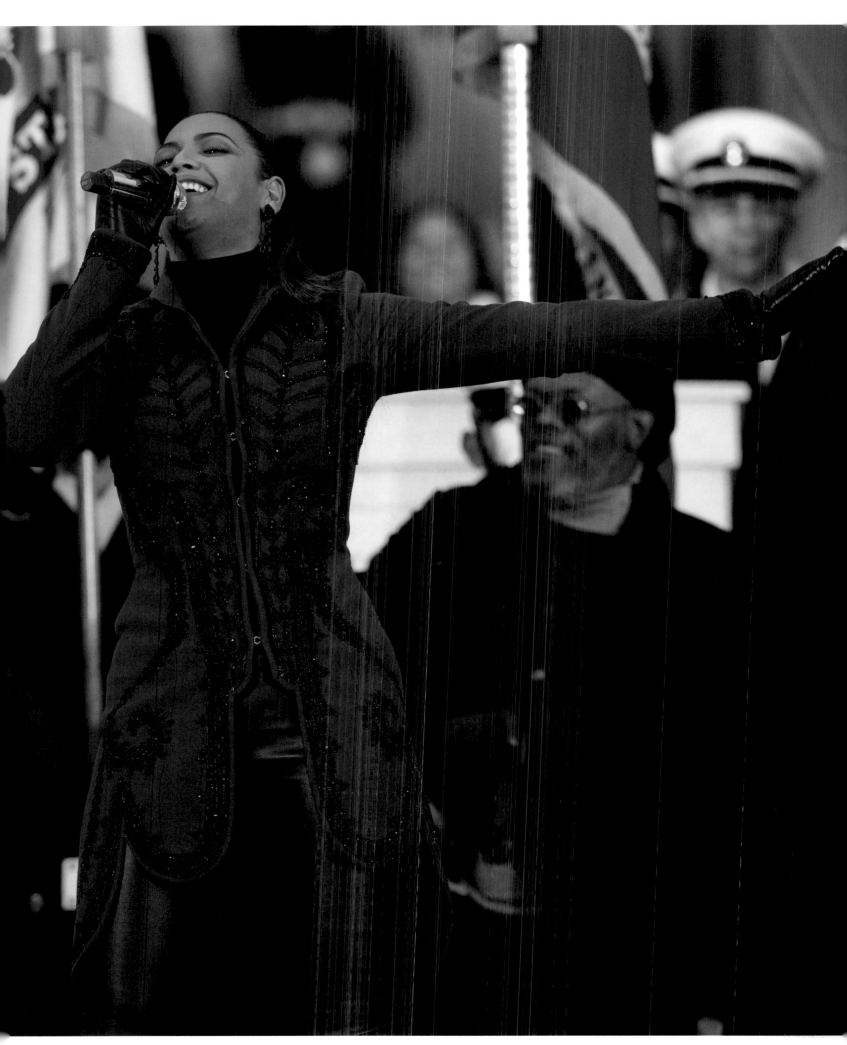

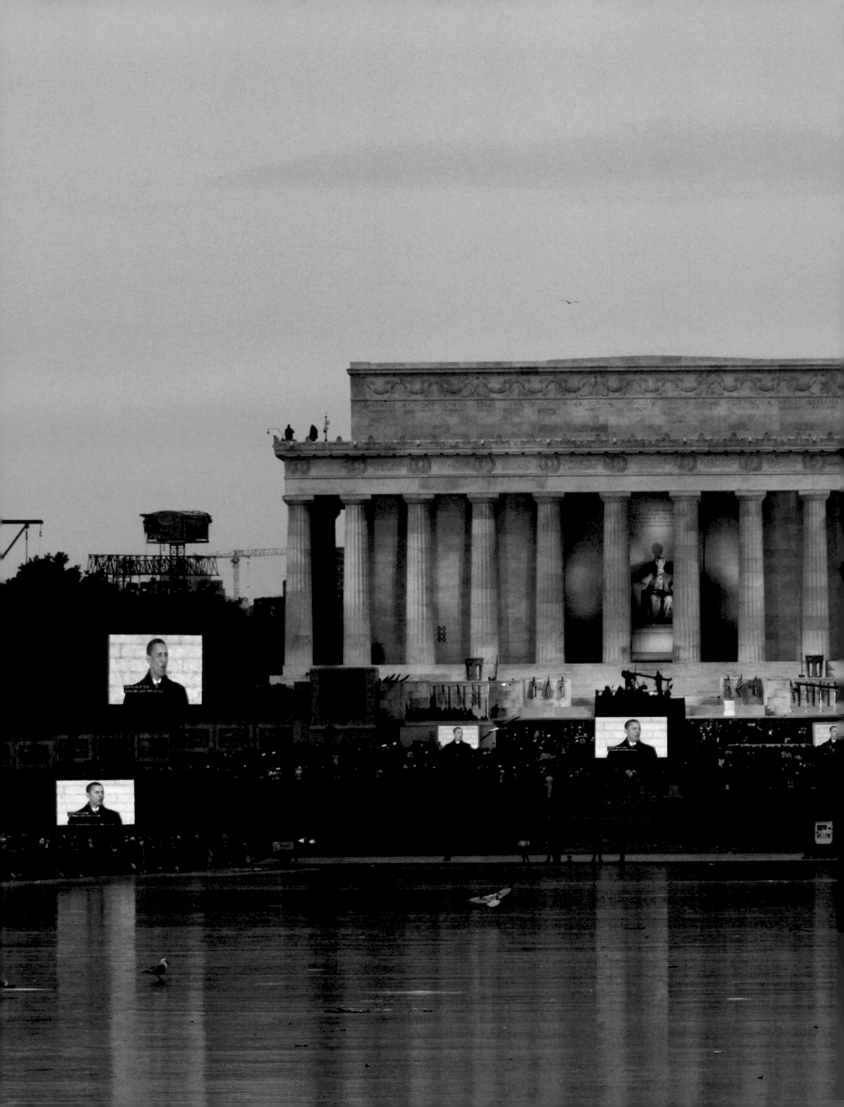

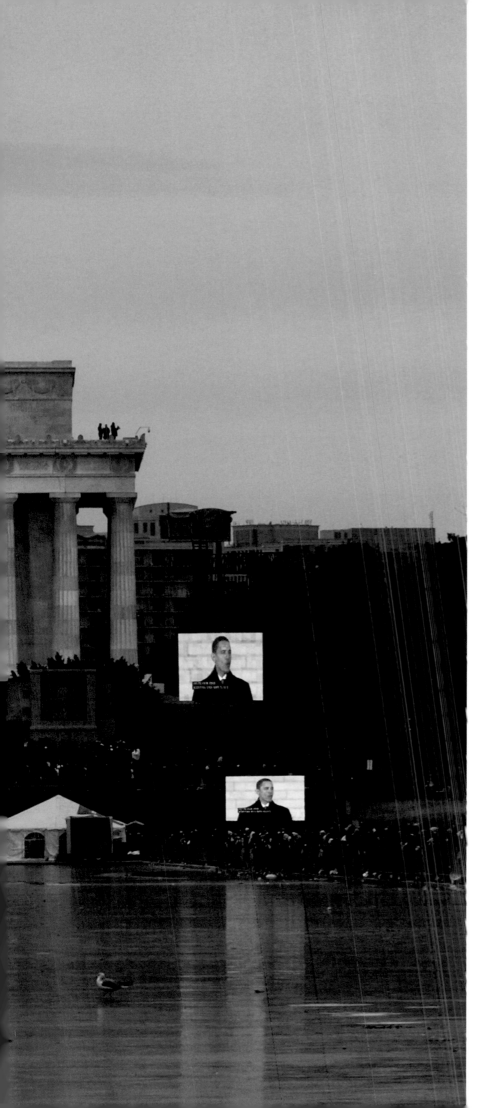

Directly in front of us is a pool that still reflects the dream of a King, and the glory of a people who marched and bled so that their children might be judged by their characters' content. And behind me, watching over the union he saved, sits the man who in so many ways made this day possible.

BARACK OBAMA
JANUARY 18, 2009

Both President-elect Obama and Vice President-elect Biden addressed the crowd as part of the "We Are One" concert on Sunday afternoon, January 18, 2009.

PHOTO BY ANNE DAY

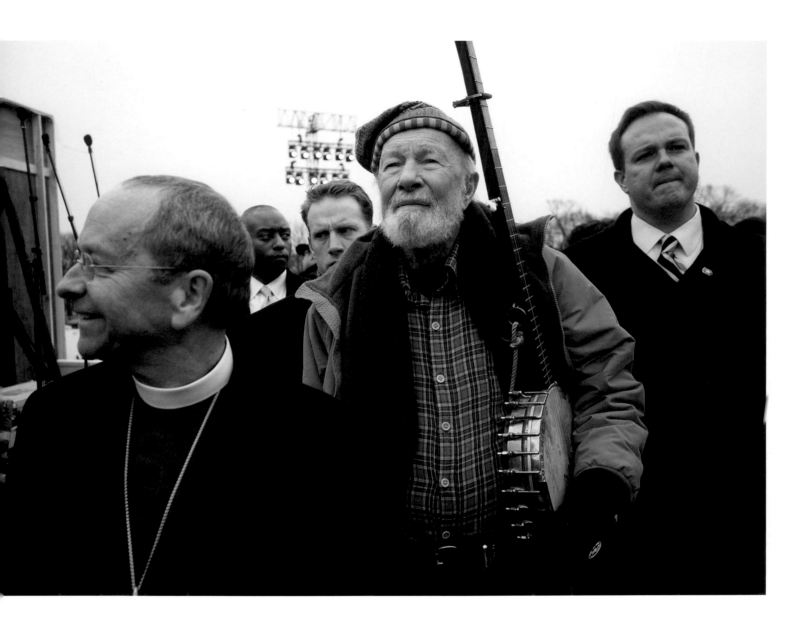

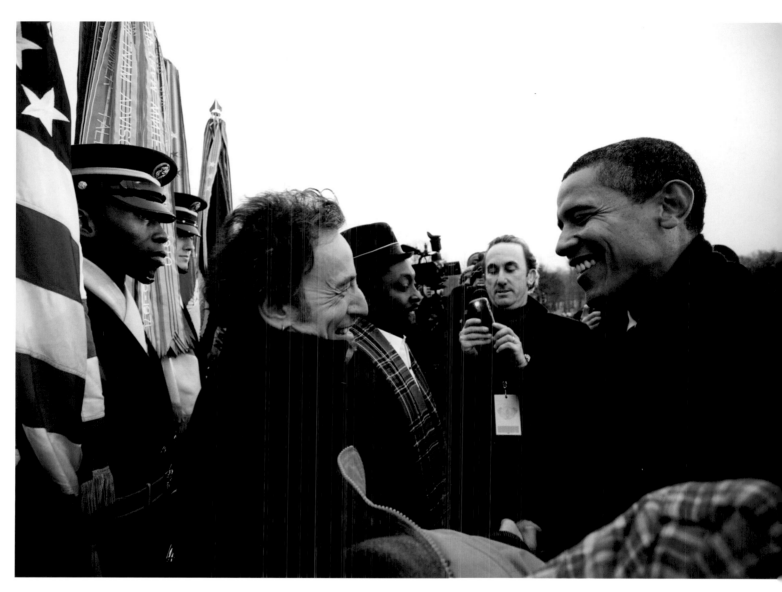

After performing a rousing sing-along version of Woody Guthrie's "This Land Is Your Land," the legendary 92-year-old Pete Seeger (opposite) and Bruce Springsteen (above) mingle backstage with other concert participants and the President-elect himself.

PHOTOS BY DAVID HUME KENNERLY

As I stand here tonight, what gives me the greatest hope of all is not the stone and marble that surrounds us today, but what fills the spaces in between. It is you—Americans of every race and region and station who came here because you believe in what this country can be and because you want to help us get there. It is the same thing that gave me hope from the day we began this campaign for the presidency nearly two years ago; a belief that if we could just recognize ourselves in one another and bring everyone together—Democrats, Republicans, and Independents; Latino, Asian, and Native-American; black and white, gay and straight, disabled and not—then not only would we restore hope and opportunity in places that yearned for both, but maybe, just maybe, we might perfect our union in the process. This is what I believed, but you made this belief real. You proved once more that people who love this country can change it. And as I prepare to assume the presidency, yours are the voices I will take with me every day I walk into that Oval Office—the voices of men and women who have different stories but hold common hopes; who ask only for what was promised us as Americans—that we might make of our lives what we will and see our children climb higher than we did.

It is this thread that binds us together in common effort; that runs through every memorial on this mall; that connects us to all those who struggled and sacrificed and stood here before. It is how this nation has overcome the greatest differences and the longest odds—because there is no obstacle that can stand in the way of millions of voices calling for change.

BARACK OBAMA
JANUARY 18, 2009

Crowds disperse after the concert. In addition to the throngs who caught
the sets from U2, Beyoncé, Stevie Wonder, and others in person, an estimated
4.1 million others watched the show's live telecast on HBO.

PHOTO BY DAVID HUME KENNERLY

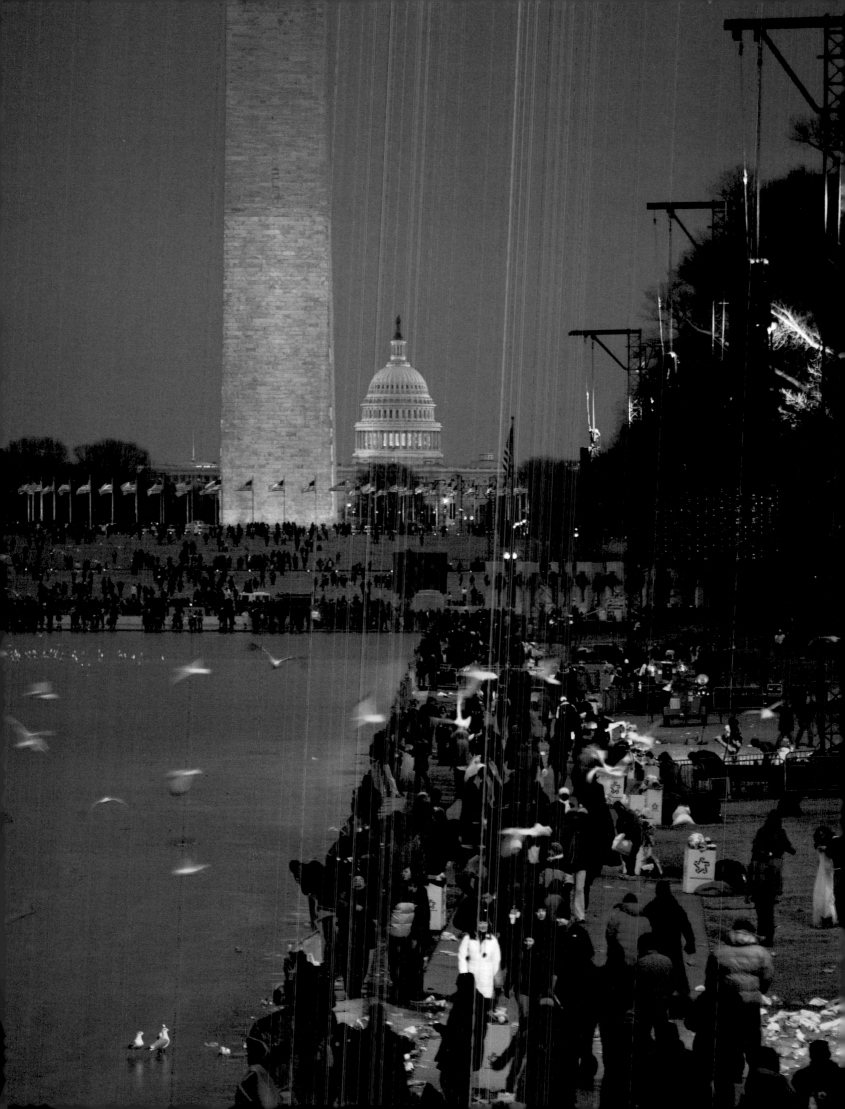

NATIONAL DAY OF SERVICE

IMAGINE AN AMERICA
where a former community
organizer spends his last day before
becoming president honoring
Martin Luther King, Jr.,
with a day of community service—
and inspires millions of
his fellow citizens to do the same.

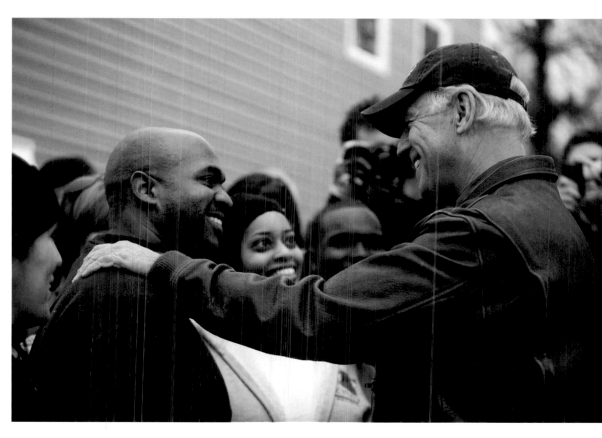

Michelle Obama and Joe Biden greet volunteers as the National Day
of Service gets under way. Timed to coincide with the federal holiday
marking Martin Luther King, Jr.'s birthday on January 19, the Day
of Service was Barack Obama's idea to capitalize on the patriotic
goodwill of Americans by encouraging them to make an ongoing
commitment to volunteer community service. Throughout the day,
Barack and Michelle Obama and Joe and Jill Biden visited several
different public-works projects around Washington to lend a hand.

LEFT
PHOTO BY HECTOR EMANUEL

ABOVE
PHOTO BY KAREN BALLARD

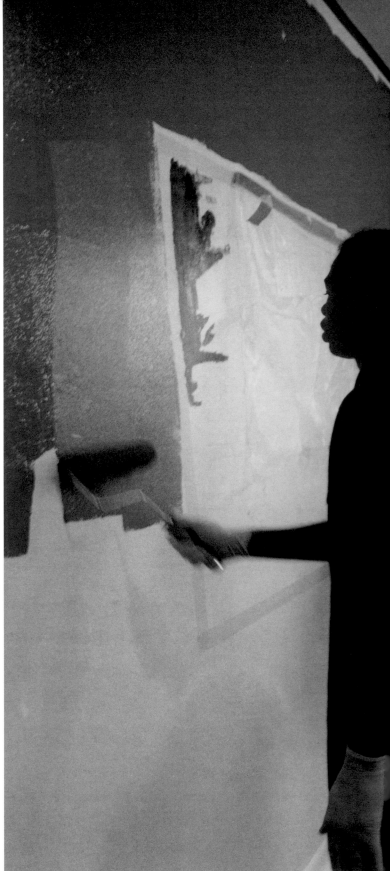

Painting a wall at an emergency shelter for homeless teens, the President-elect joked, "It's good practice because I'm moving into a new house tomorrow." Despite the jocular mood, the day was no laughing matter for Obama. On the campaign trail, he had often faulted George W. Bush for not calling the nation to service after September 11; the Day of Service was the new president's way of putting those words into action.

PHOTO BY ROBERT McNEELY

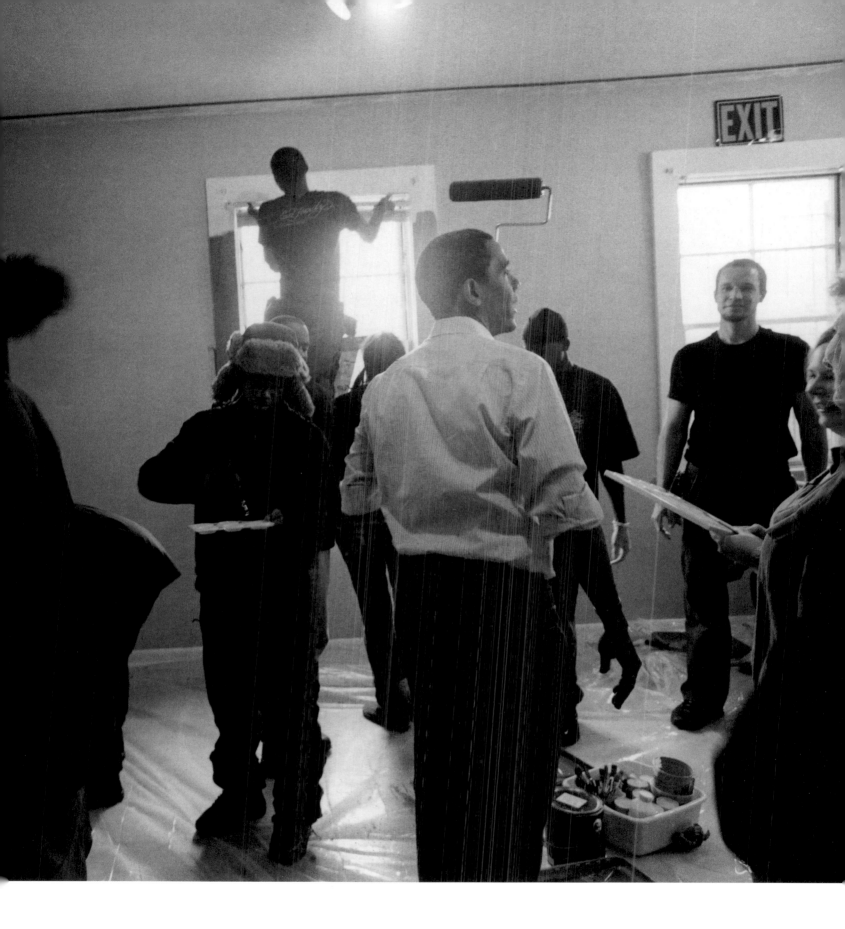

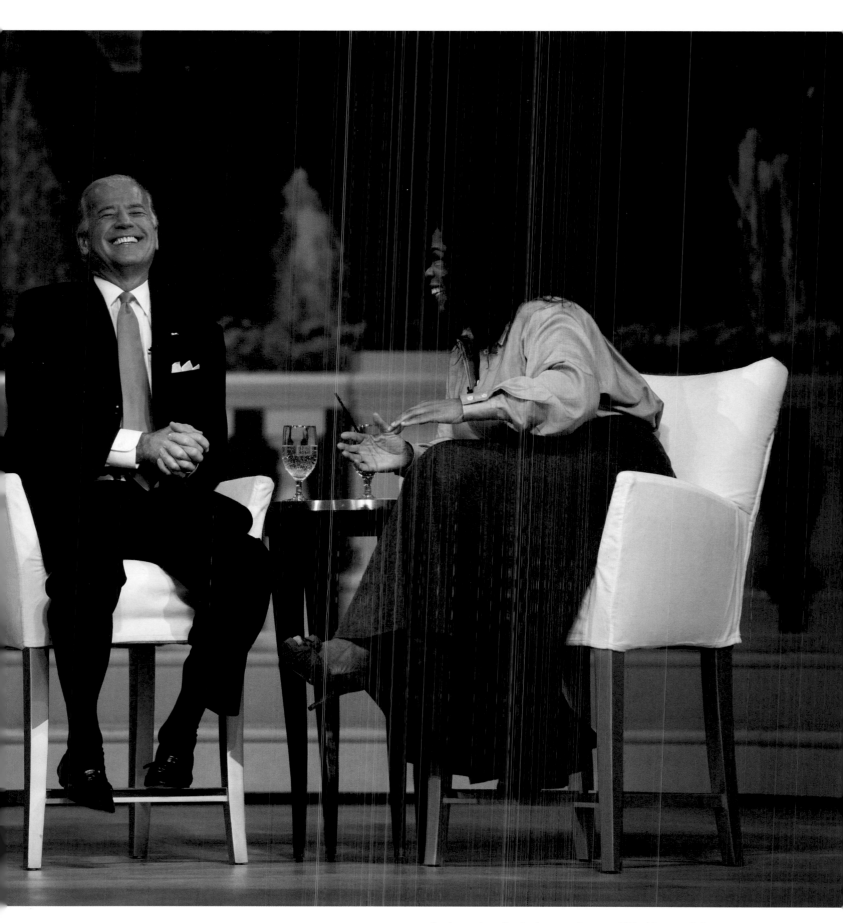

During a day of volunteer work around Washington, DC, Vice President-elect Biden pitches in at a Habitat for Humanity construction project (opposite top), and poses with ROTC cadets at Calvin Coolidge High School (opposite bottom). Later in the afternoon, he and Mrs. Biden are interviewed by Oprah Winfrey, who telecast her show live from the Kennedy Center.

PHOTOS BY KAREN BALLARD

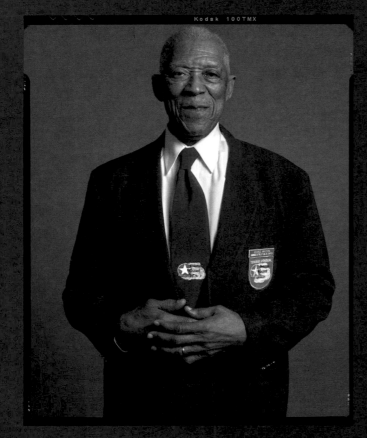

George Watson, Sr., Lakewood, New Jersey

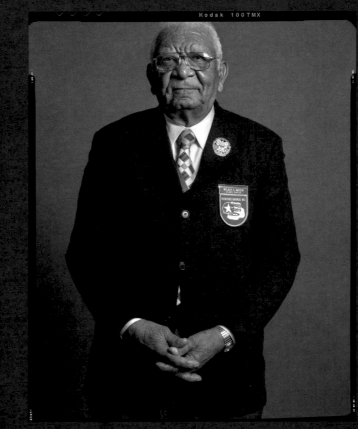

Wilbur G. Mason, Conyers, Georgia

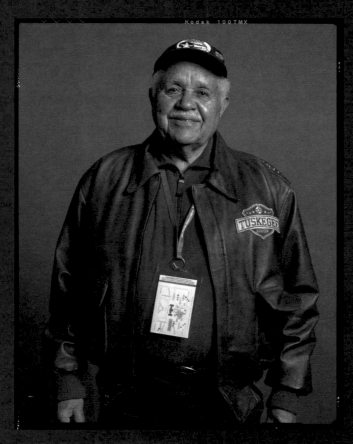

Leo R. Gray, Fort Lauderdale, Florida

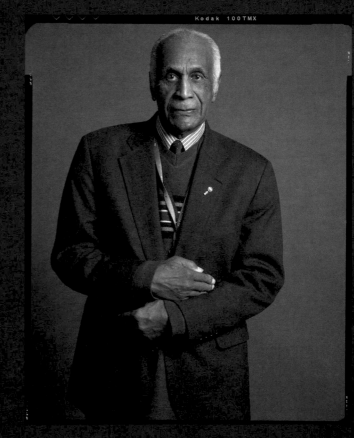

Milton Crenshaw, Little Rock, Arkansas

PHOTOS BY JOHN FRANCIS FICARA

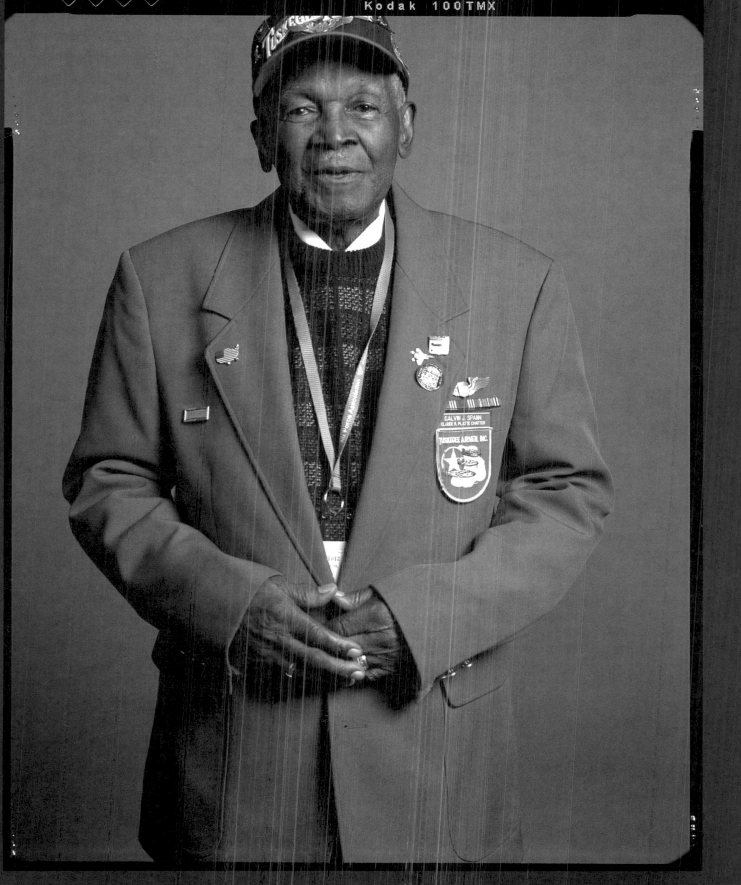

Kodak 100 TMX

Calvin Spann, Dallas, Texas

The above portraits are of five of the more than 180 Tuskegee Airmen who attended the inaugural ceremonies by special invitation from Barack Obama. The first African-American fighter pilots in the U.S. Army, the Tuskegee Airmen's highly distinguished record during World War II, coupled with their courage in the face of continued segregation and racism in the military, laid the groundwork both for today's integrated Army and for the larger civil-rights movement in America. Said retired Lt. William Broadwater of Obama's election, "The culmination of our efforts and others' was this great prize we were given on November 4. Now we feel like we've completed our mission."

Hosted by Michelle Obama and Jill Biden, the Kids' Inaugural "We Are the Future" concert was held Monday evening at Washington's Verizon Center. Tickets for the star-studded show were made available mainly to families of military service members, who were thrilled by sets from megastar Miley Cyrus and other teen favorites.

RIGHT AND ABOVE TOP
PHOTOS BY ANNE DAY

ABOVE BOTTOM
PHOTO BY MATTHEW NAYTHONS

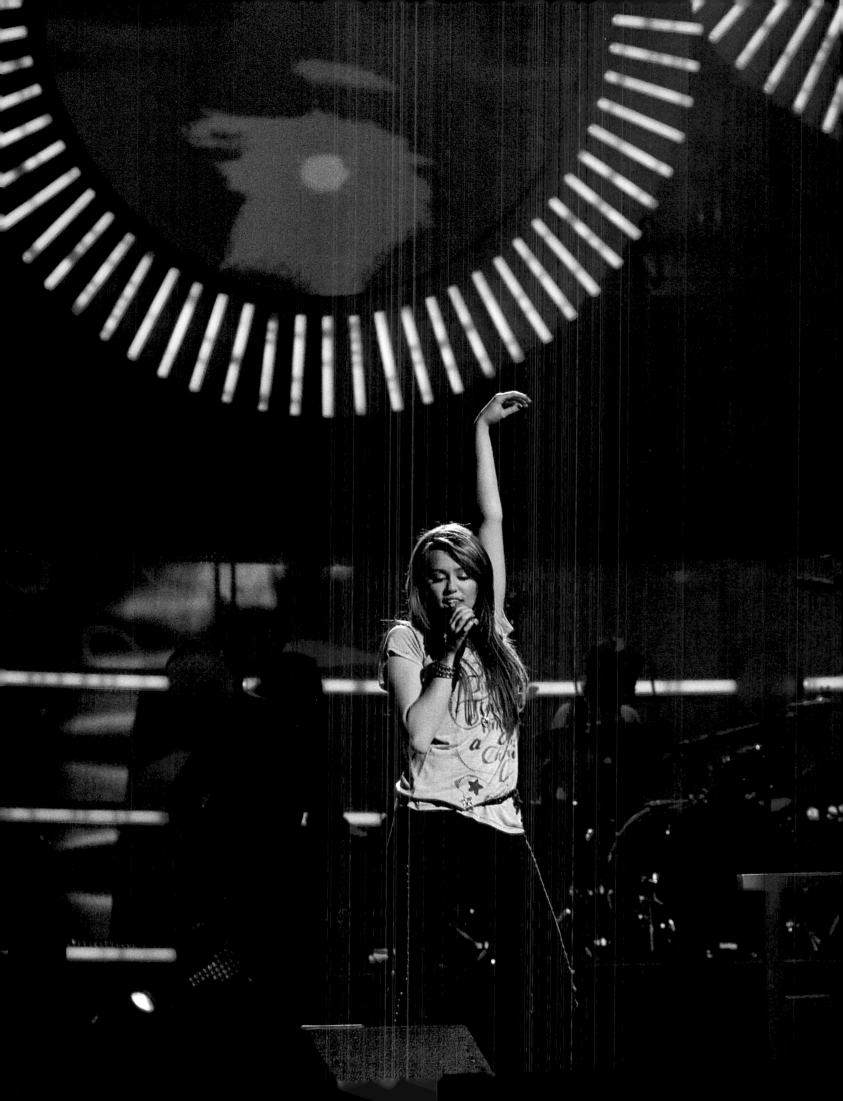

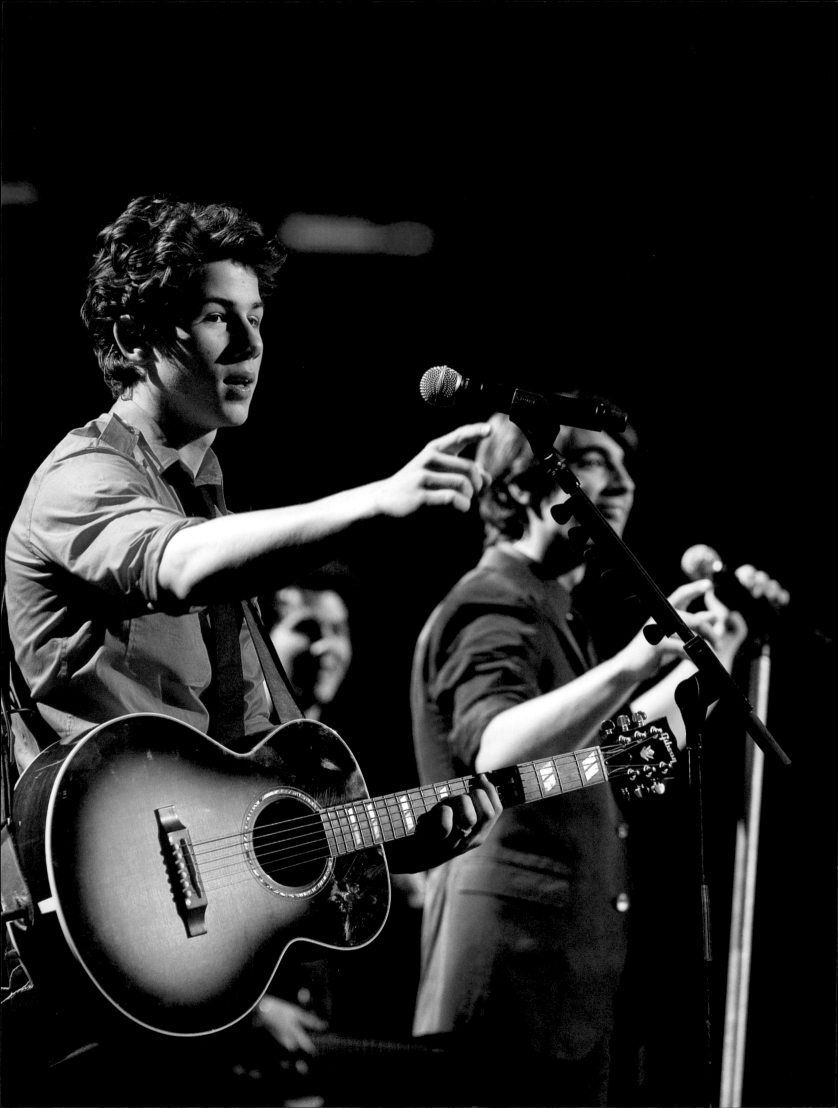

Much to the delight of ten-year-old Malia Obama, above with her mother, Michelle, the Kids' Inaugural concert featured a set from teen pop idols the Jonas Brothers (opposite). The talent lineup was reportedly selected by Malia and Sasha and also included Miley Cyrus, Bow Wow, and Demi Lovato, among others.

PHOTOS BY ANNE DAY

SWEARING IN

IMAGINE AN AMERICA where the new president, ten minutes into his term of office, asks us to participate in the fight for our bright future with the words of George Washington: "Let it be told to the future world that in the depth of winter, when nothing but hope and virtue could survive, that the city and the country, alarmed at one common danger, came forth to meet it."

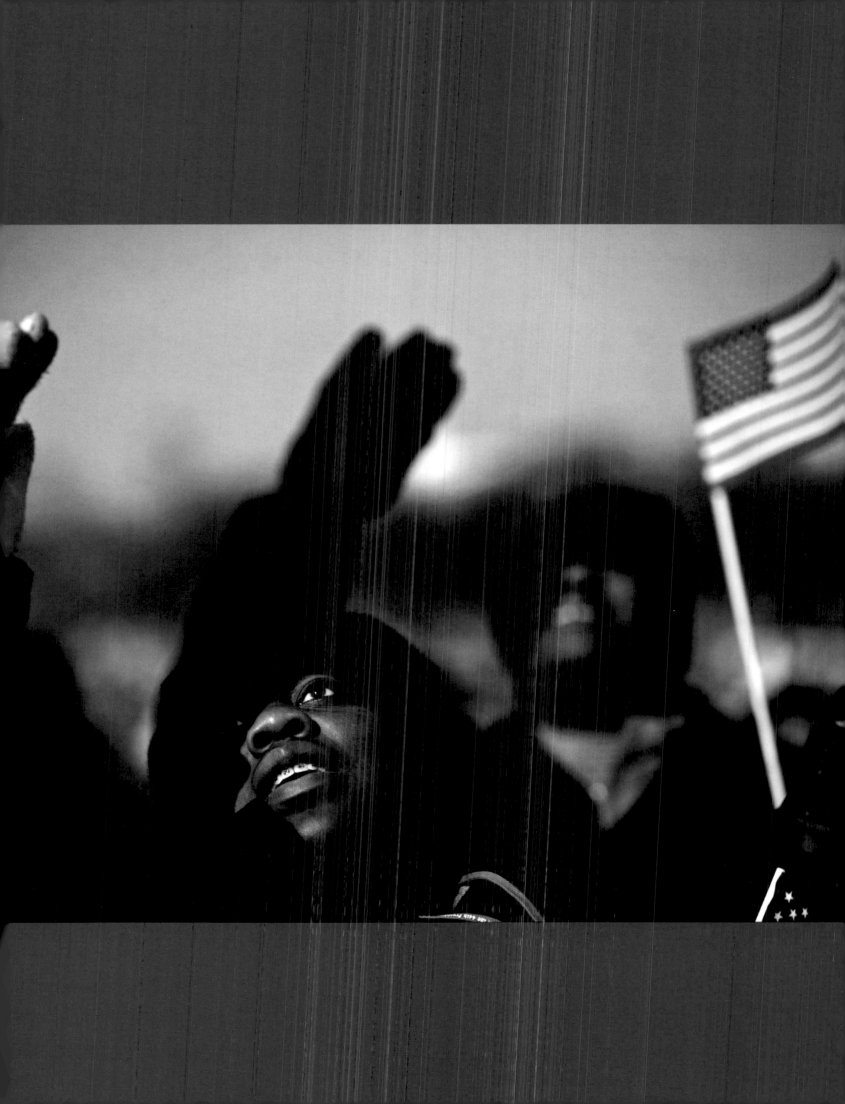

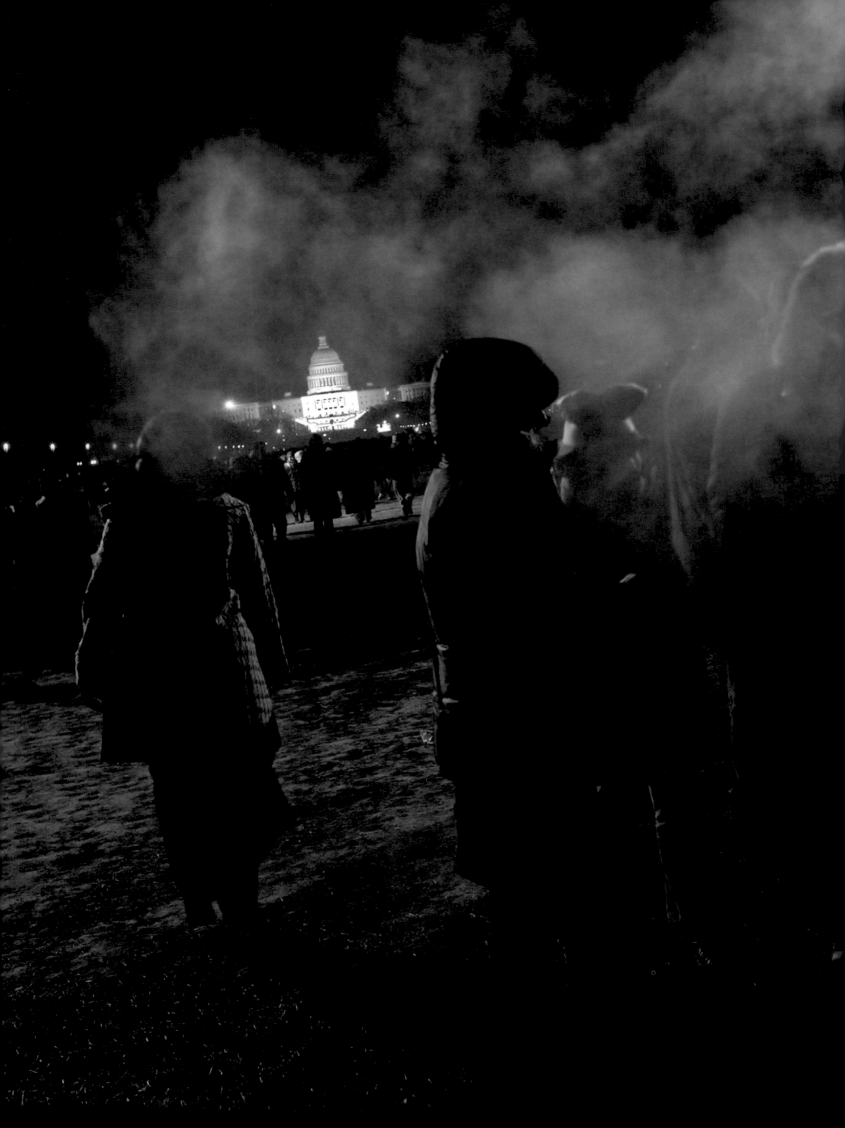

Frigid temperatures in the teens aren't enough to deter some celebrants from camping out all night to claim a prime viewing spot for the inaugural ceremonies on the National Mall.

PHOTO BY PETE MAROVICH

75

Some of the million-plus riders who jammed the DC Metro's train service on Inauguration Day ride to the swearing-in ceremony at the U.S. Capitol. Counting bus and paratransit rides, the Metro recorded 1,544,721 trips, a record for a single day in the transit system's 33-year history.

PHOTOS BY HECTOR EMANUEL

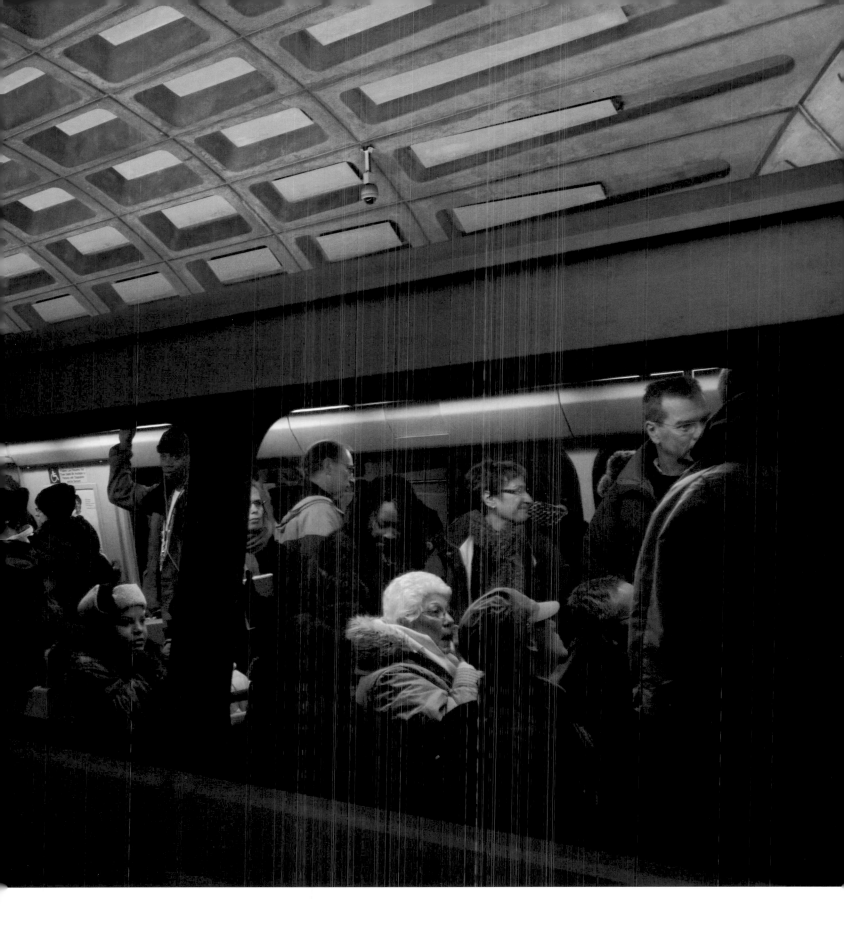

People walked to the ceremony with optimism and hope, and also expectation about what they were going to hear. And peacefully—I've never seen so many people in one place conducting themselves with such a peaceful spirit.

SHERYL CROW

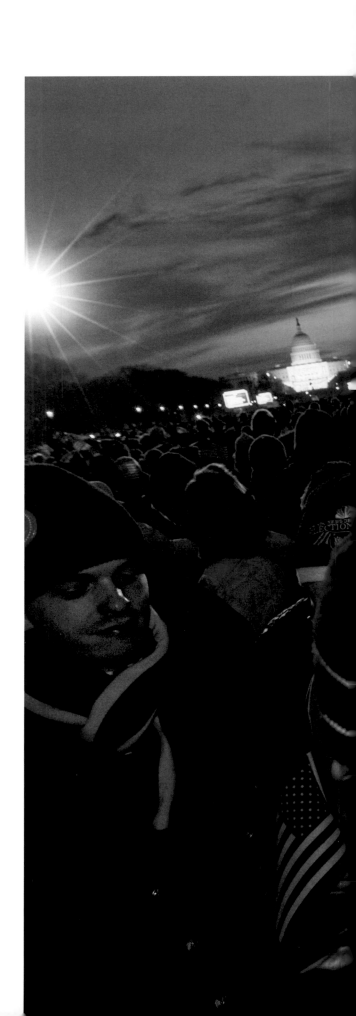

At dawn's first light, five hours before the official start time of the swearing in, crowds gather in front of the Capitol to secure their places to watch the ceremony.

PREVIOUS PAGE
PHOTO BY ANNE DAY
RIGHT
PHOTO BY PETE MAROVICH

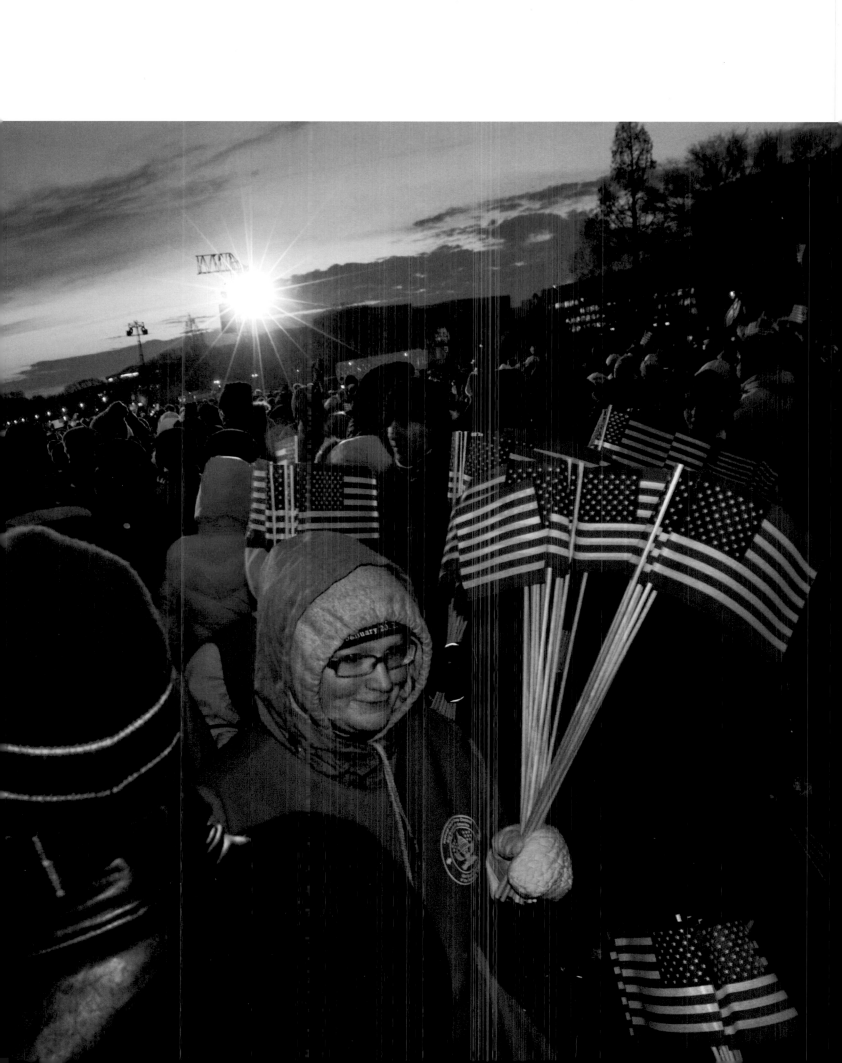

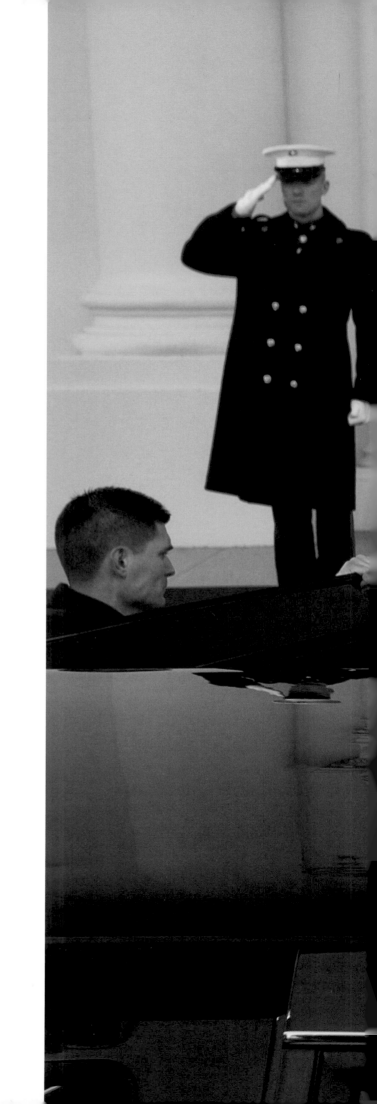

After having coffee together at the White House, President George W. Bush and President-elect Barack Obama depart for the inaugural ceremonies at the U.S. Capitol. In an interview for this book, President George H.W. Bush reflected that, "January 20 was an emotional day for Barbara and me for several reasons. First, we saw our son, of whom we are very proud, leave office after eight historic years of challenge. At the same time, we watched as our new president, whom we respect, was sworn into the presidency and pledged to help lead us forward by relying on the timeless values that have always sustained America.

"So it was emotional, and wonderful, and a powerful reminder of why Inauguration Day is one of America's greatest, most honored traditions."

PHOTO BY DAVID HUME KENNERLY

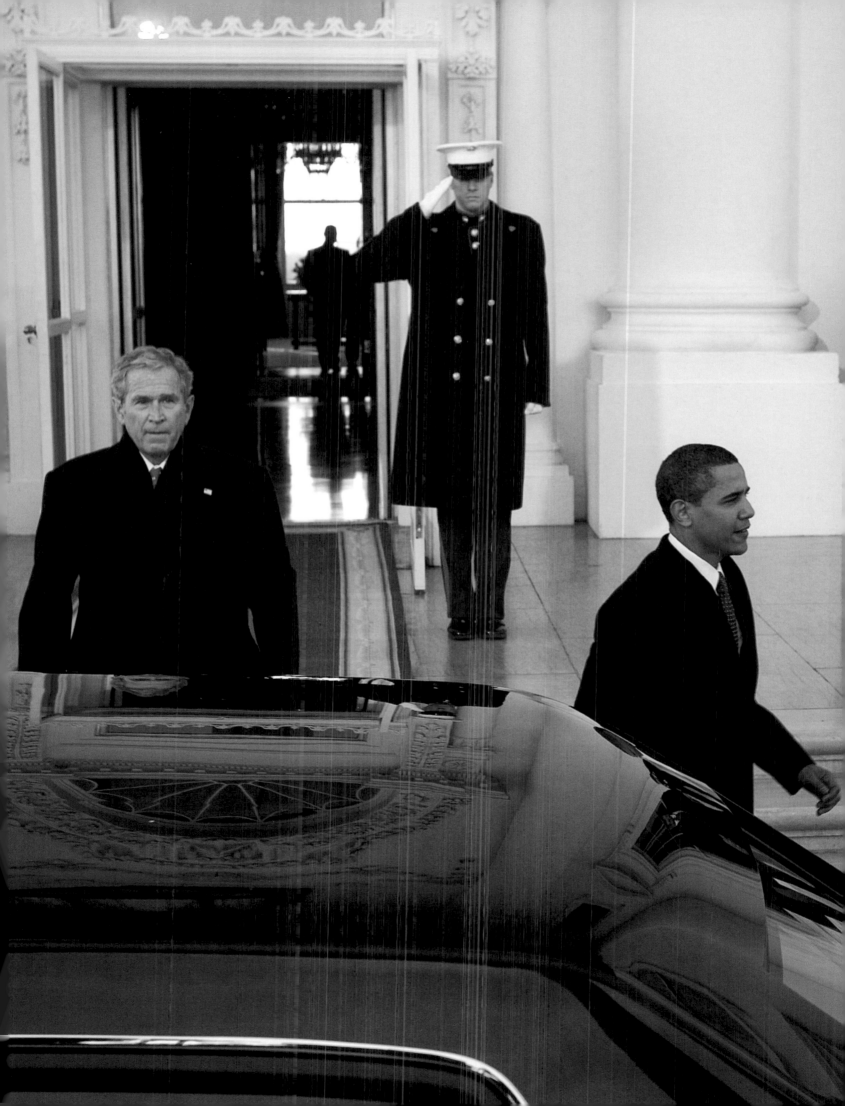

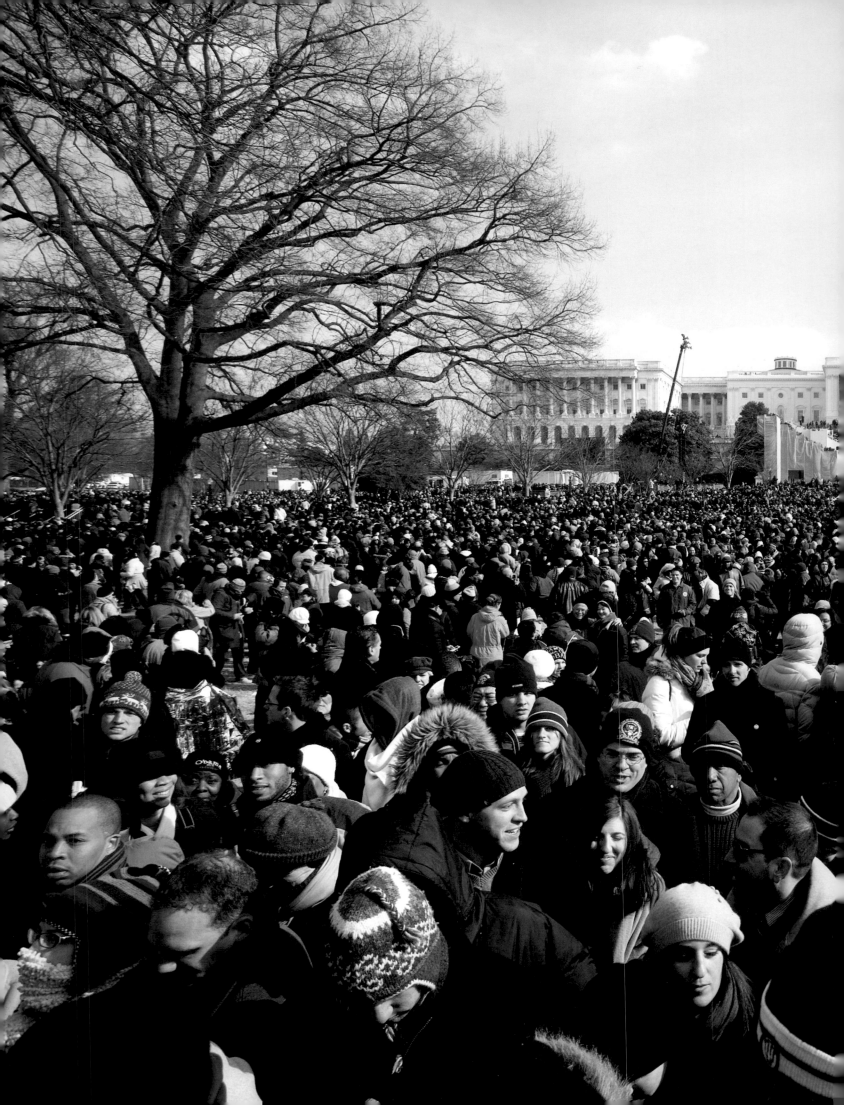

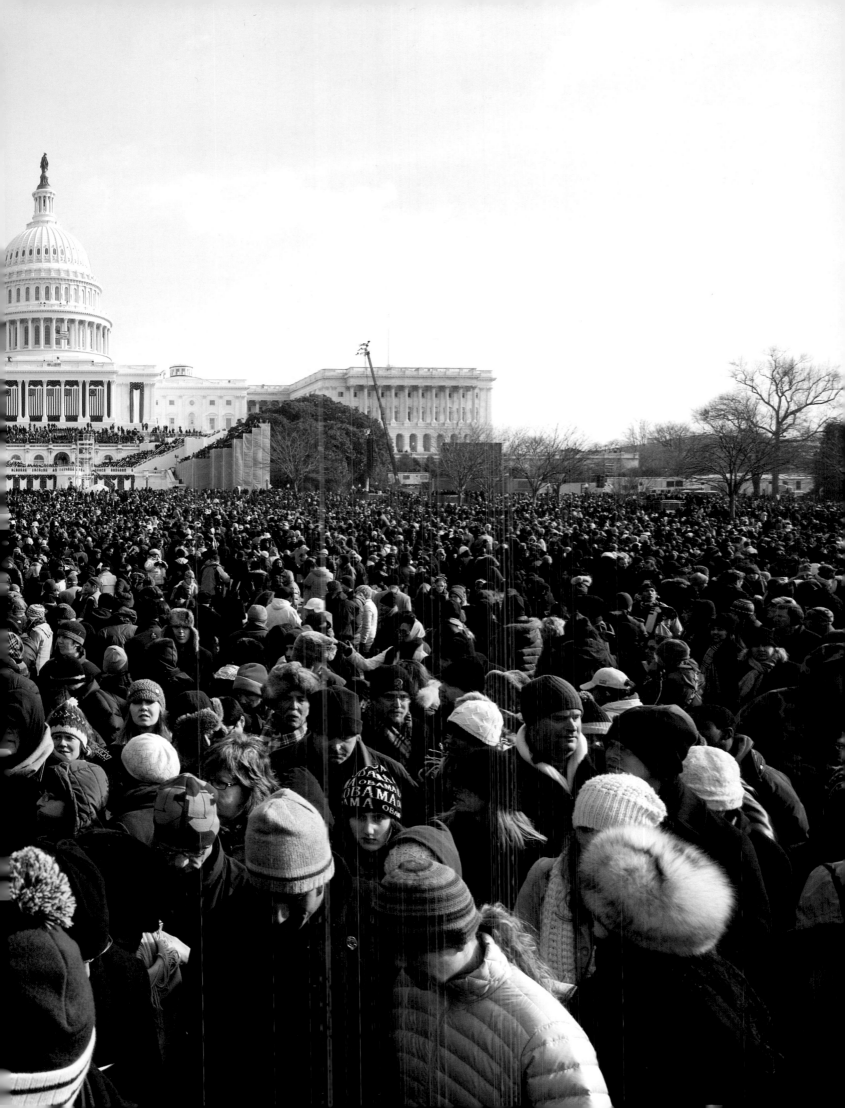

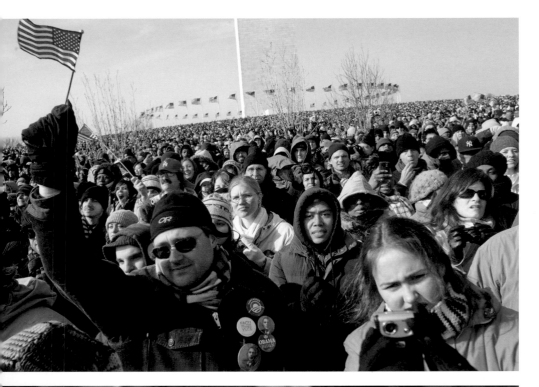

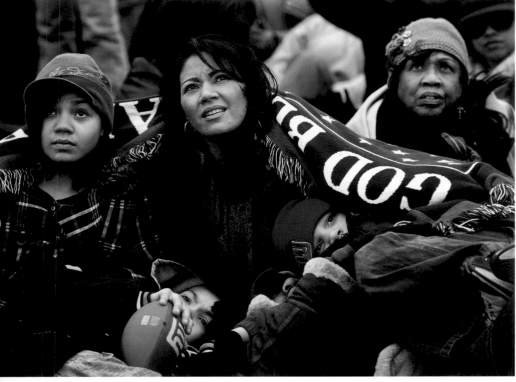

Almost two miles from the steps of the Capitol, the crowd at
the Washington Monument waits for the ceremony to begin.

ABOVE TOP
PHOTO BY MIKE GENDIMENICO

ABOVE BOTTOM
PHOTO BY PETE MAROVICH

OPPOSITE
PHOTO BY ROBERT McNEELY

PREVIOUS PAGE
PHOTO BY GIL GARCETTI

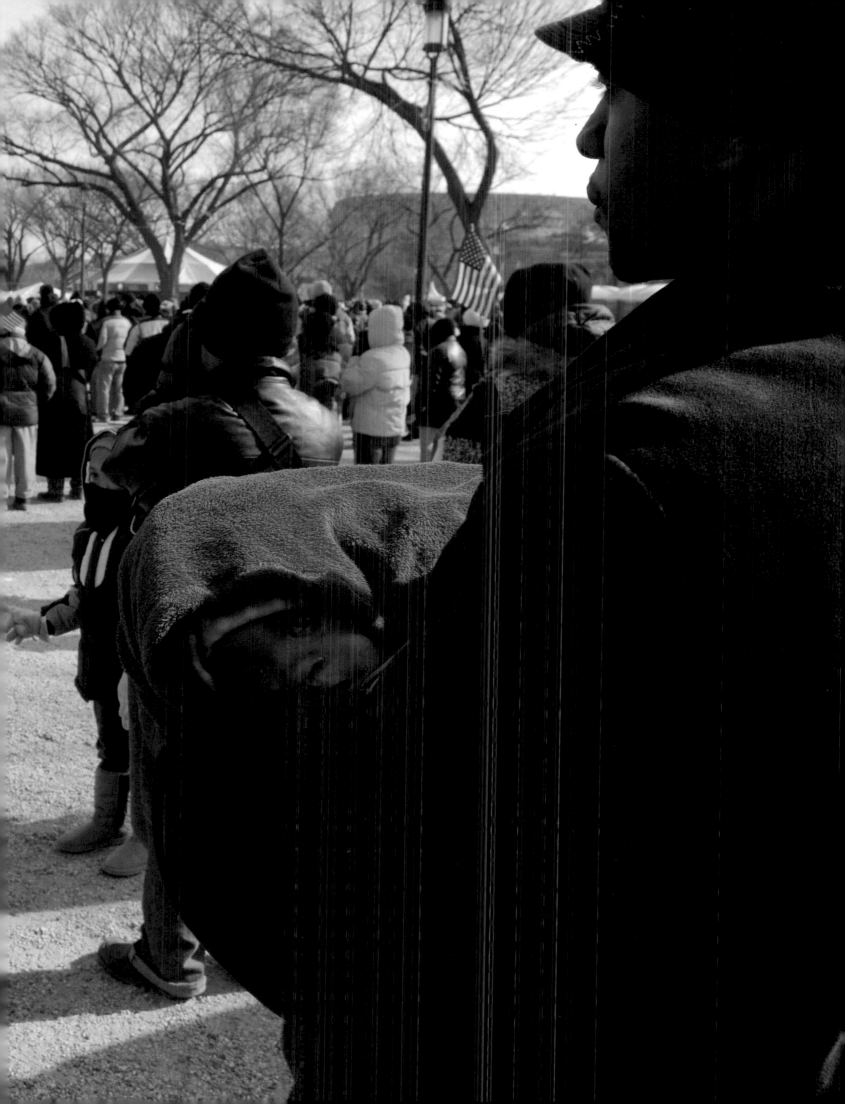

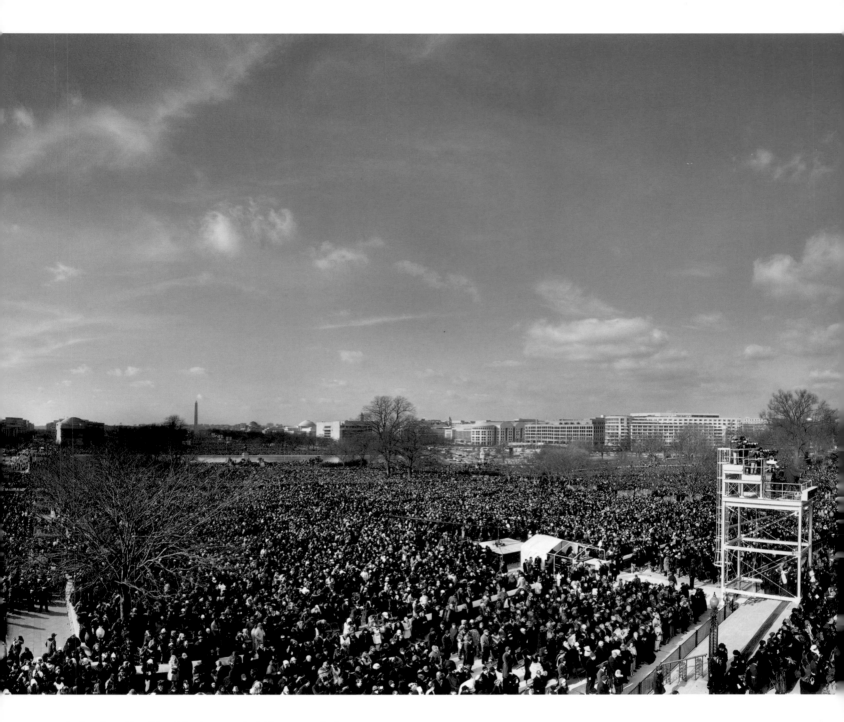

A view from the side of the inaugural platform reveals the
enormity of the crowd awaiting Barack Obama's historic moment.
This panoramic composite was put together from a series of
six different photos taken from the same position.

PHOTO BY SAM KITTNER

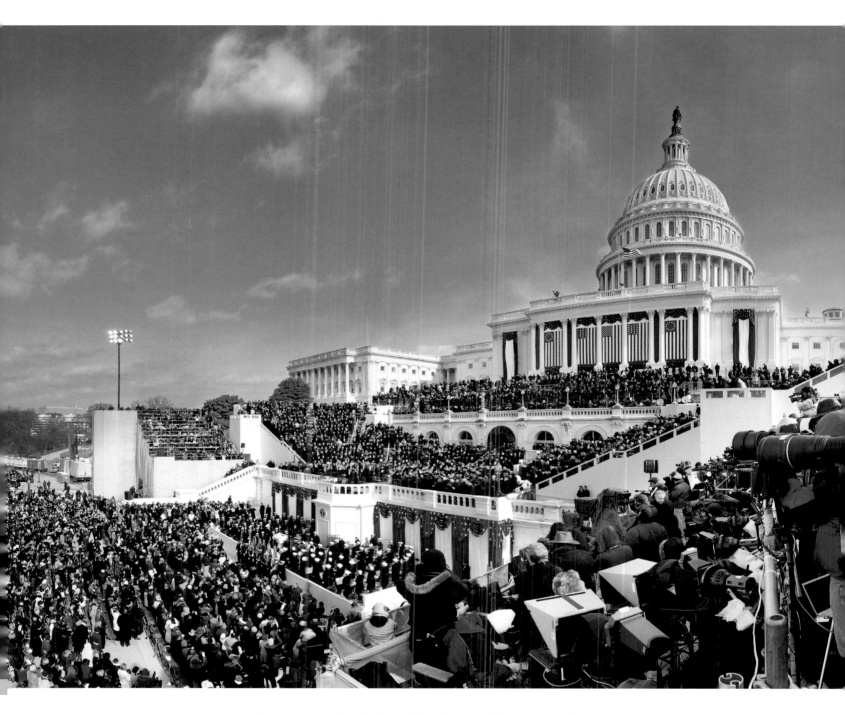

I never doubted that this day would come. When you're a minority in America with aspirations of leadership and public service, only hope makes the impossible a reality.... If nothing else, Inauguration Day proved that our destiny is in our own hands and that America can rise above past injustices and petty differences to achieve greatness.

ANTON O R. VILLARAIGOSA
MAYOR CITY OF LOS ANGELES

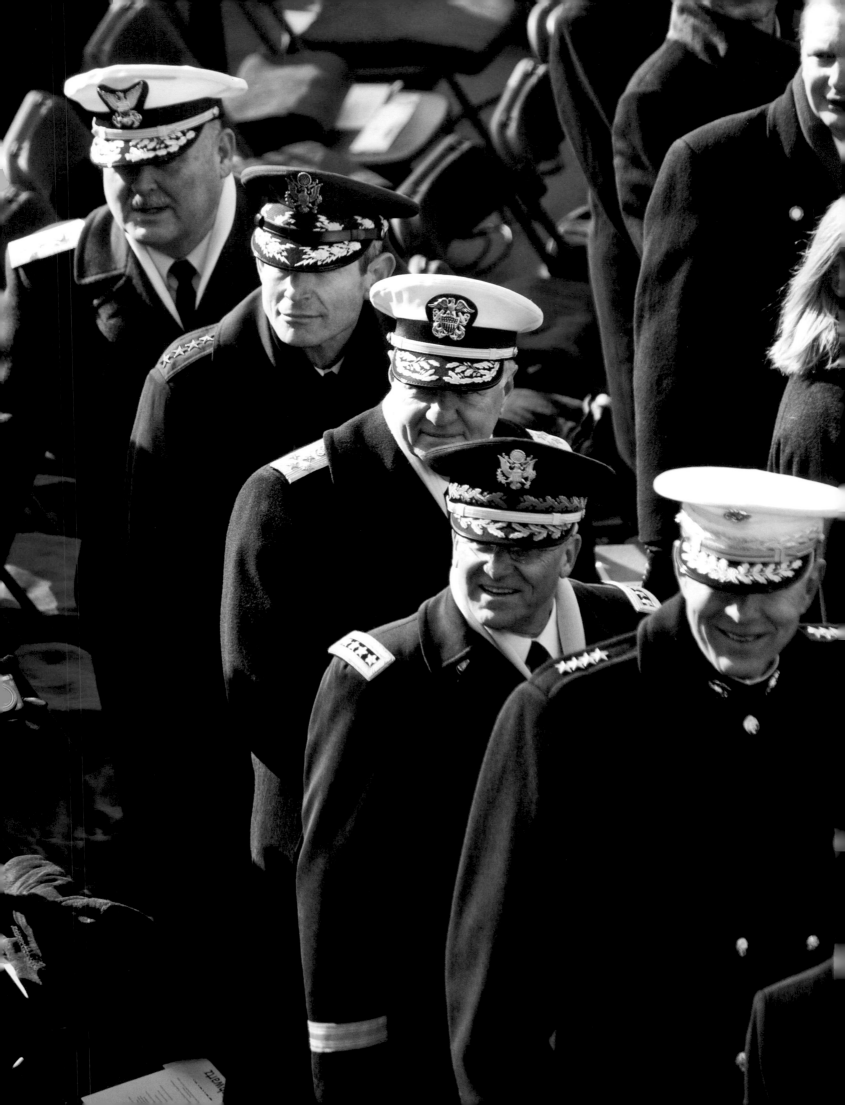

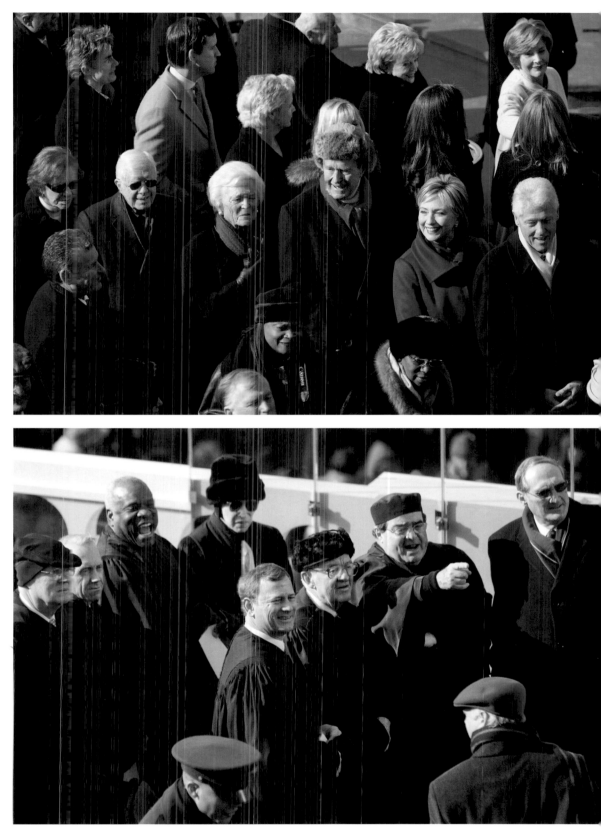

The guests gathered on the inaugural platform included many leading lights of the U.S. government past and present. Rising as the President-elect makes his entrance are (opposite) the Joint Chiefs of Staff and the Commandant of the U.S. Coast Guard; (above top) former presidents Jimmy Carter and George H.W. Bush and their wives, Rosalyn and Barbara, and former president Bill Clinton and Senator Hillary Clinton; and (above) the justices of the Supreme Court.

OPPOSITE
PHOTO BY GREG MATHIESON

ABOVE
PHOTOS BY PAUL MORSE

We believe that we are witnessing something truly historic not only in the political annals of your great nation, the United States of America, but of the world.... The election of Barack Obama to this high office has inspired people as few other events in recent times have done.... He will always be in our affection as a young man who dared to dream and to pursue that dream.

NELSON MANDELA

The eyes of the world upon him, Barack Obama emerges from the Capitol and into the arms of history.

PHOTO BY PETE SOUZA

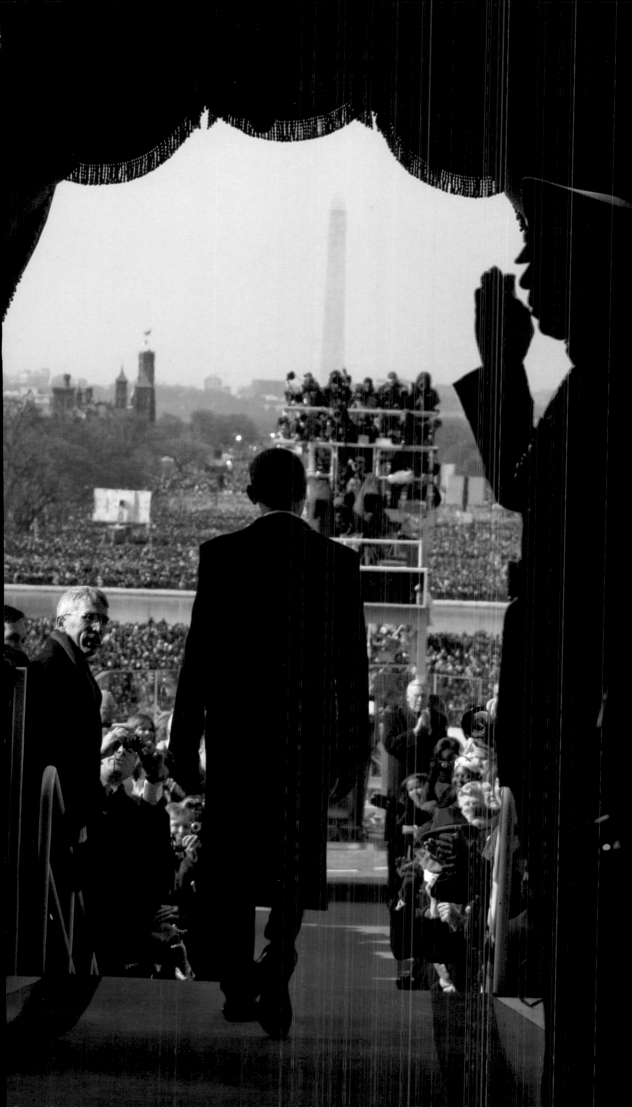

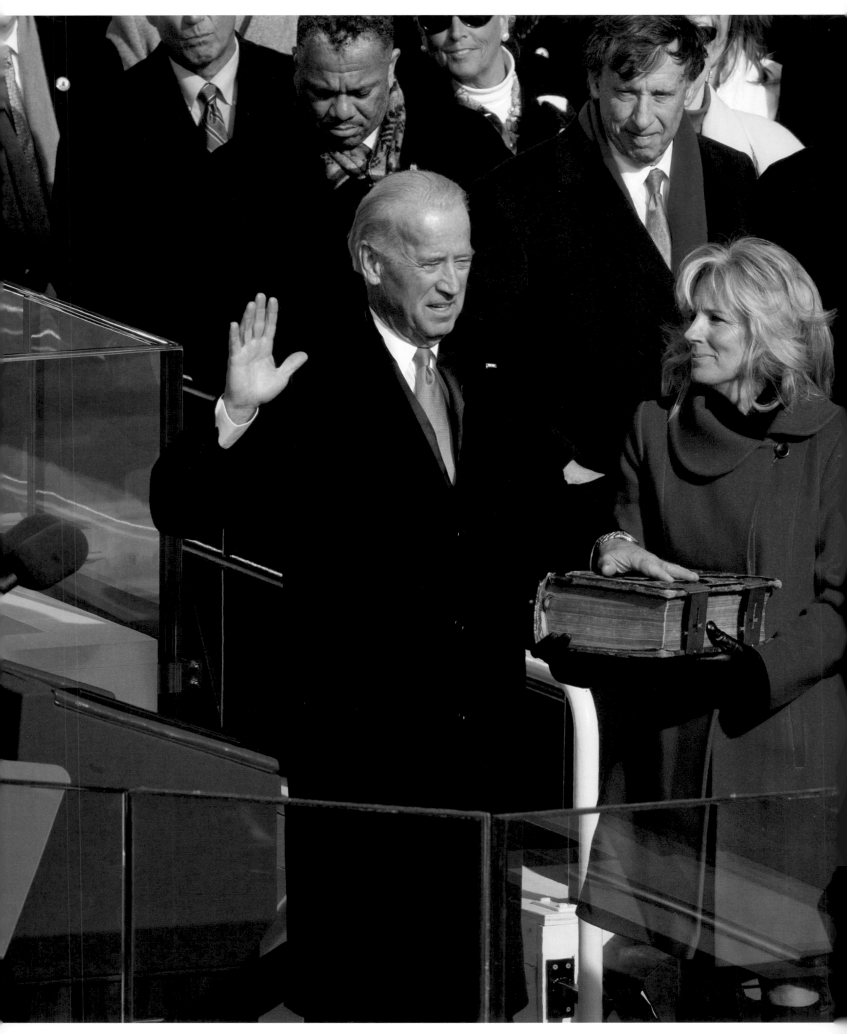

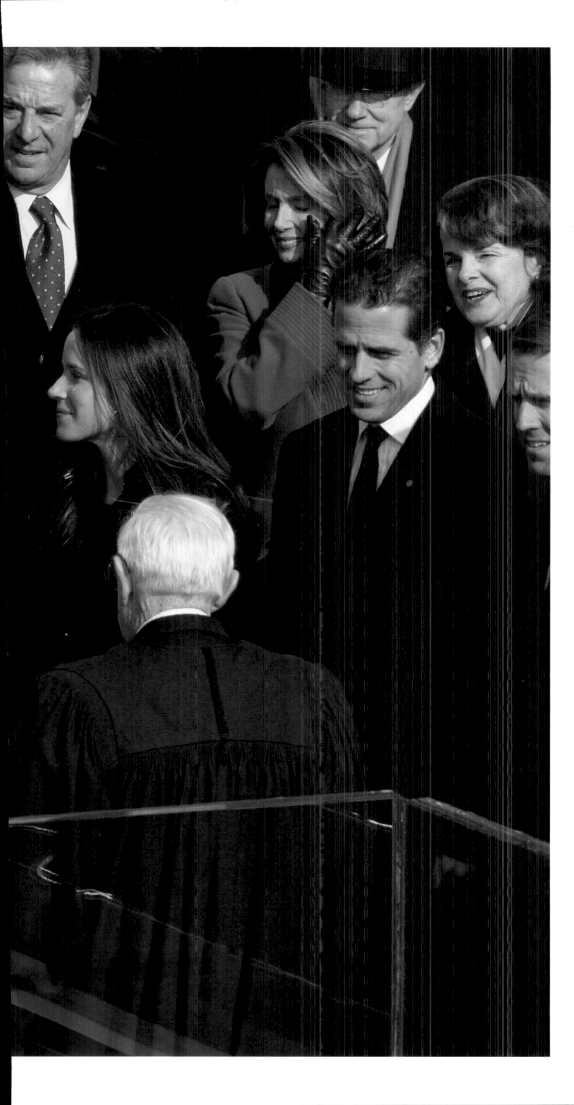

With his wife, Jill, holding the Biden family bible, Joe Biden takes the vice-president al oath of office, administered by Justice John Paul Stevens, who was appointed to the Supreme Court by President Gerald Ford in 1975.

PHOTO BY JOHN HARRINGTON

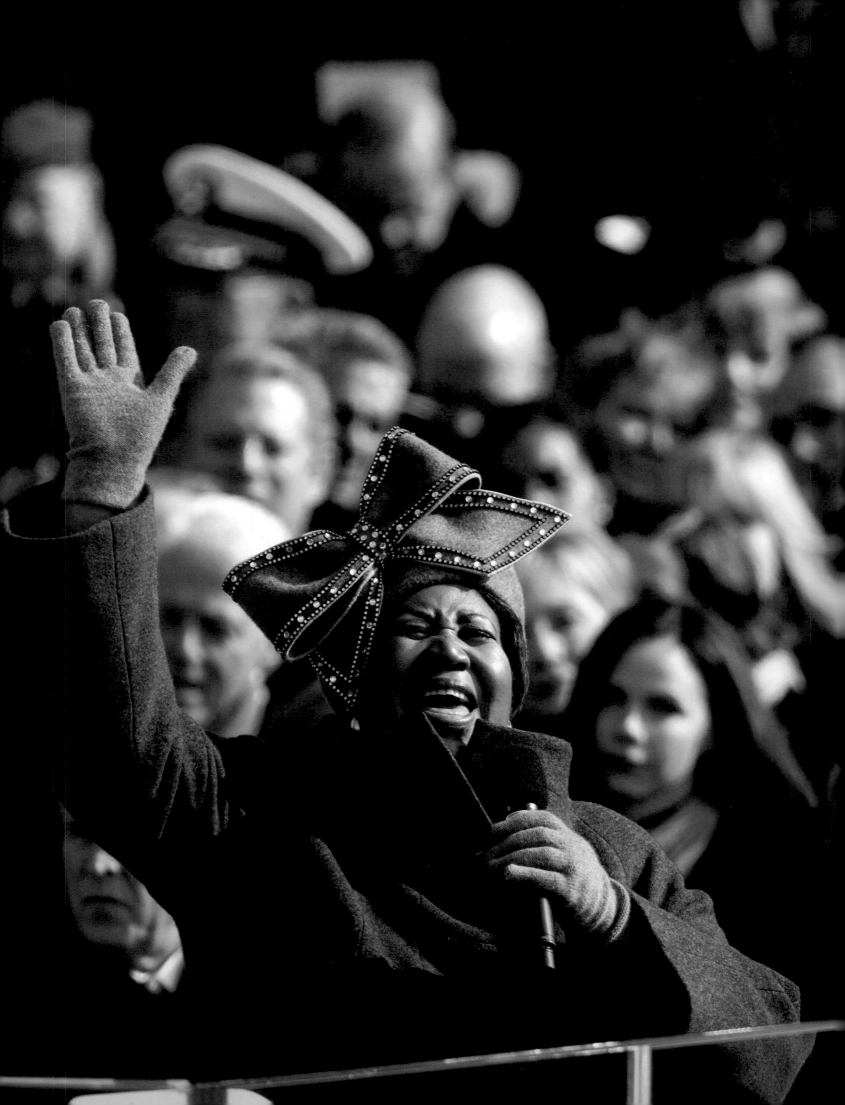

Aretha Franklin sings "My Country 'Tis of Thee." Franklin participated in the official concerts at both of President Bill Clinton's inaugurations, but this was her first time as part of the swearing-in ceremony.

PHOTO BY KAREN BALLARD

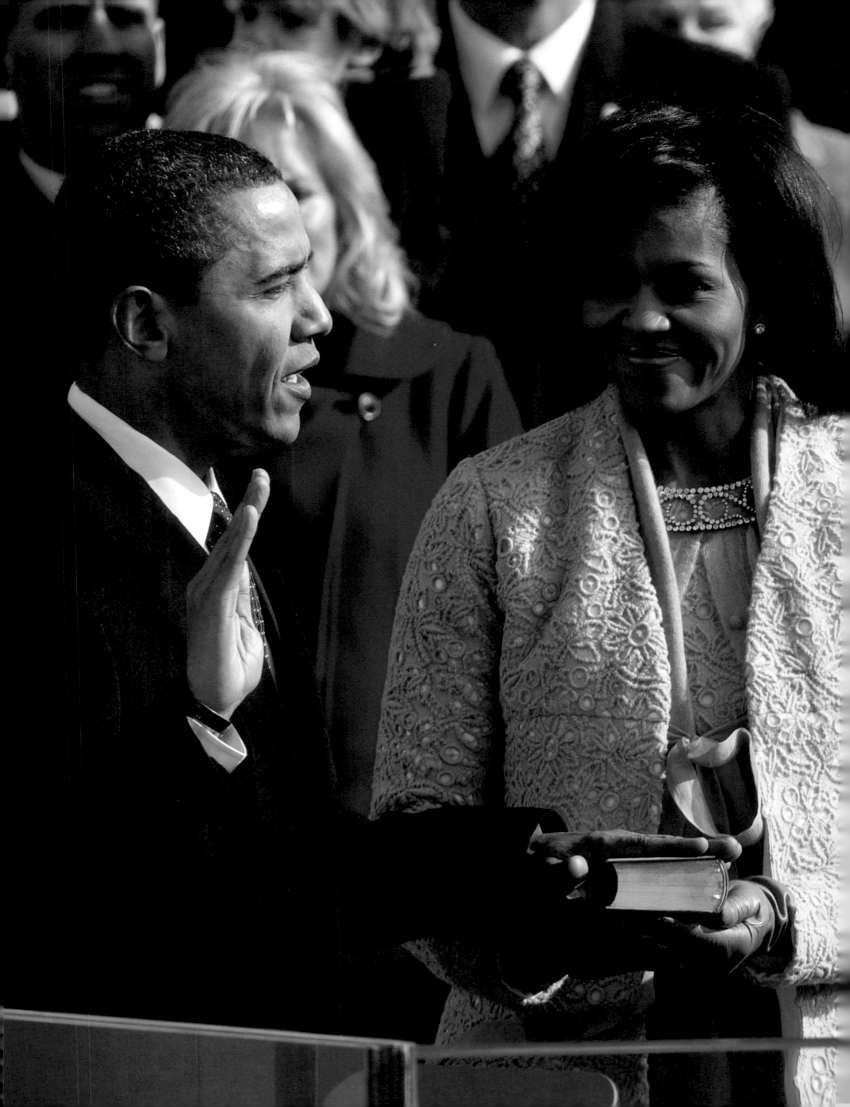

Barack Obama, his hand on the same bible that Abraham Lincoln used in his inauguration in 1861, takes the oath of office from Chief Justice John Roberts to become the 44th president of the United States.

OPPOSITE
PHOTO BY KAREN BALLARD

BELOW
PHOTO BY PAUL MORSE

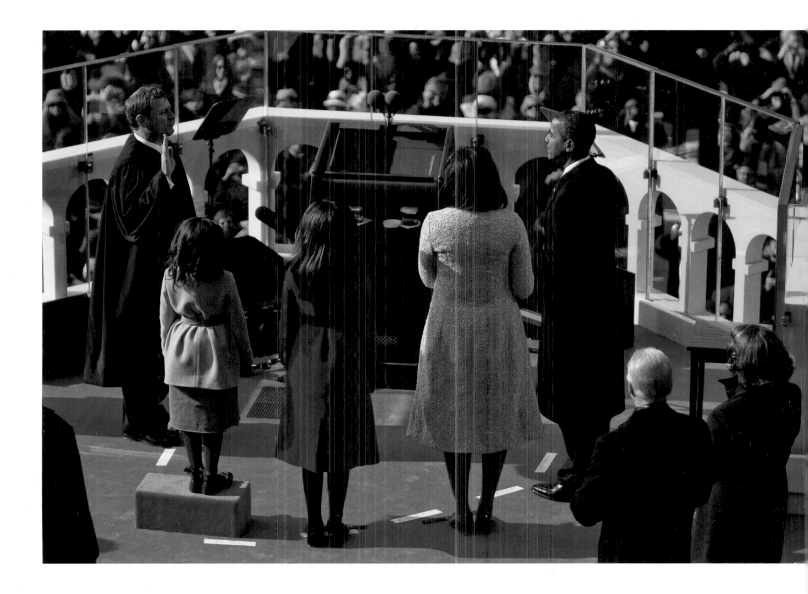

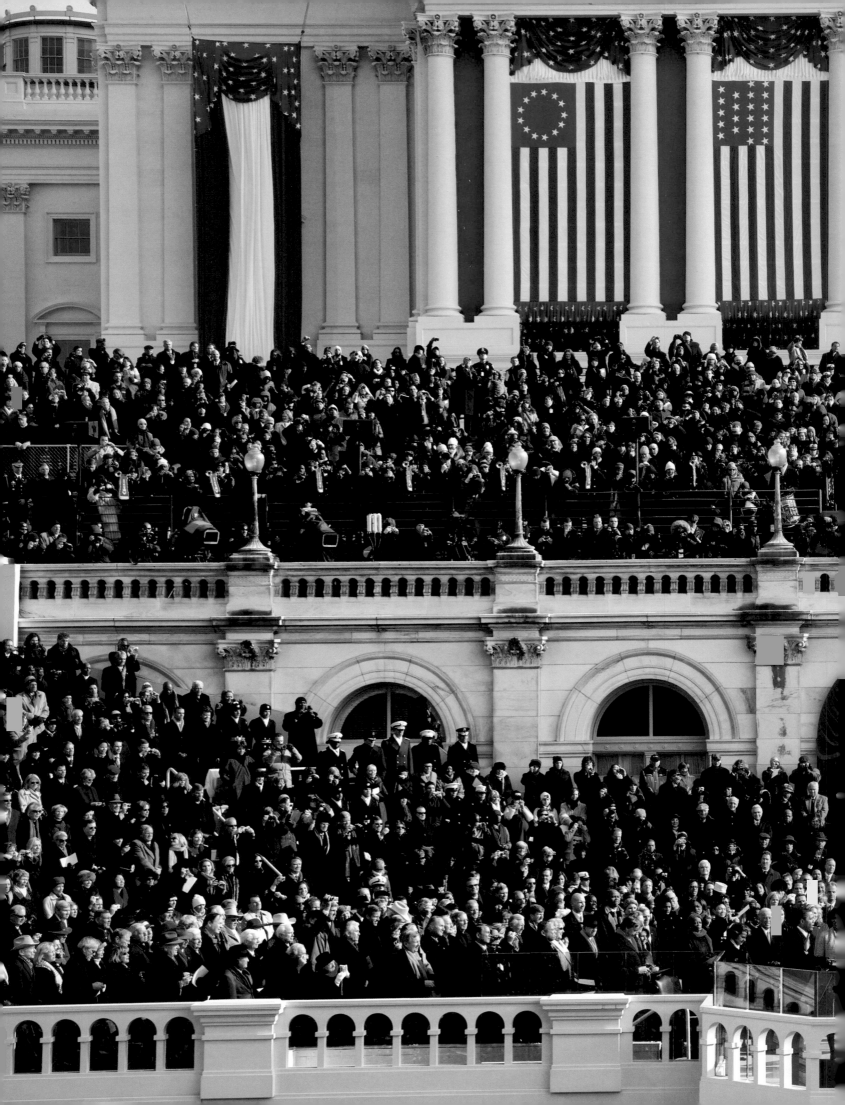

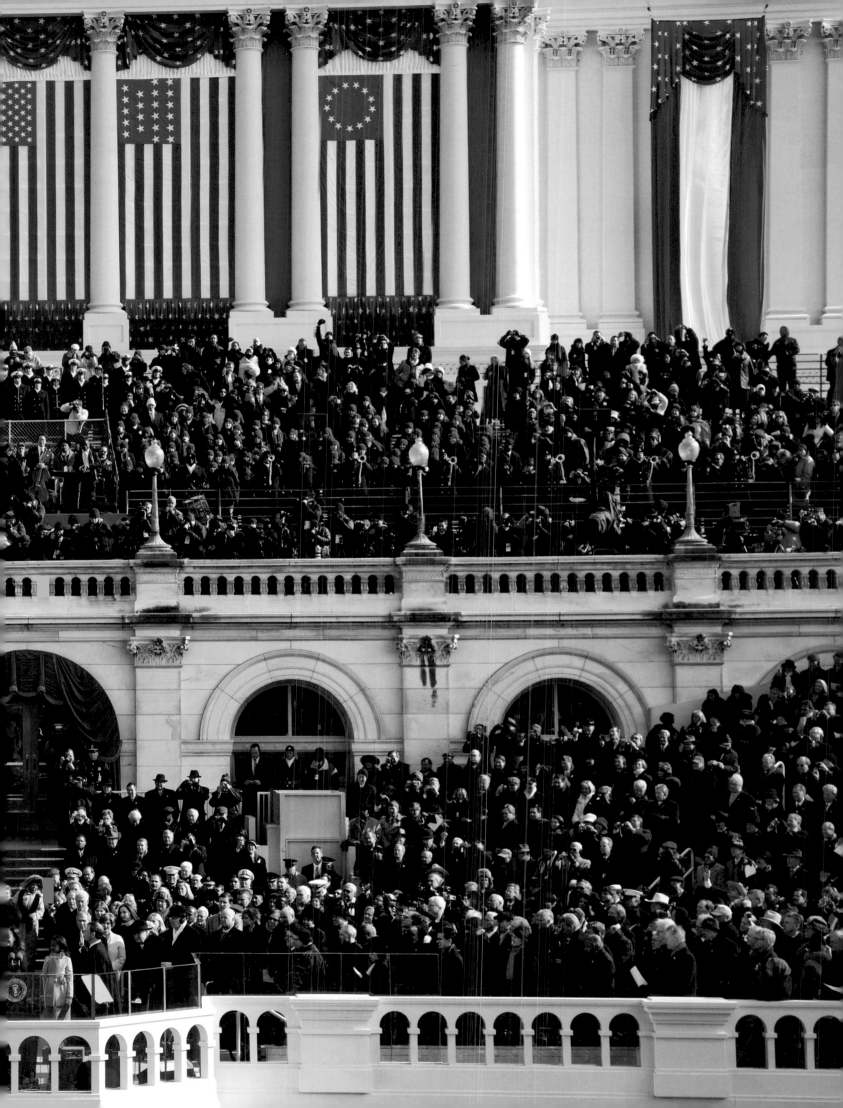

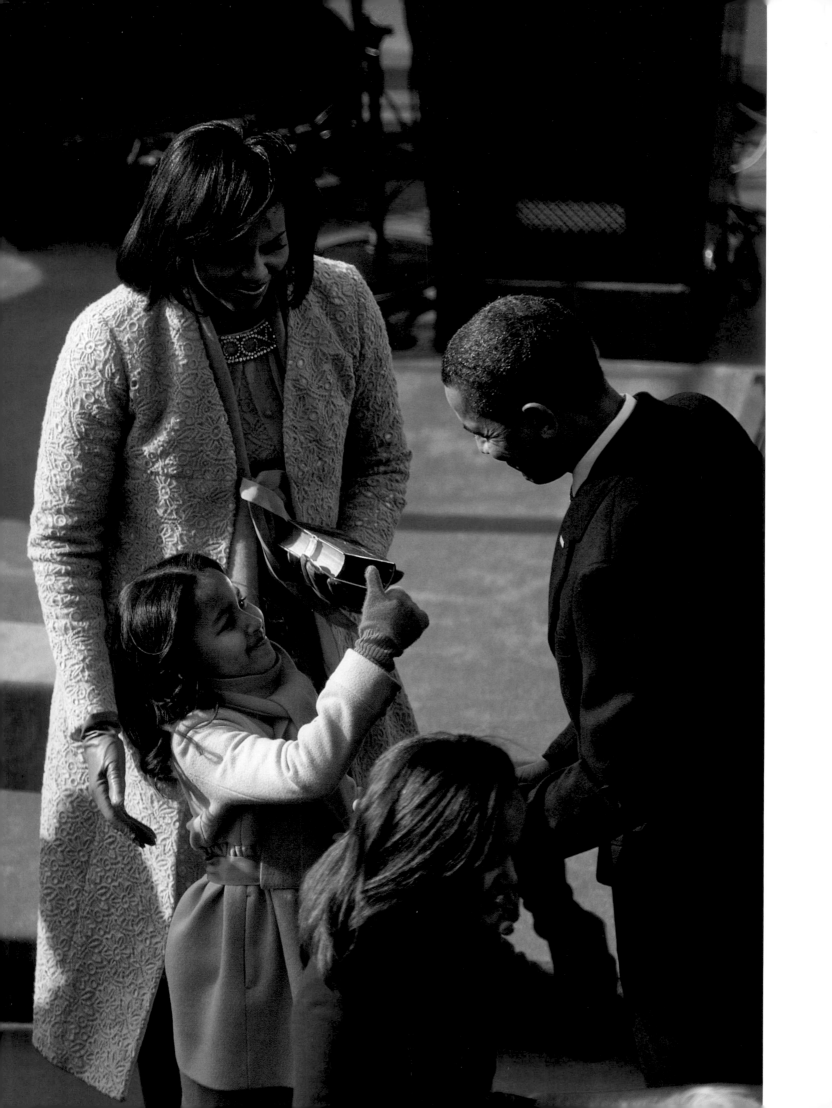

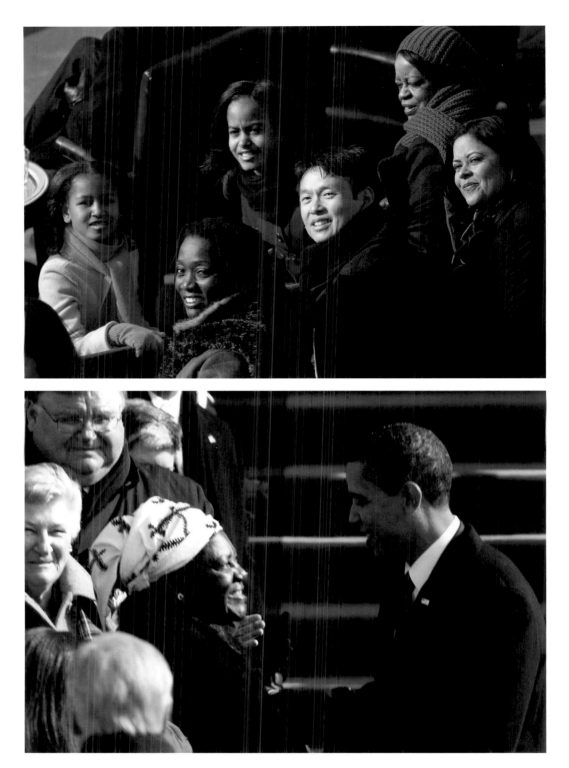

Immediately following his oath of office, the new president gets
the thumbs-up from seven-year-old Sasha and congratulations
from family members gathered near the podium (above top,
clockwise from top right): his mother-in-law, Marian Robinson;
his half-sister, Maya Soetoro-Ng, and her husband, Konrad Ng;
his sister, Auma Obama; and his daughters, Sasha and Malia.
He also greets his 87-year-old grandmother, Sarah Hussein Obama
(above bottom), who flew to Washington from her home in Kenya.

OPPOSITE AND ABOVE TOP
PHOTOS BY PAUL MORSE

PREVIOUS PAGE AND ABOVE BOTTOM
PHOTOS BY KAREN BALLARD

The world will be watching as America celebrates a rite that goes to the heart of our greatness as a nation. For the 43rd time, we will execute the peaceful transfer of power from one president to the next.

The first inauguration took place 220 years ago. Our nation's capital had yet to be built, so President George Washington took the oath of office in New York City. It was a spring day, just over a decade after the birth of our nation, as Washington assumed the new office that he would do so much to shape, and swore an oath to the Constitution that guides us to this very day.

Since then, inaugurations have taken place during times of war and peace; in depression and prosperity. Our democracy has undergone many changes, and our people have taken many steps in pursuit of a more perfect union. What has always endured is this peaceful and orderly transition of power.

BARACK OBAMA
JANUARY 17, 2009

Immediately following his oath of office, President Obama shares a moment with his predecessor, George W. Bush.

PHOTO BY PAUL MORSE

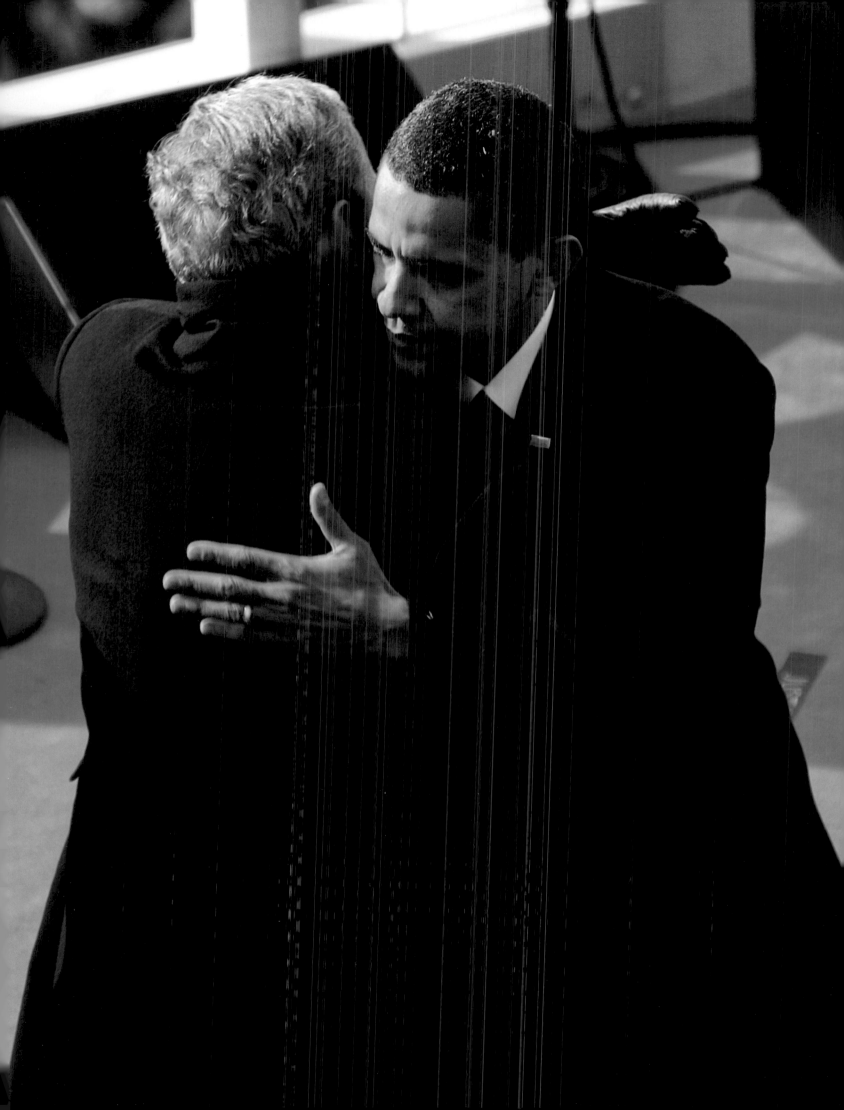

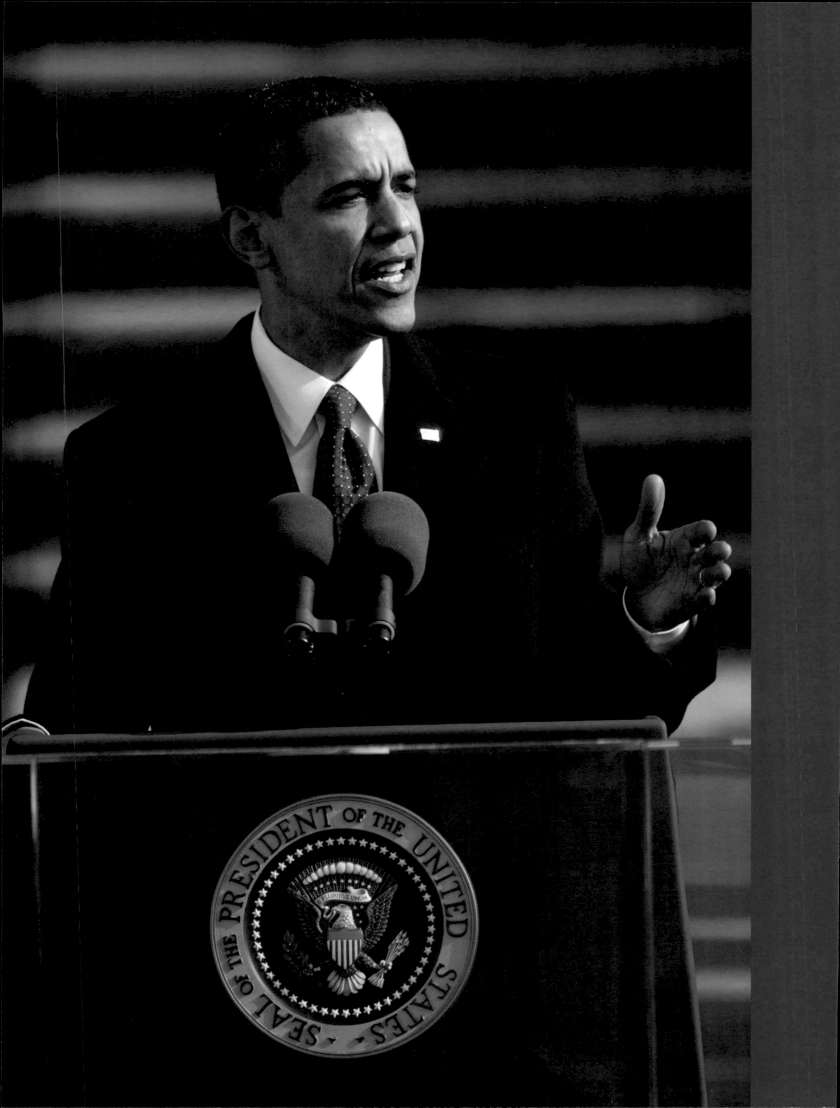

INAUGURAL ADDRESS

PRESIDENT BARACK OBAMA

"The time has come to reaffirm our enduring spirit; to choose our better history; to carry forward that precious gift, that noble idea, passed on from generation to generation: the God-given promise that all are equal, all are free, and all deserve a chance to pursue their full measure of happiness."

MY FELLOW CITIZENS: I stand here today humbled by the task before us, grateful for the trust you have bestowed mindful of the sacrifices borne by our ancestors. I thank President Bush for his service to our nation... as well as the generosity and cooperation he has shown throughout this transition.

Forty-four Americans have now taken the presidential oath. The words have been spoken during rising tides of prosperity and the still waters of peace. Yet, every so often the oath is taken amidst gathering clouds and raging storms. At these moments, America has carried on not simply because of the skill or vision of those in high office, but because we, the people, have remained faithful to the ideals of our forebears, and true to our founding documents.

So it has been. So it must be with this generation of Americans.

That we are in the midst of crisis is now well understood. Our nation is at war against a far-reaching network of violence and hatred. Our economy is badly weakened, a consequence of greed and irresponsibility on the part of some, but also our collective failure to make hard choices and prepare the nation for a new age.

Homes have been lost, jobs shed, businesses shuttered. Our health care is too costly, our schools fail too many, and each day brings further evidence that the ways we use energy strengthen our adversaries and threaten our planet.

These are the indicators of crisis, subject to data and statistics. Less measurable, but no less profound, is a sapping of confidence across our land; a nagging fear that America's decline is inevitable, that the next generation must lower its sights.

Today, I say to you that the challenges we face are real, they are serious and they are many. They will not be met easily or in a short span of time. But know this, America: They will be met.

On this day, we gather because we have chosen hope over fear, unity of purpose over conflict and discord.

On this day, we come to proclaim an end to the petty grievances and false promises, the recriminations and worn-out dogmas that for far too long have strangled our politics.

We remain a young nation. But in the words of Scripture, the time has come to set aside childish things. The time has come to reaffirm our enduring spirit; to choose our better history; to carry forward that precious gift, that noble idea, passed on from generation to generation: the God-given promise that all are equal, all are free, and all deserve a chance to pursue their full measure of happiness.

In reaffirming the greatness of our nation, we understand that greatness is never a given. It must be earned. Our journey has never been one of shortcuts or settling for less.

On this day, we gather because we have chosen hope over fear, unity of purpose over conflict and discord.

It has not been the path for the faint-hearted, for those who prefer leisure over work, or seek only the pleasures of riches and fame.

Rather, it has been the risk-takers, the doers, the makers of things—some celebrated, but more often men and women obscure in their labor—who have carried us up the long, rugged path towards prosperity and freedom.

For us, they packed up their few worldly possessions and traveled across oceans in search of a new life. For us, they toiled in sweatshops and settled the West, endured the lash of the whip and plowed the hard earth.

For us, they fought and died in places like Concord and Gettysburg; Normandy and Khe Sanh.

PHOTO BY DANIEL CIMA

Time and again these men and women struggled and sacrificed and worked till their hands were raw so that we might live a better life. They saw America as bigger than the sum of our individual ambitions; greater than all the differences of birth or wealth or faction.

This is the journey we continue today. We remain the most prosperous, powerful nation on Earth. Our workers are no less productive than when this crisis began. Our minds are no less inventive, our goods and services no less needed than they were last week, or last month, or last year. Our capacity remains undiminished. But our time of standing pat, of protecting narrow interests and putting off unpleasant decisions—that time has surely passed.

Starting today, we must pick ourselves up, dust ourselves off, and begin again the work of remaking America.

For everywhere we look, there is work to be done.

The state of our economy calls for action: bold and swift. And we will act not only to create new jobs but to lay a new foundation for growth.

We will build the roads and bridges, the electric grids and digital lines that feed our commerce and bind us together.

We will restore science to its rightful place, and wield technology's wonders to raise health care's quality and lower its cost.

We will harness the sun and the winds and the soil to fuel our cars and run our factories. And we will transform our schools and colleges and universities to meet the demands of a new age.

All this we can do. All this we will do.

Now, there are some who question the scale of our ambitions, who suggest that our system cannot tolerate too many big plans. Their memories are short, for they have forgotten what this country has already done, what free men and women can achieve when imagination is joined to common purpose and necessity to courage.

What the cynics fail to understand is that the ground has shifted beneath them, that the stale political arguments that have consumed us for so long, no longer apply.

The question we ask today is not whether our government is too big or too small, but whether it works—whether it helps families find jobs at a decent wage, care they can afford, a retirement that is dignified.

Where the answer is yes, we intend to move forward. Where the answer is no, programs will end.

And those of us who manage the public's dollars will be held to account, to spend wisely, reform bad habits, and do our business in the light of day, because only then can we restore the vital trust between a people and their government.

In reaffirming the greatness of our nation, we understand that greatness is never a given. It must be earned.

Nor is the question before us whether the market is a force for good or ill. Its power to generate wealth and expand freedom is unmatched.

But this crisis has reminded us that without a watchful eye, the market can spin out of control. The nation cannot prosper long when it favors only the prosperous.

The success of our economy has always depended not just on the size of our gross domestic product, but on the reach of our prosperity, on the ability to extend opportunity to every willing heart—not out of charity, but because it is the surest route to our common good.

As for our common defense, we reject as false the choice between our safety and our ideals. Our founding fathers, faced with perils that we can scarcely imagine, drafted a charter to assure the rule of law and the rights of man—a charter expanded by the blood of generations.

Those ideals still light the world, and we will not give them up for expedience's sake.

And so, to all other peoples and governments who are watching today, from the grandest capitals to the small village where my father was born, know that America is a friend of each nation, and every man, woman, and child who seeks a future of peace and dignity. And we are ready to lead once more.

Recall that earlier generations faced down fascism and communism not just with missiles and tanks, but with sturdy alliances and enduring convictions.

They understood that our power alone cannot protect us, nor does it entitle us to do as we please. Instead, they knew that our power grows through its prudent use; our security emanates from the justness of our cause, the force of our example, the tempering qualities of humility and restraint.

We are the keepers of this legacy. Guided by these principles once more, we can meet those new threats that demand even greater effort, even greater cooperation and understanding between nations. We will begin to responsibly leave Iraq to its people and forge a hard-earned peace in Afghanistan.

With old friends and former foes, we will work tirelessly to lessen the nuclear threat and roll back the specter of a warming planet.

We will not apologize for our way of life, nor will we waver in its defense. And for those who seek to advance their aims by inducing terror and slaughtering innocents, we say to you now that our spirit is stronger and cannot be broken—you cannot outlast us, and we will defeat you.

For we know that our patchwork heritage is a strength, not a weakness. We are a nation of Christians and Muslims,

PHOTO BY CLARENCE WILLIAMS

Jews and Hindus, and nonbelievers. We are shaped by every language and culture, drawn from every end of this Earth; and because we have tasted the bitter swill of civil war and segregation and emerged from that dark chapter stronger and more united, we cannot help but believe that the old hatreds shall someday pass; that the lines of tribe shall soon dissolve; that as the world grows smaller, our common humanity shall reveal itself; and that America must play its role in ushering in a new era of peace.

To the Muslim world, we seek a new way forward, based on mutual interest and mutual respect.

To those leaders around the globe who seek to sow conflict, or blame their society's ills on the West, know that your people will judge you on what you can build, not what you destroy.

To those who cling to power through corruption and deceit and the silencing of dissent, know that you are on the wrong side of history, but that we will extend a hand if you are willing to unclench your fist.

To the people of poor nations, we pledge to work alongside you to make your farms flourish and let clean waters flow; to nourish starved bodies and feed hungry minds. And to those nations like ours that enjoy relative plenty, we say we can no longer afford indifference to the suffering outside our borders, nor can we consume the world's resources without regard to effect. For the world has changed, and we must change with it.

As we consider the road that unfolds before us, we remember with humble gratitude those brave Americans who, at this very hour, patrol far-off deserts and distant mountains.

Our challenges may be new…but those values upon which our success depends, honesty and hard work, courage and fair play, tolerance and curiosity, loyalty and patriotism—these things are old.

They have something to tell us, just as the fallen heroes who lie in Arlington whisper through the ages.

We honor them not only because they are guardians of our liberty, but because they embody the spirit of service: a willingness to find meaning in something greater than themselves.

And yet, at this moment, a moment that will define a generation, it is precisely this spirit that must inhabit us all. For as much as government can do, and must do, it is ultimately the faith and determination of the American people upon which this nation relies.

It is the kindness to take in a stranger when the levees break; the selflessness of workers who would rather cut their hours than see a friend lose their job which sees us through our darkest hours.

It is the firefighter's courage to storm a stairway filled with smoke, but also a parent's willingness to nurture a child that finally decides our fate.

Our challenges may be new. The instruments with which we meet them may be new. But those values upon which our success depends—honesty and hard work, courage and fair play, tolerance and curiosity, loyalty and patriotism—these things are old. These things are true. They have been the quiet force of progress throughout our history.

What is demanded, then, is a return to these truths. What is required of us now is a new era of responsibility—a recognition on the part of every American that we have duties to ourselves, our nation, and the world; duties that we do not grudgingly accept, but rather seize gladly, firm in the knowledge that there is nothing so satisfying to the spirit, so defining of our character than giving our all to a difficult task.

This is the price and the promise of citizenship.

This is the source of our confidence: the knowledge that God calls on us to shape an uncertain destiny.

This is the meaning of our liberty and our creed, why men and women and children of every race and every faith can join in celebration across this magnificent mall; and why a man whose father less than 60 years ago might not have been served at a local restaurant can now stand before you to take a most sacred oath.

So let us mark this day in remembrance of who we are and how far we have traveled.

In the year of America's birth, in the coldest of months, a small band of patriots huddled by dying campfires on the shores of an icy river. The capital was abandoned. The enemy was advancing. The snow was stained with blood.

At a moment when the outcome of our revolution was most in doubt, the father of our nation ordered these words be read to the people: "Let it be told to the future world…that in the depth of winter, when nothing but

hope and virtue could survive…that the city and the country, alarmed at one common danger, came forth to meet it."

America: In the face of our common dangers, in this winter of our hardship, let us remember these timeless words. With hope and virtue, let us brave once more the icy currents, and endure what storms may come. Let it be said by our children's children that when we were tested,

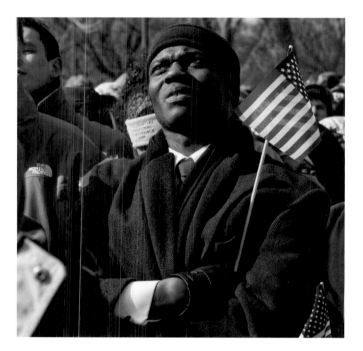

PHOTO BY ROBERT MCNEELY

we refused to let this journey end, that we did not turn back nor did we falter; and with eyes fixed on the horizon and God's grace upon us, we carried forth that great gift of freedom and delivered it safely to future generations.

Thank you. God bless you.

And God bless the United States of America.

With the inauguration of President Barack Obama, our country has raised the bar, choosing an inspirational leader who reaches out to people of all backgrounds and connects with our generation in a way that few presidents ever have. While President Obama may be viewed by most adults as the country's first black president, for our children and future generations, he will simply be looked upon as the president. His victory is truly an inspiration to us all.

ADRIAN M. FENTY
MAYOR, WASHINGTON, DC

An estimated 1.8 million people crowd nearly every inch of the National Mall.
OPPOSITE
PHOTO BY PAUL MORSE

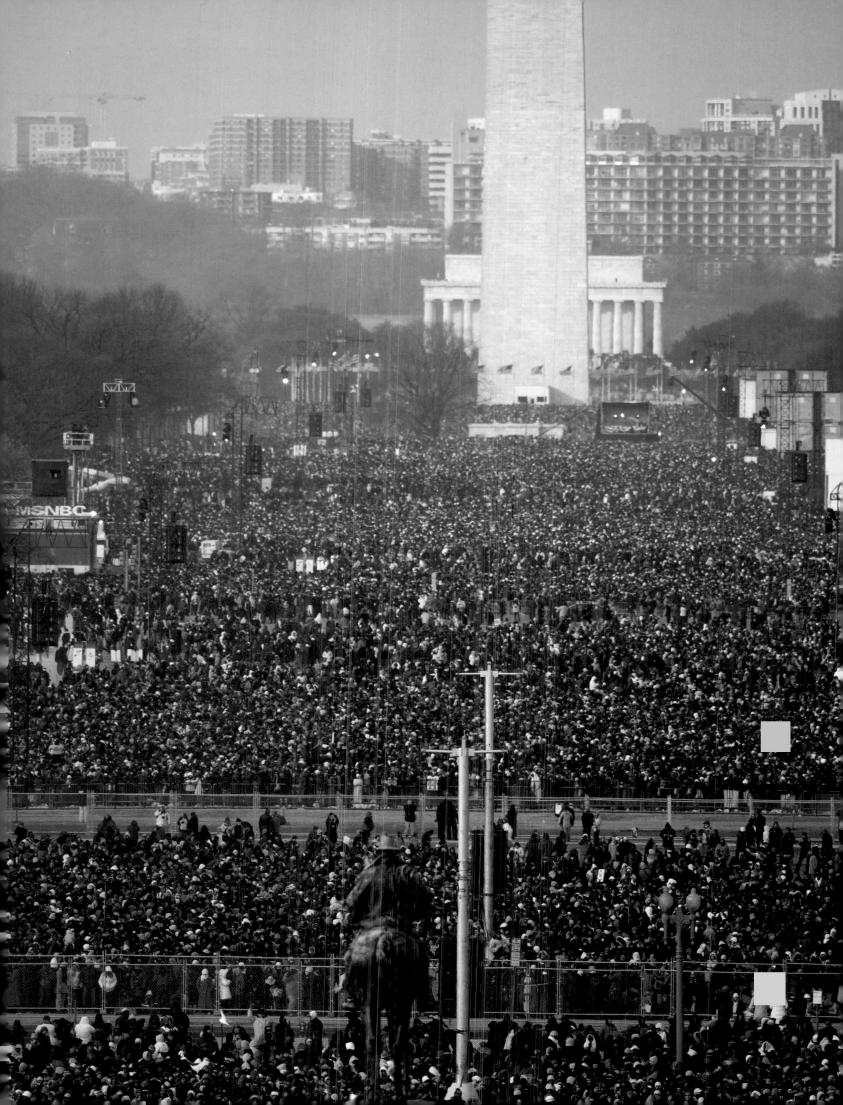

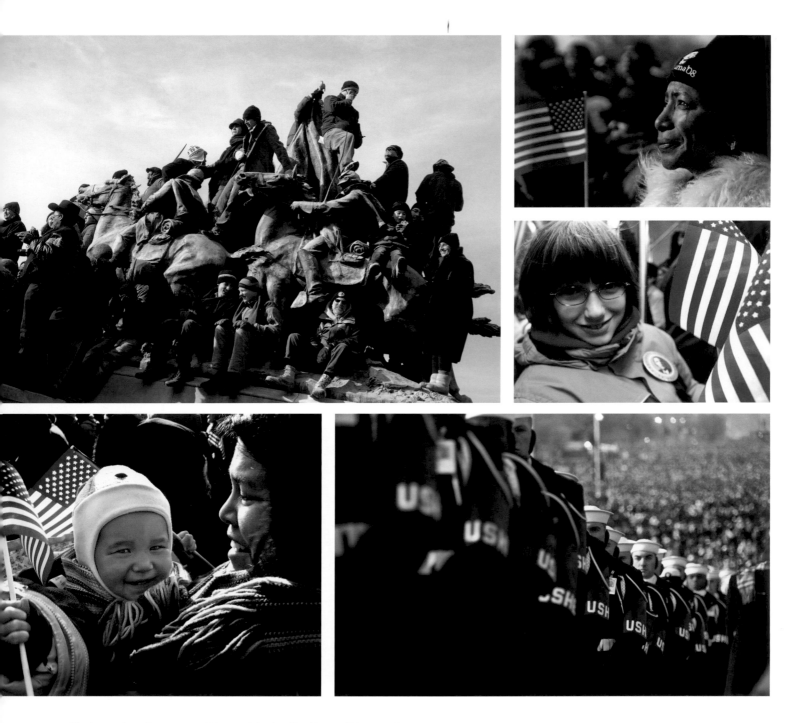

Photographers from around the world submitted tens of thousands of photographs to the project through photobucket.com and obamaphotobook.com. Some of the best images are on these pages, and throughout the book.

ABOVE, CLOCKWISE FROM TOP LEFT
PHOTOS BY CHRISTOPHER BEECROFT, BRYAN DOZIER, STEVEN ROSENBAUM, MARTA EVRY, ALEX PASCOVER (ALL PHOTOBUCKET)

OPPOSITE, CLOCKWISE FROM TOP LEFT
PHOTOS BY CECILIA COSTELLA, PAUL LOVELAND, SHRIYA MALHOTRA, SANDY CHOI (ALL PHOTOBUCKET)

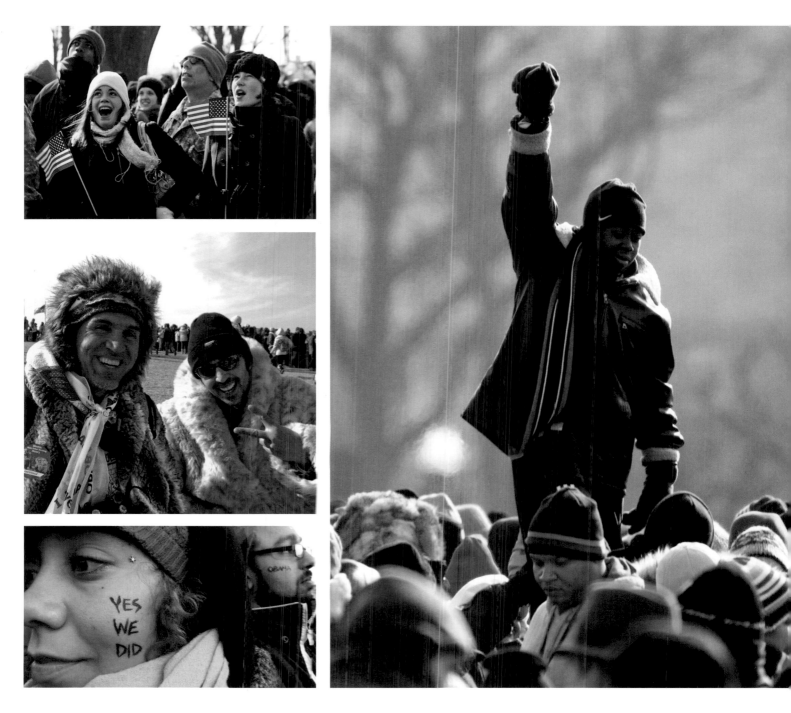

Help us work for that day when black will not be asked to give back, when brown can stick around, when yellow will be mellow, when the red man can get ahead, man, and when white will embrace what is right.

REVEREND JOSEPH LOWERY,
INAUGURAL BENEDICTION

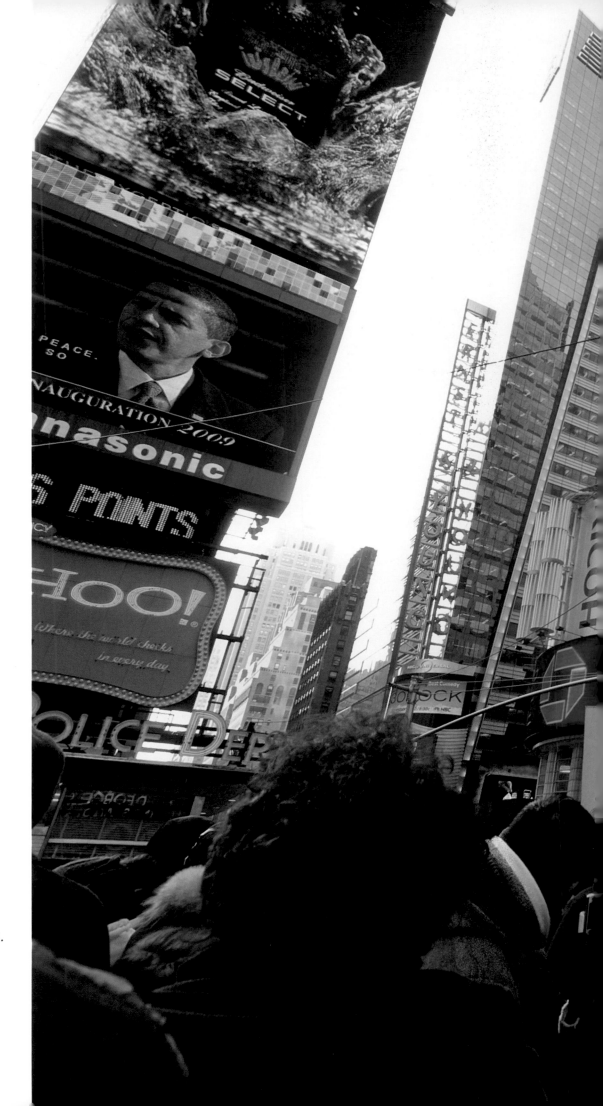

Obama's Inaugural Address is watched by crowds around the world, including this one in Times Square, New York City.

PHOTO BY CHRISTOR LUKASIEWICZ (PHOTOBUCKET)

The period that starts today in your country, above all else, is a great milestone in one of the most impassioned odysseys in history: the struggle against discrimination and for equality of opportunities.

PRESIDENT CRISTINA FERNÁNDEZ DE KIRCHNER ARGENTINA

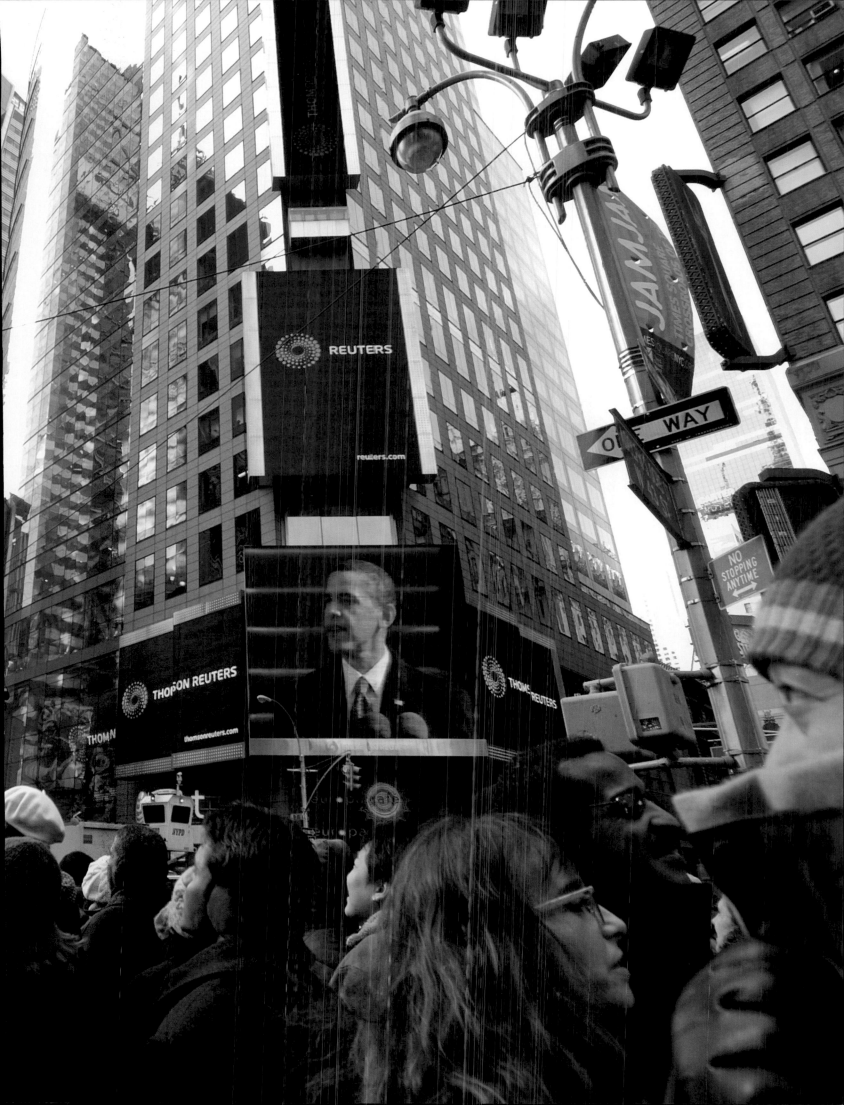

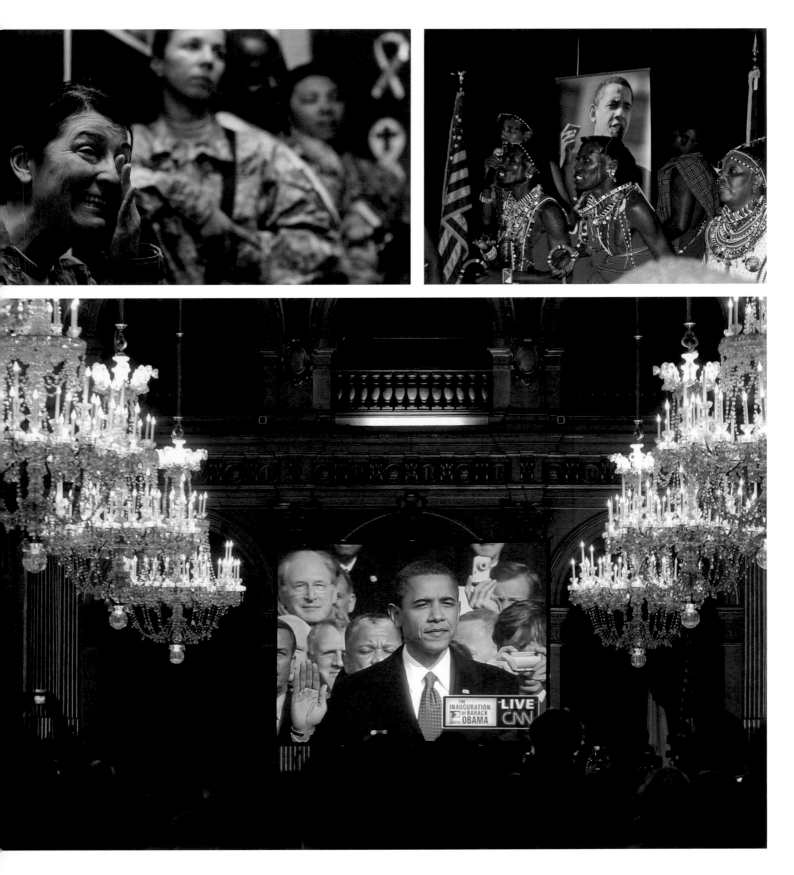

CLOCKWISE FROM TOP LEFT
Celebrating the inauguration of Barack Obama are American soldiers at Camp Liberty in
Baghdad, Iraq; Masai dancers at a party thrown by the Kenyan Embassy in Washington,
DC; and people at the Hotel de Ville in Paris.

**PHOTOS BY MAYA ALLERUZZO/AP PHOTO; KETAN SHAH (PHOTOBUCKET);
JACQUES BRINON/AP PHOTO**

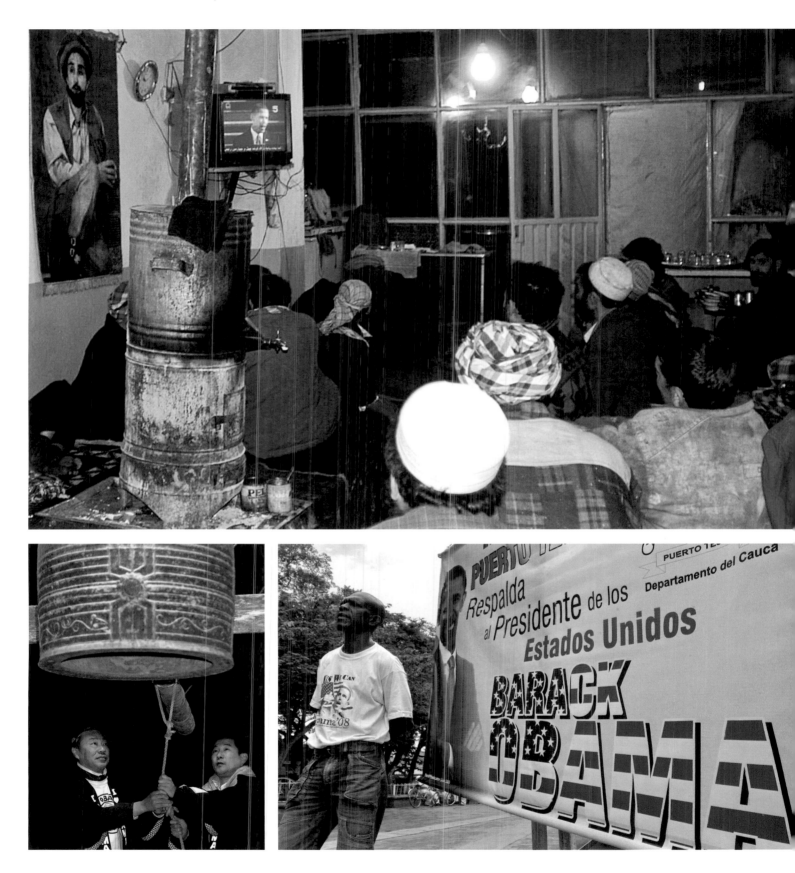

CLOCKWISE FROM TOP
The world watches the inauguration, from a restaurant in Kabul, Afghanistan;
to Pureto Tejado, Columbia; to the city of Obama, Japan.

PHOTOS BY AHMAD MASOUD/AP PHOTO; LUIS ROBAYO/AFP/GETTY IMAGES;
KIYOSHI OTA/GETTY IMAGES

Power is nothing if it does not help to realize the dreams of people. Barack Obama has a vision for a harmonious society, and he was able to awaken the best of what's inside of the American people, and of people everywhere. He is not only the American president, but also one of the most progressive leaders of the Western world.

Intelligence took power on the day of Barack Obama's inauguration as the 44th president of the United States. There are world leaders who are not conscious of the history of their own countries. Obama is the living representation of his, in the tradition of Abraham Lincoln and Martin Luther King. Precisely because of his background, his presence in the White House transcends race, pointing toward a citizenry of the world.

Every country has two sides. A great democratic leader is a man or woman who is able to move a society positively through creativity and imagination. The genius of Obama is in the music of his voice, his choice of words, the construction of his phrases, the coherence of his speeches. He is a poet, not because he writes poetry, but in his bearing, in the marvelous consistency of his judgment, and in the rigor of his vision.

As the former Minister of Culture and Education under François Mitterand, I am indeed amazed at the true cultural and political revolution now under way. "The audacity of hope" is not an empty phrase. With the election of Barack Obama, we saw the impossible; what is still unimaginable in many parts of the world became a reality.

On the day of Obama's inauguration, America showed its luminous face. The grandeur and courage of American democracy was given back to us. Our hope is that President Obama will bring confidence to the United States, and to the world. Our hope is that he stands for peace and dialogue—the outstretched hand— and for the upholding of human rights everywhere.

JACK LANG
DÉPUTÉ, PRESIDENT OF L'INSTITUT MÉMOIRES
DE L'ÉDITION CONTEMPORAINE/IMEC

Residents of Kibera, one of the poorest neighborhoods of Nairobi Kenya, watch the inauguration of the "Son of Kenya"—as President Barack Obama is frequently called in the African press.

PHOTO BY YASUYOSHI CHIBA/AFP/GETTY IMAGES

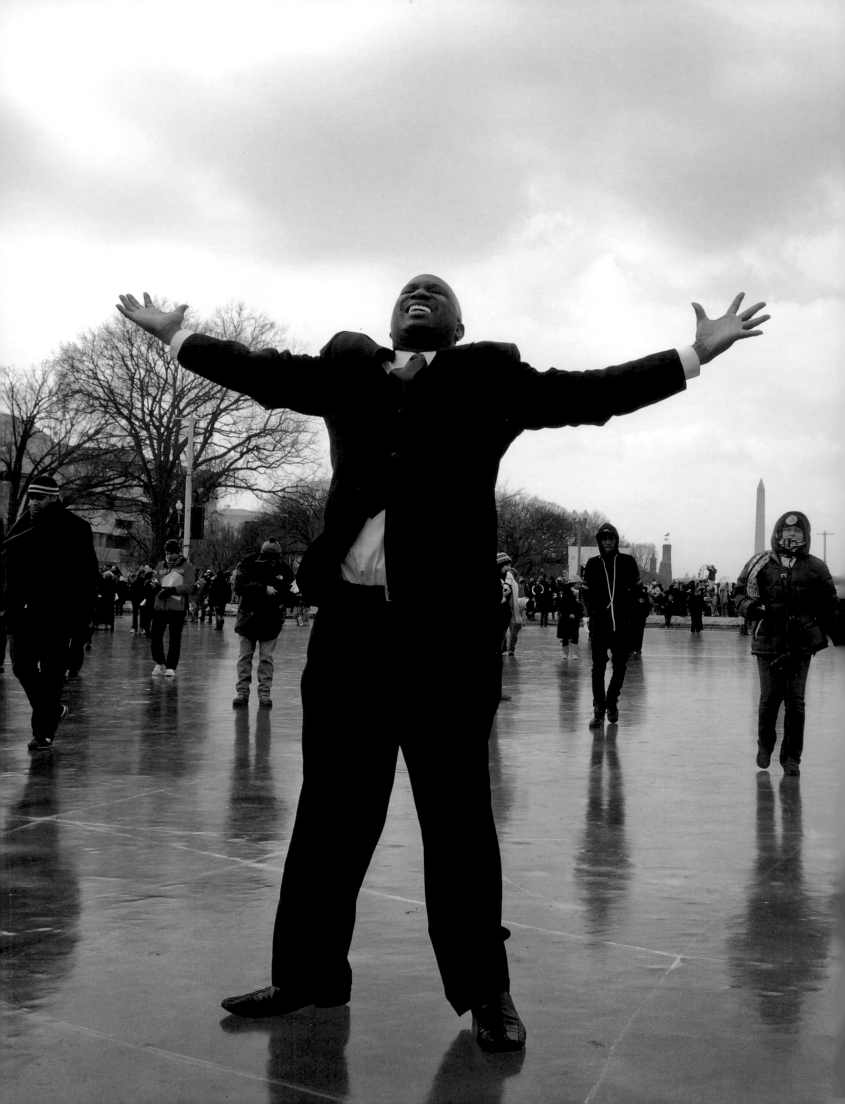

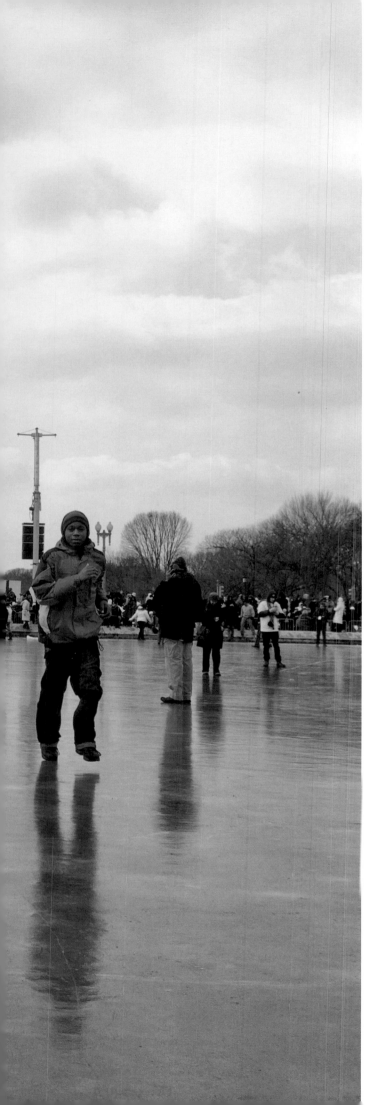

I watched as several million people took a very deep breath.... I looked around on that historic day and witnessed the passing of the torch and the beginning of the realization, once and for all, that we really are "one people," and that we will absolutely prevail in our belief that tomorrow will be a brighter day.

GRAHAM NASH

On the frozen reflecting pool of the National Mall, one of many Americans exulting in President Obama's inauguration.

PHOTO BY ANDY ISAACSON (PHOTOBUCKET)

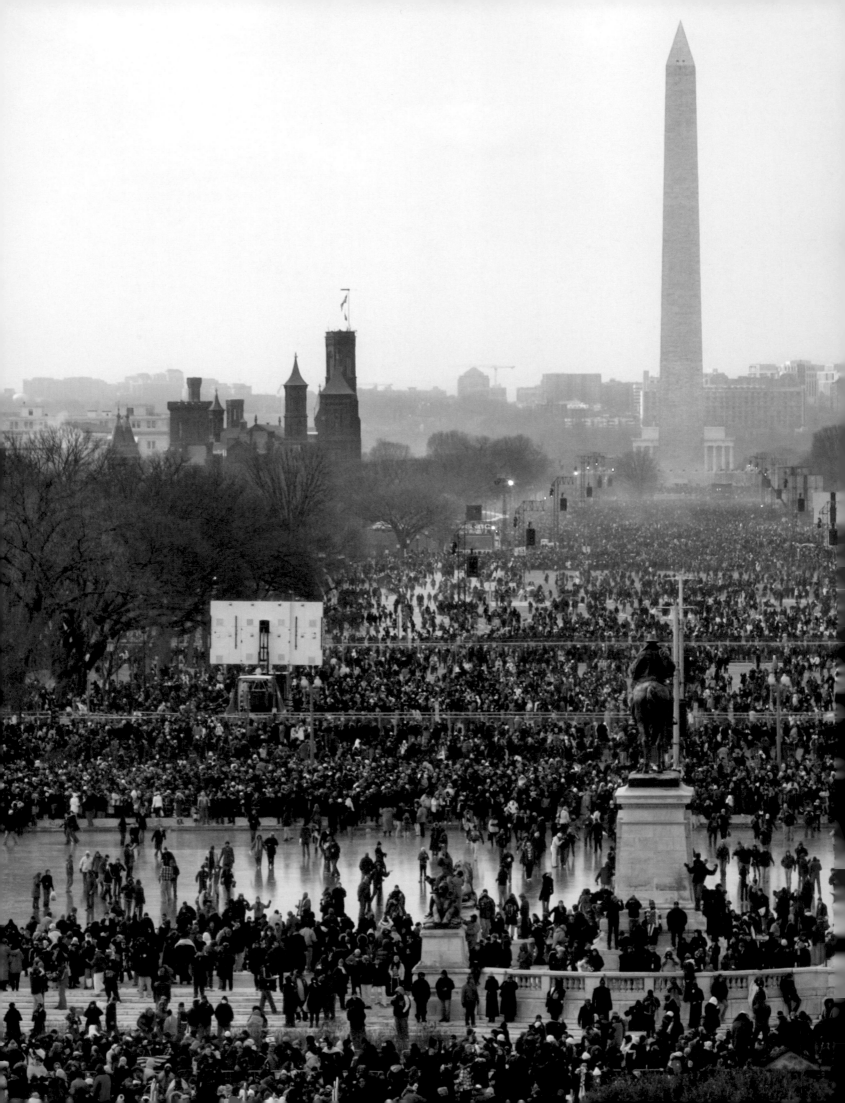

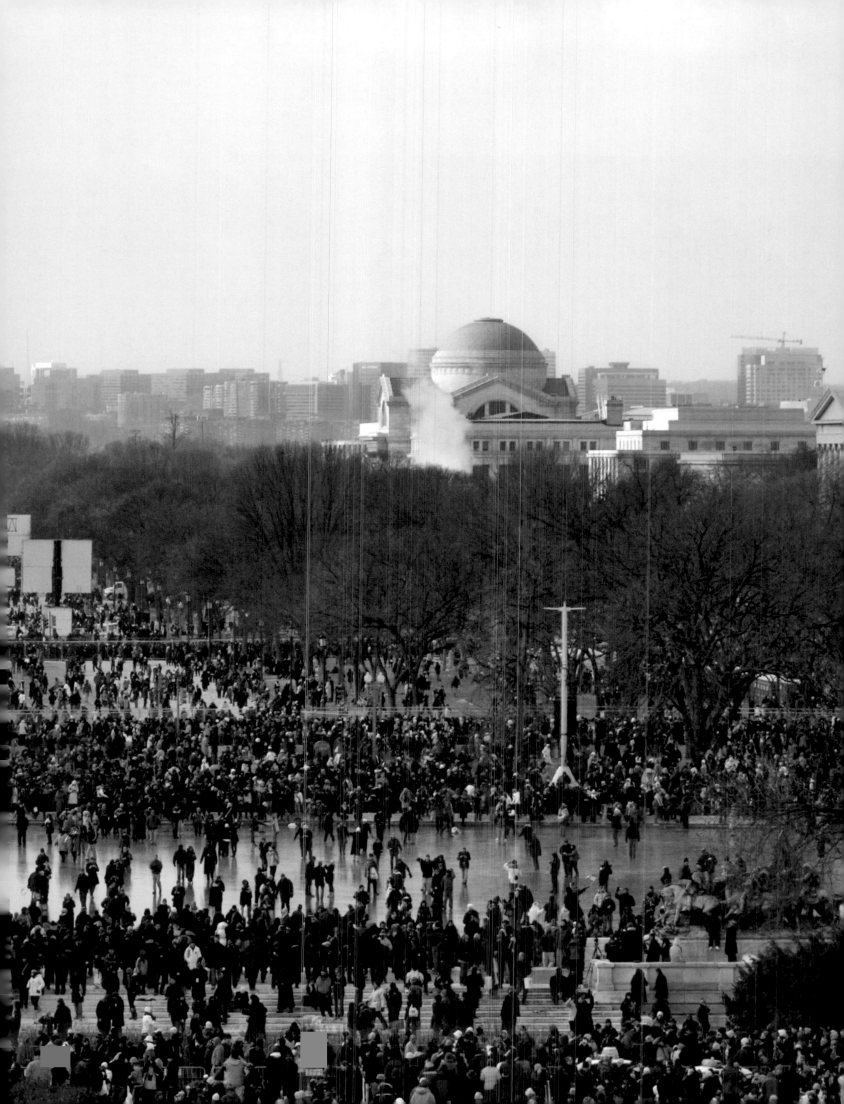

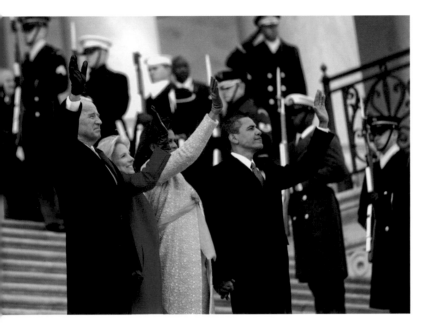

Following tradition, the new First Family bids goodbye to their predecessors from the steps of the Capitol after the inaugural ceremony. The Obamas and Bidens watch as Marine One—the presidential helicopter—ferries George and Laura Bush from the Capitol to Andrews Air Force Base and George W. Bush's new life as a former president.

ABOVE
PHOTO BY LUIGI CIUFFETELLI

RIGHT
PHOTO BY BRUCE TALAMON

PREVIOUS PAGE
The crowd, by far the largest ever recorded for a presidential inauguration (or any other event in Washington, DC), begins to leave the Mall after the ceremony. Despite the huge numbers, neither the DC Metro Police Department nor the U.S. National Park Police (which has jurisdiction over the Mall) reported a single arrest.

PHOTO BY KAREN BALLARD

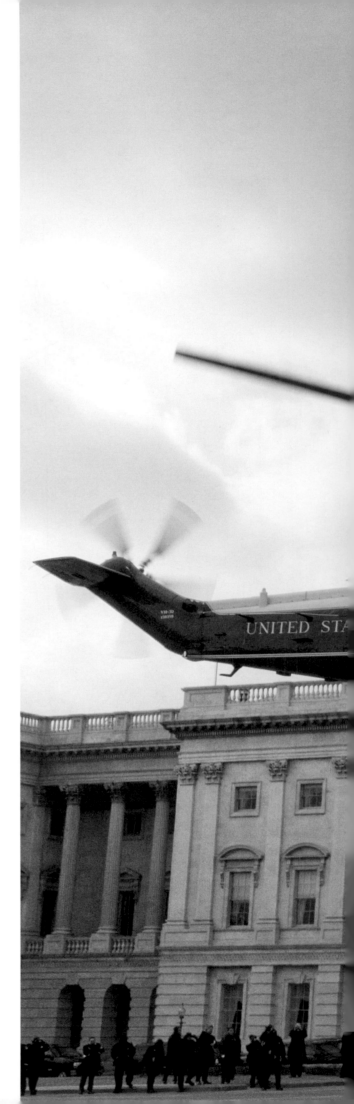

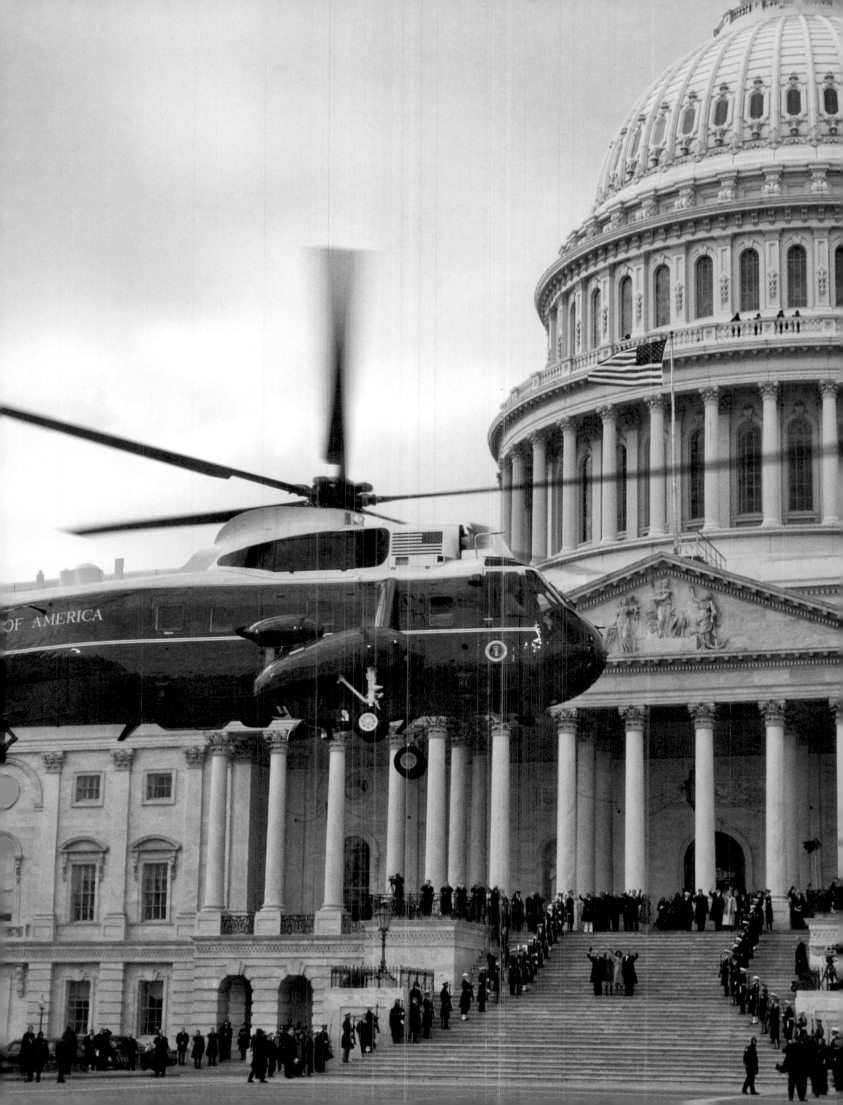

During the inaugural ceremonies, workers at the White House are busy moving the Obamas' belongings into the family's new home. In the Oval Office (following page), technicians change the extensions on the phones in preparation for the new administration.

THIS PAGE AND FOLLOWING PAGE

PHOTOS BY DAVID HUME KENNERLY

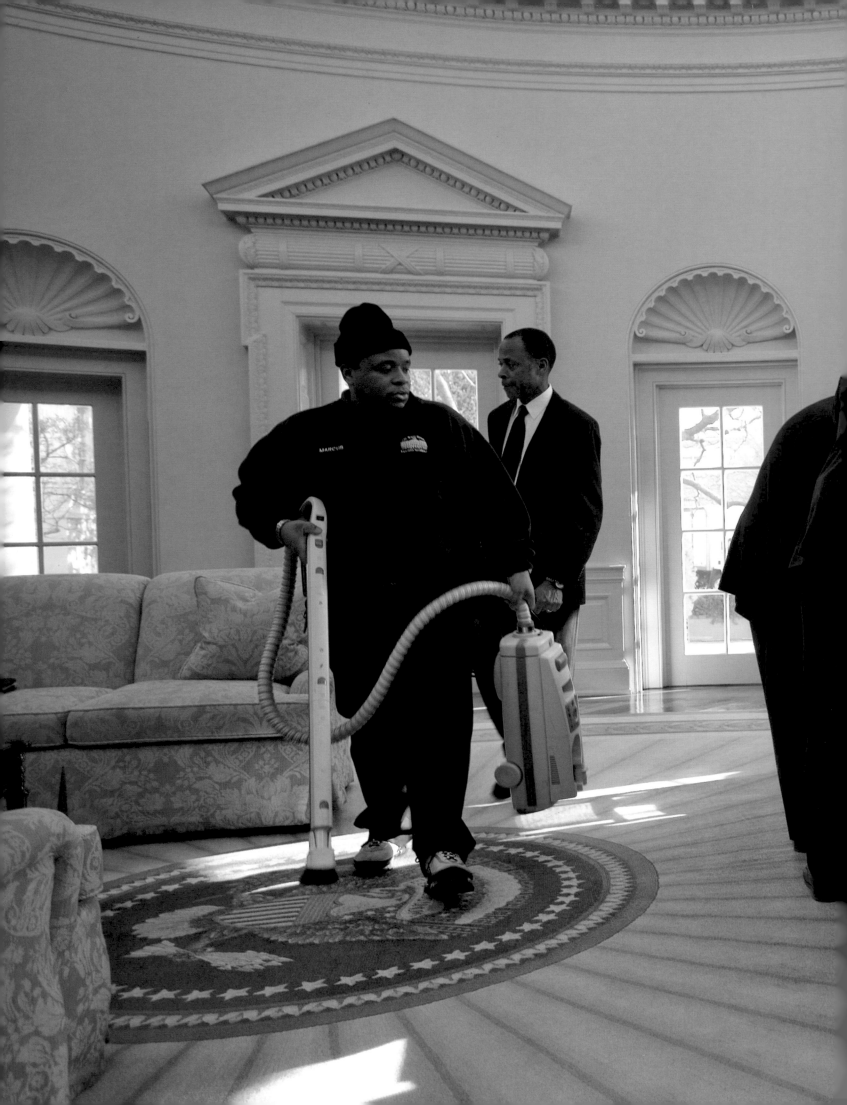

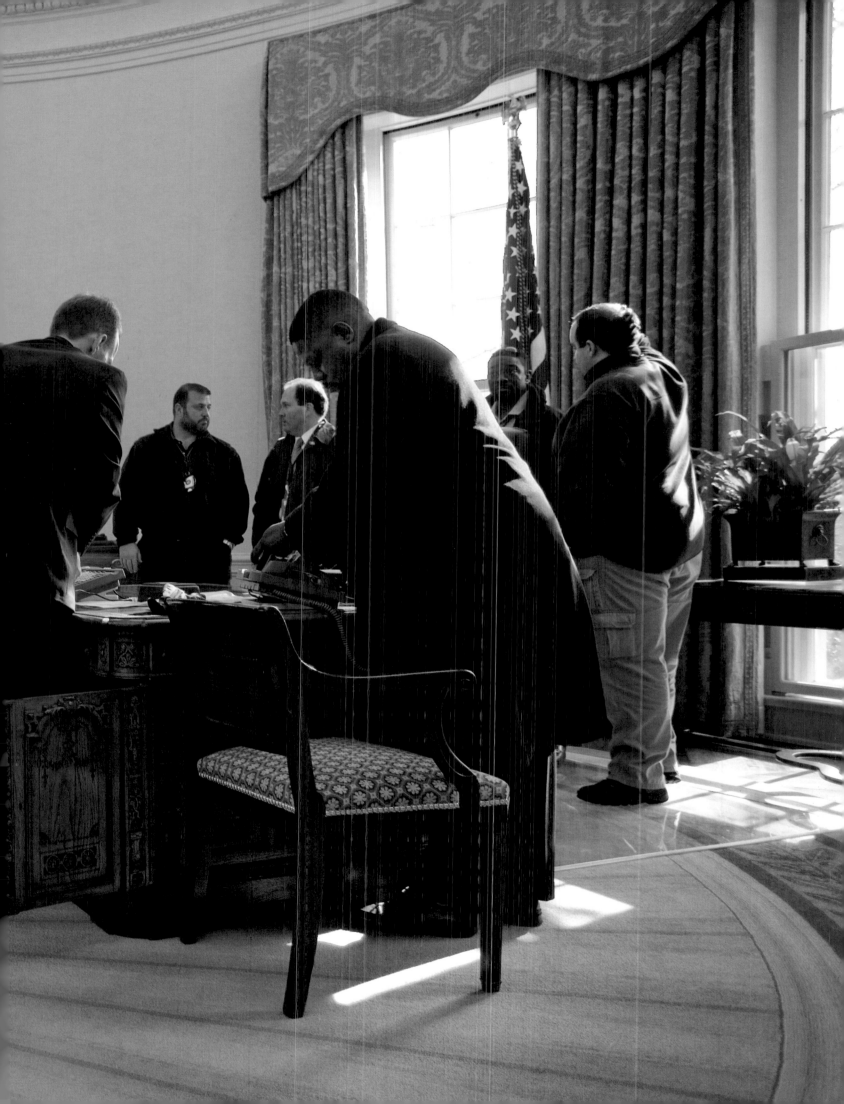

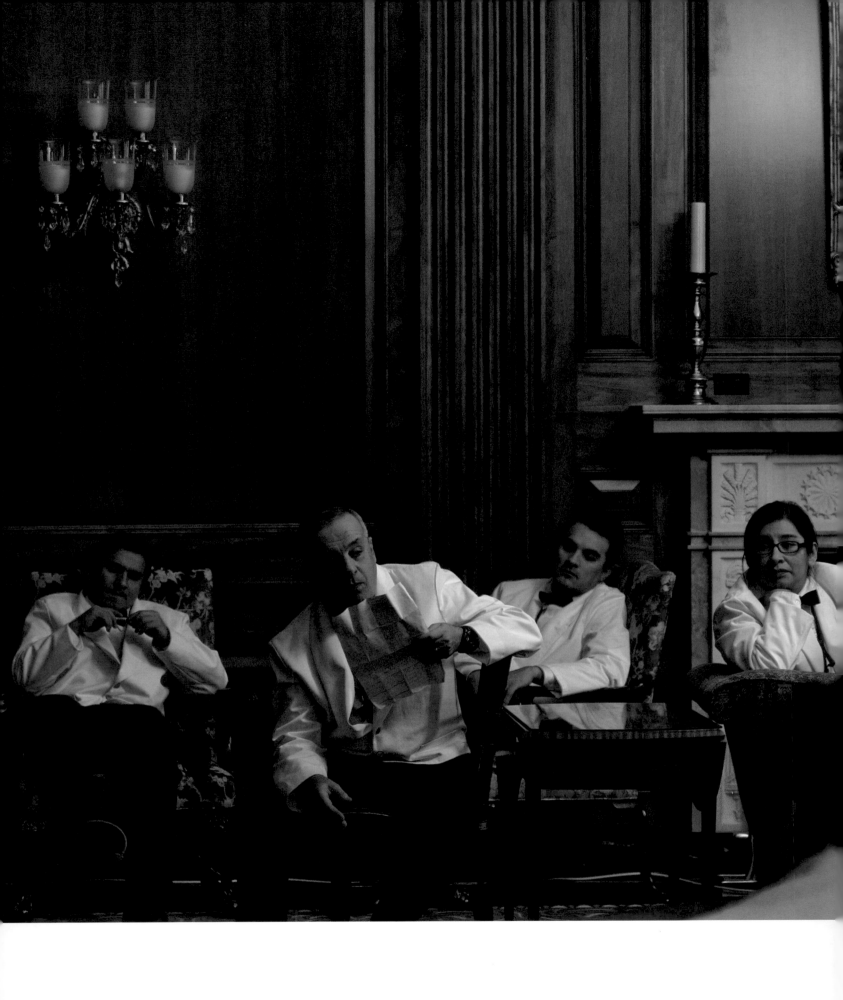

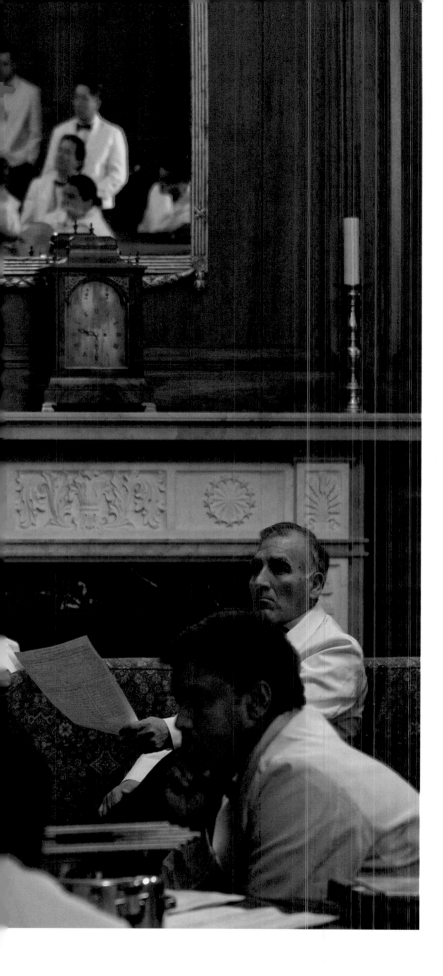

After the swearing-in ceremony, the new President and First Lady, along with Vice President and Mrs. Biden, attend the traditional luncheon with members of Congress in Statuary Hall in the Capitol building. Before the event, wait staff receive their final briefing.

LEFT, ABOVE, AND FOLLOWING PAGE
PHOTOS BY DANIEL ROSENBAUM

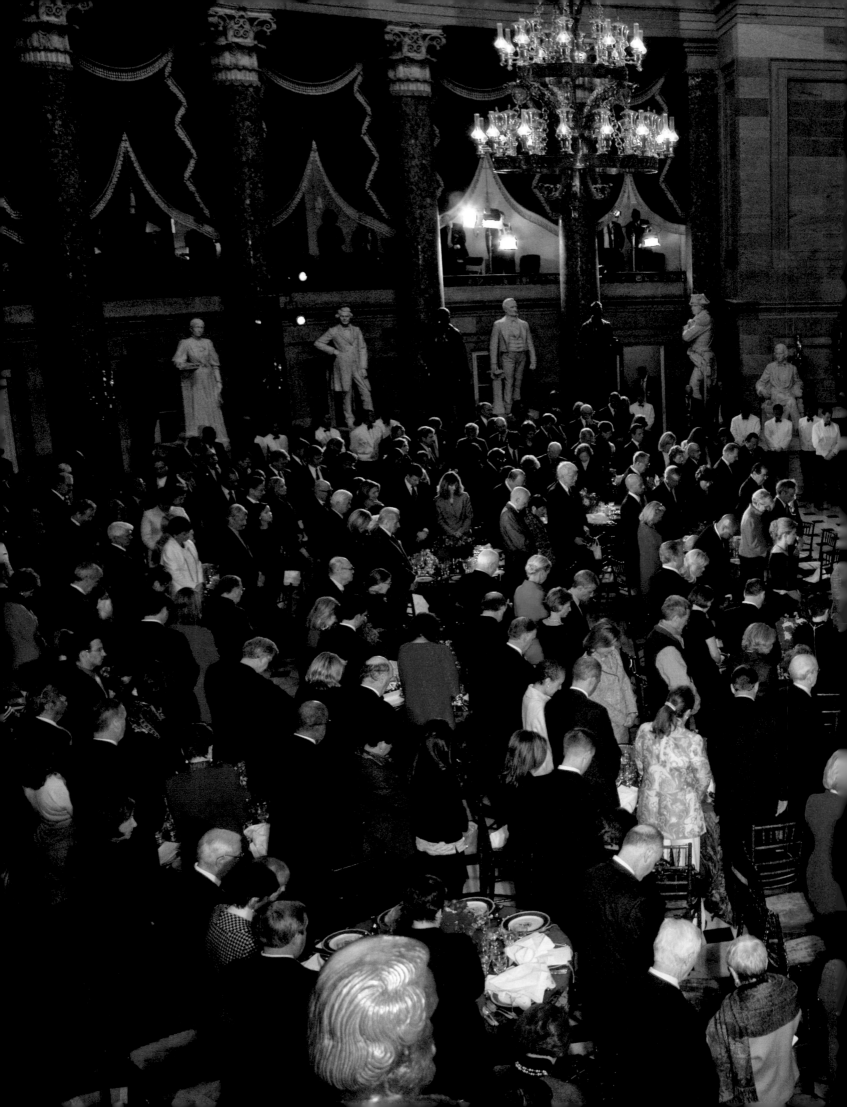

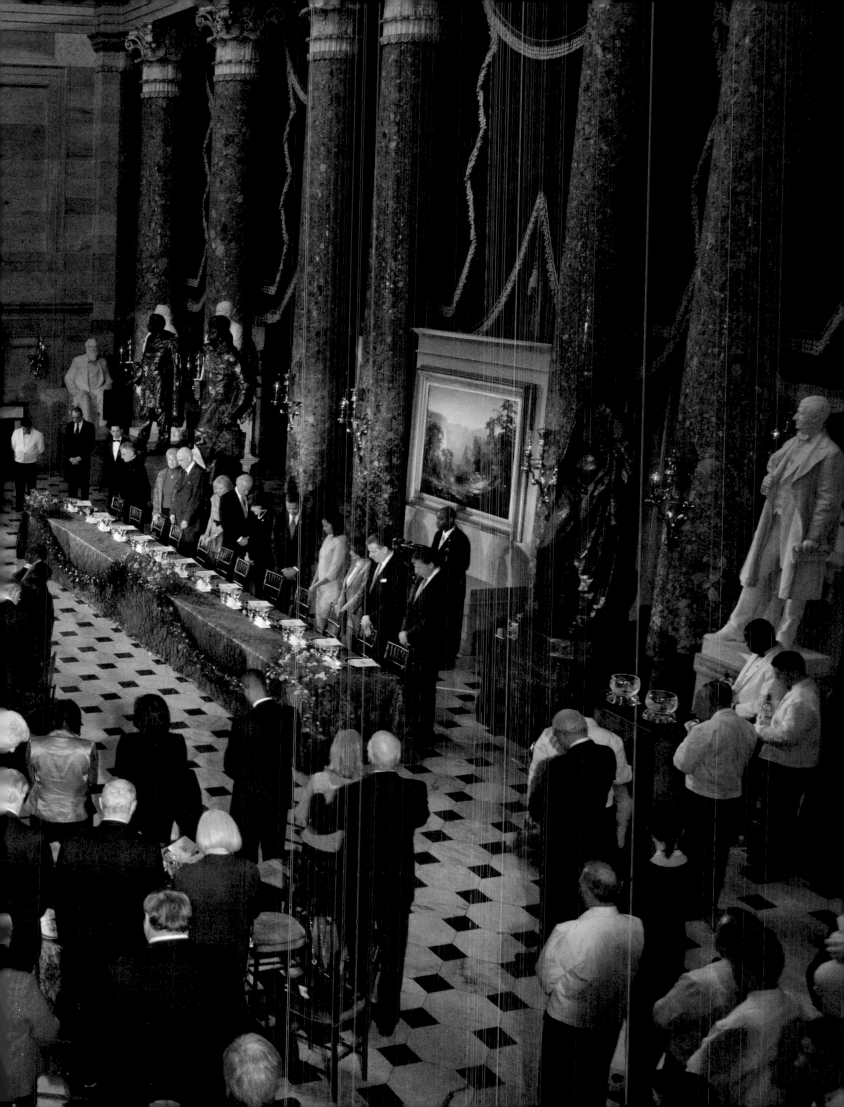

THE PARADE

IMAGINE AN AMERICA
where a bleacher full of citizens
in front of the White House,
freezing for hours to catch
a glimpse of their new president,
are so filled with excitement
that they spontaneously start
singing "America the Beautiful"
and "Amazing Grace" together
in imperfect harmony to
welcome him to his new home.

PHOTO BY MIKE GENDIMENICO

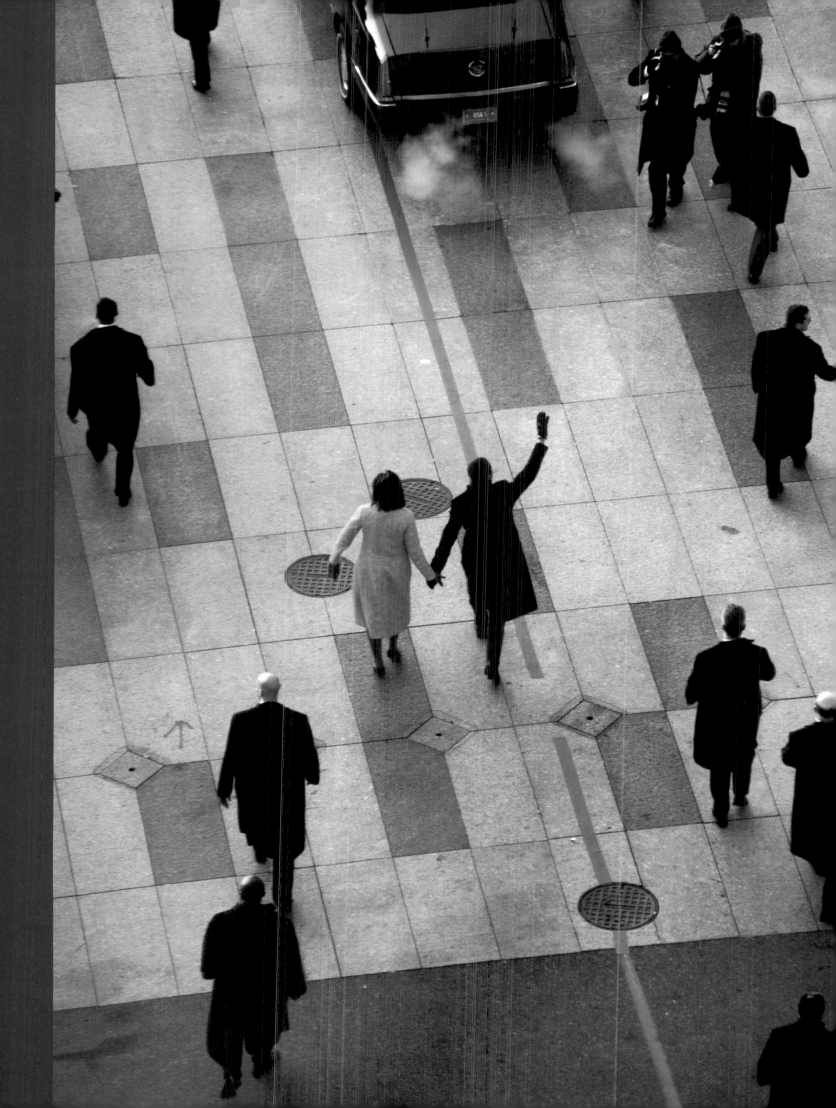

The inaugural parade takes the new president down Pennsylvania
Avenue to the White House. The tradition dates back to
Thomas Jefferson's second inauguration in 1805—although George
Washington was paraded around the streets of New York City
by Continental Army members after the first presidential
inauguration in 1789. A row of motorcycle police stand ready
to escort the new president, as the U.S. Army Old Guard Fife
and Drum Corps march directly ahead of him. Dressed in
Revolutionary War uniforms, the Corps serves as the official
ceremonial escort to the president.

ABOVE
PHOTO BY PAUL MORSE

OPPOSITE
PHOTO BY MARK SENNET

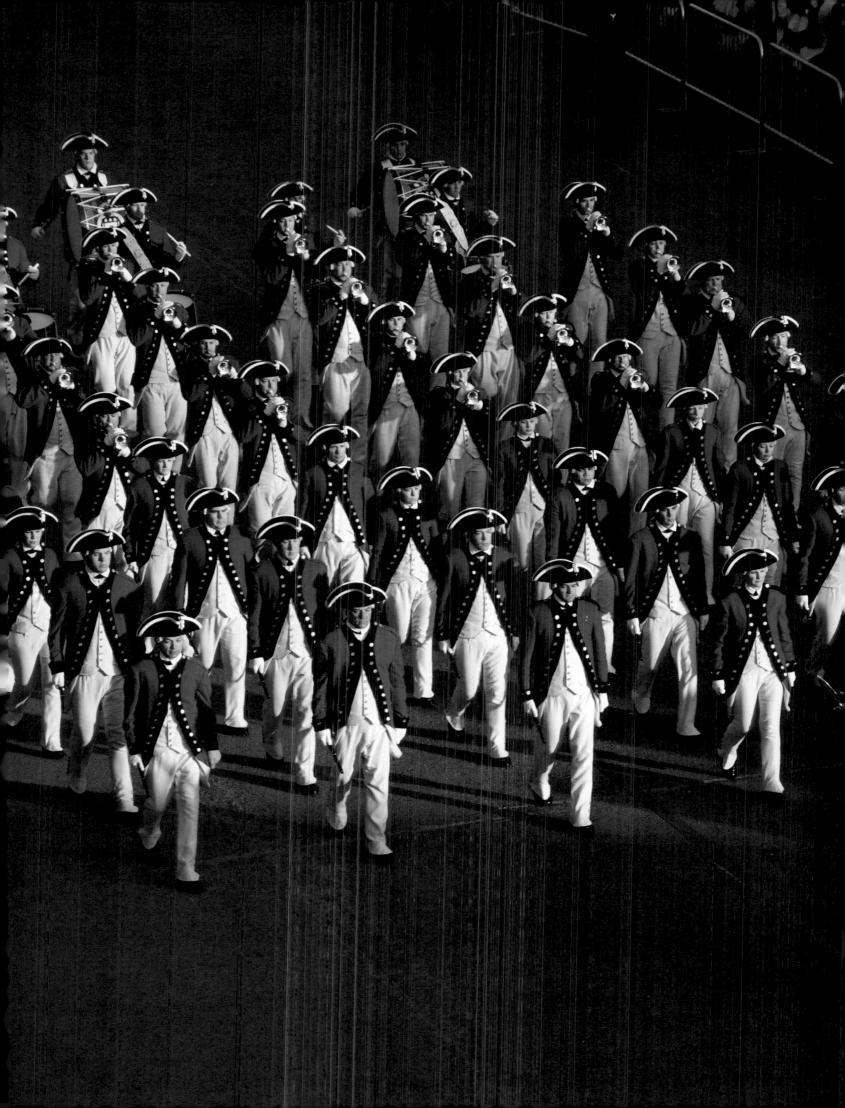

PREVIOUS PAGE
One of the 90-plus groups that marched in the inaugural parade makes its way down Pennsylvania Avenue.

PHOTO BY ROBERT McNEELY

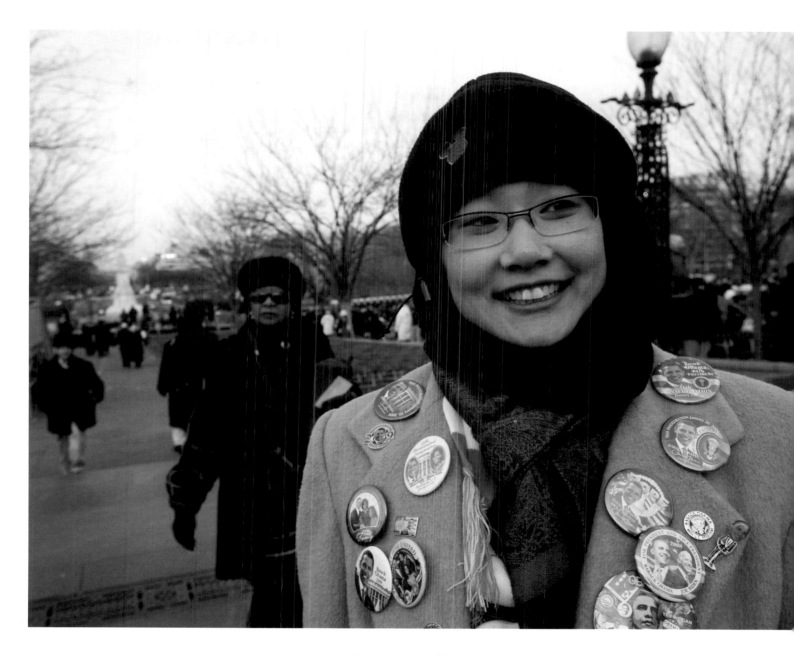

Americans came from all corners of the country to be part of the inaugural festivities. The desire for access to the parade was so great that when the Presidential Inaugural Committee made an additional 5,000 tickets available a week beforehand, they were snatched up online in less than a minute.

OPPOSITE, CLOCKWISE FROM LEFT
PHOTOS BY ANDRÉ CHUNG, SANDY CHOI (PHOTOBUCKET), GIL GARCETTI

ABOVE
PHOTO BY KAREN BALLARD

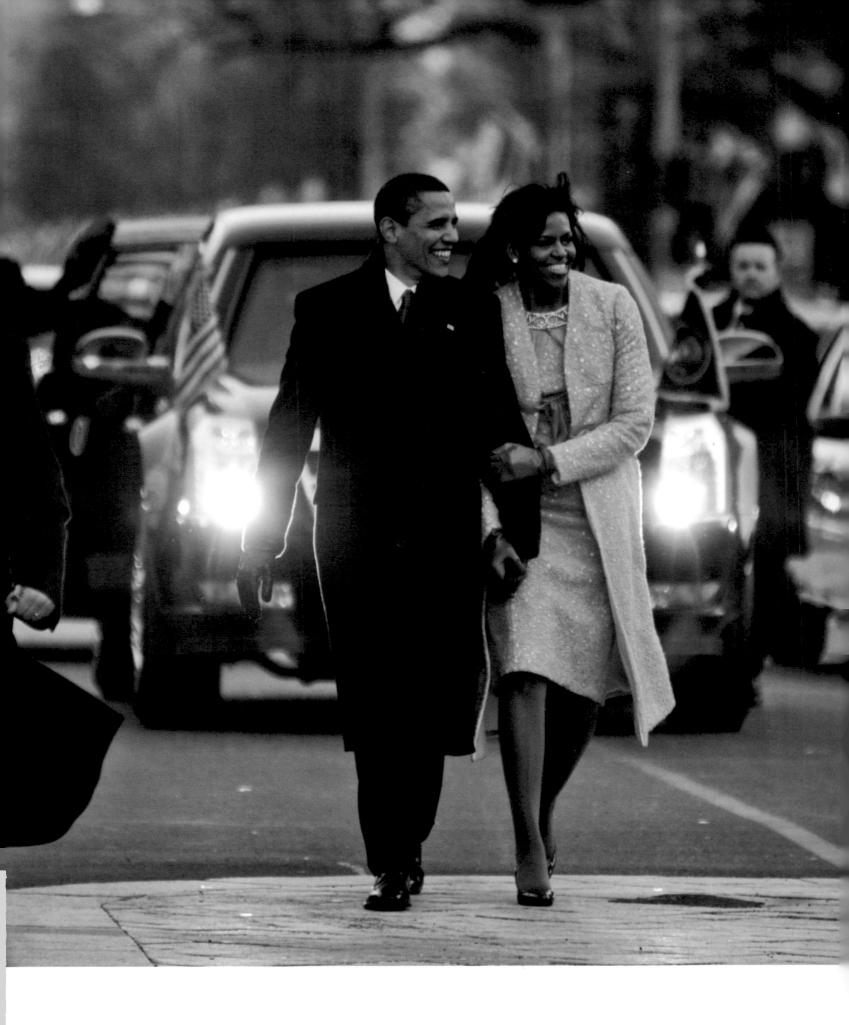

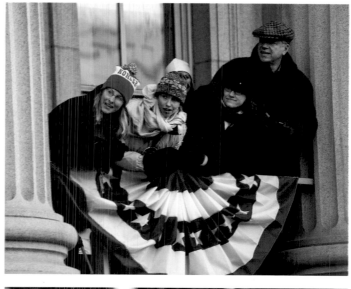

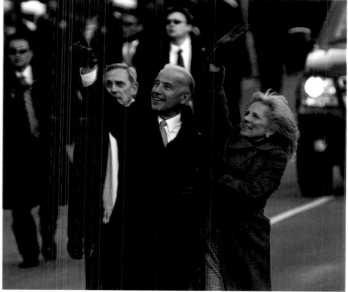

The Obamas and the Bidens leave their cars to walk the last leg of the 1.8-mile parade route from the Capitol building to the White House. Enthusiastic supporters filled every available balcony, window, and rooftop along the route.

LEFT
PHOTO BY PAUL MORSE

ABOVE
PHOTOS BY GREG MATHIESON

FOLLOWING PAGE
From their perch in the presidential viewing box, the President and First Lady wave to the colorful Azalea Trail Maids of Mobile, Alabama.

PHOTO BY DAVID HUME KENNERLY

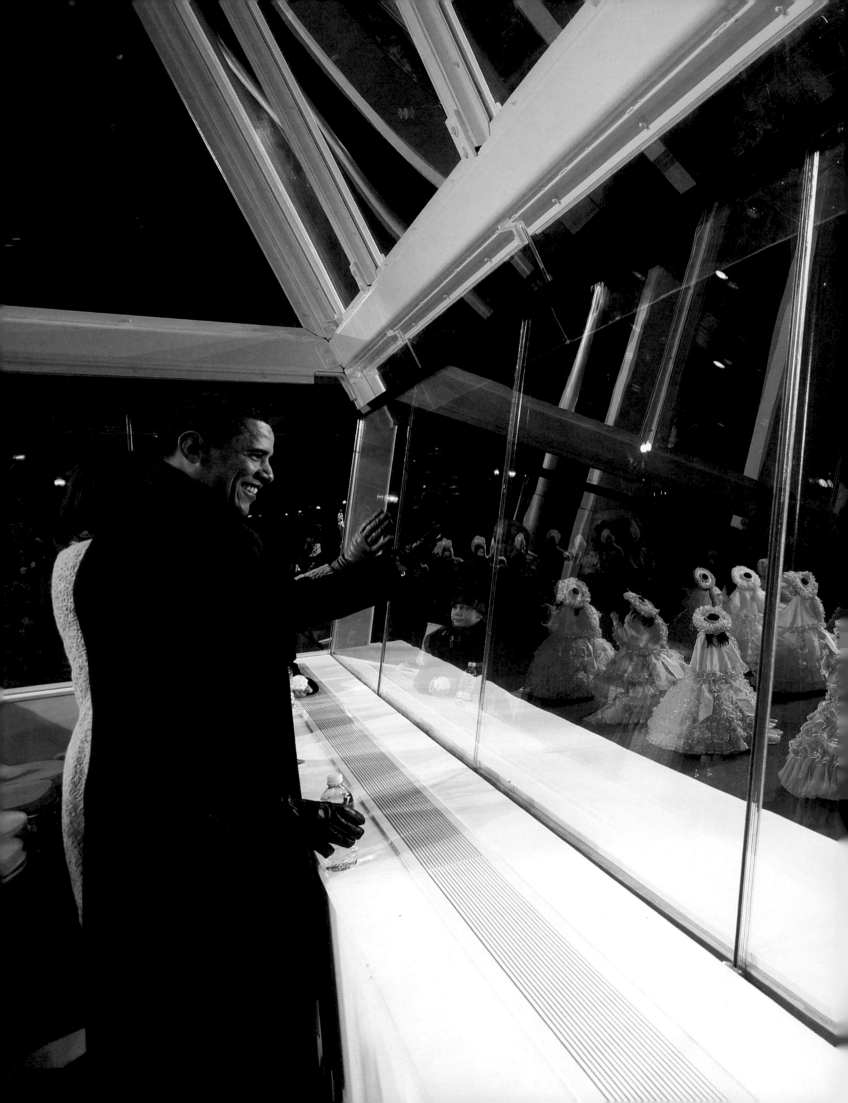

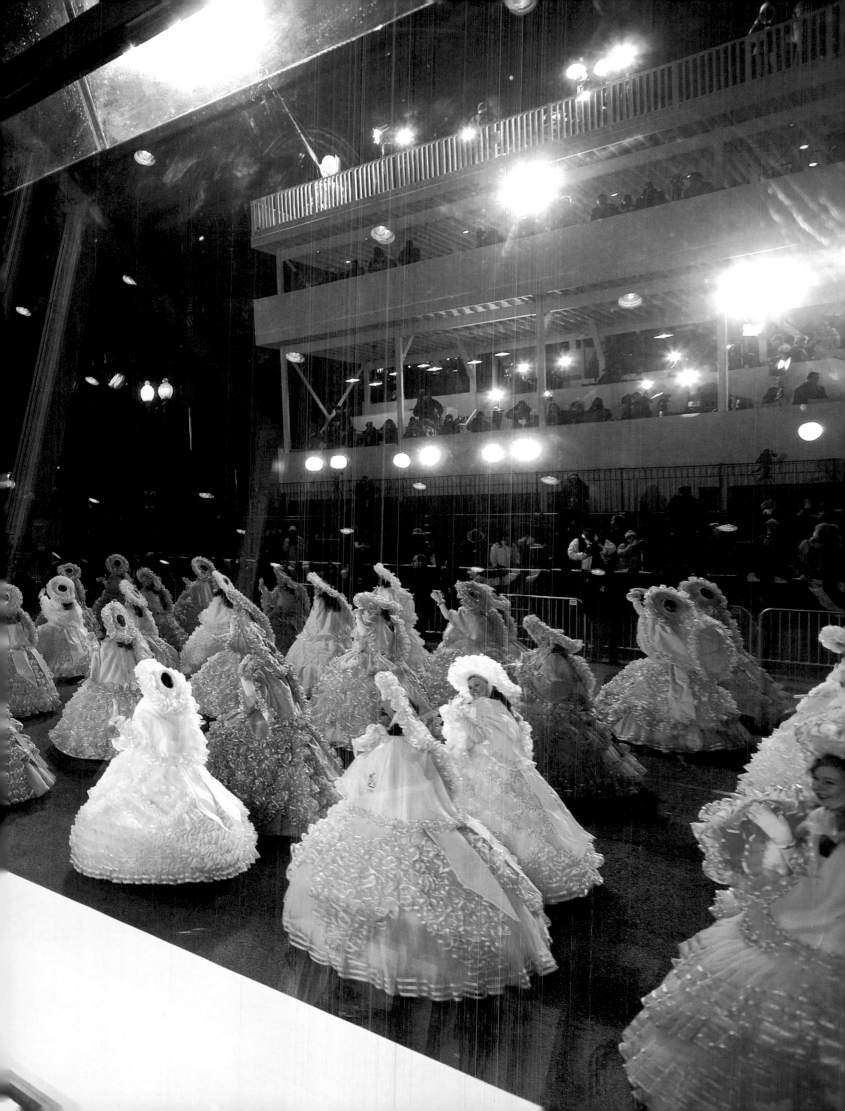

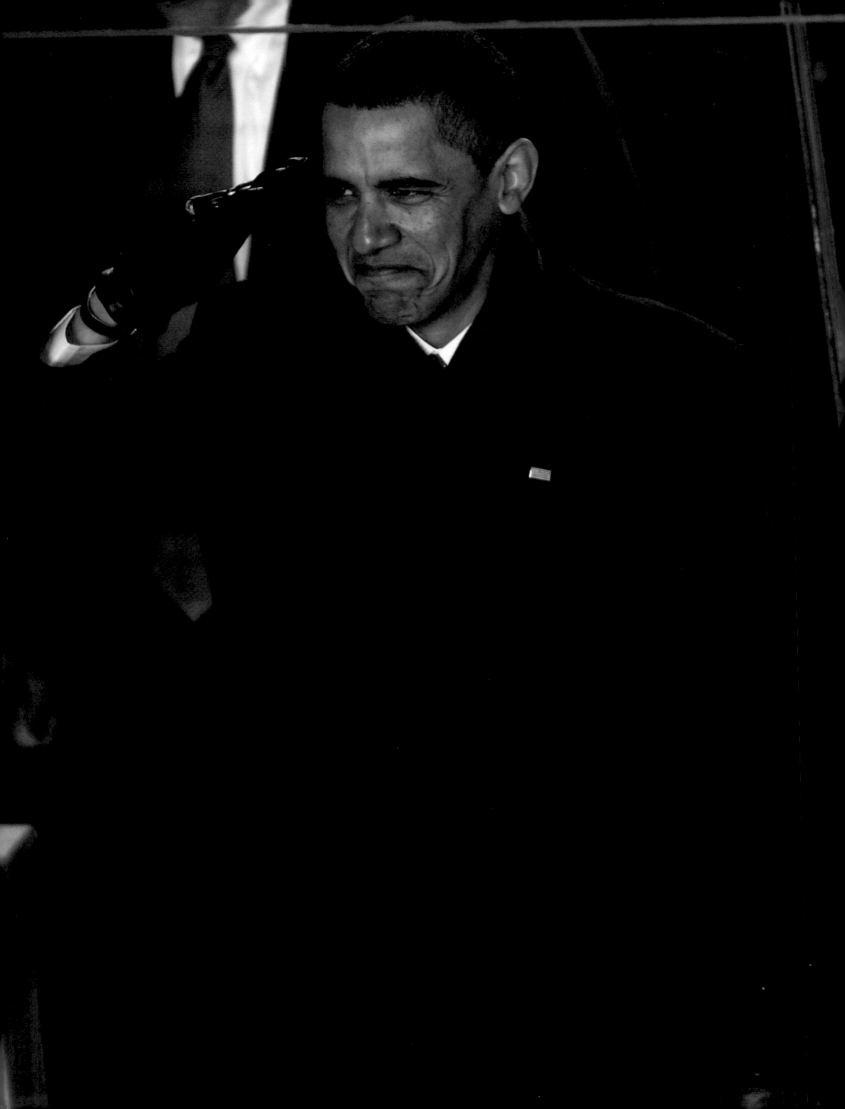

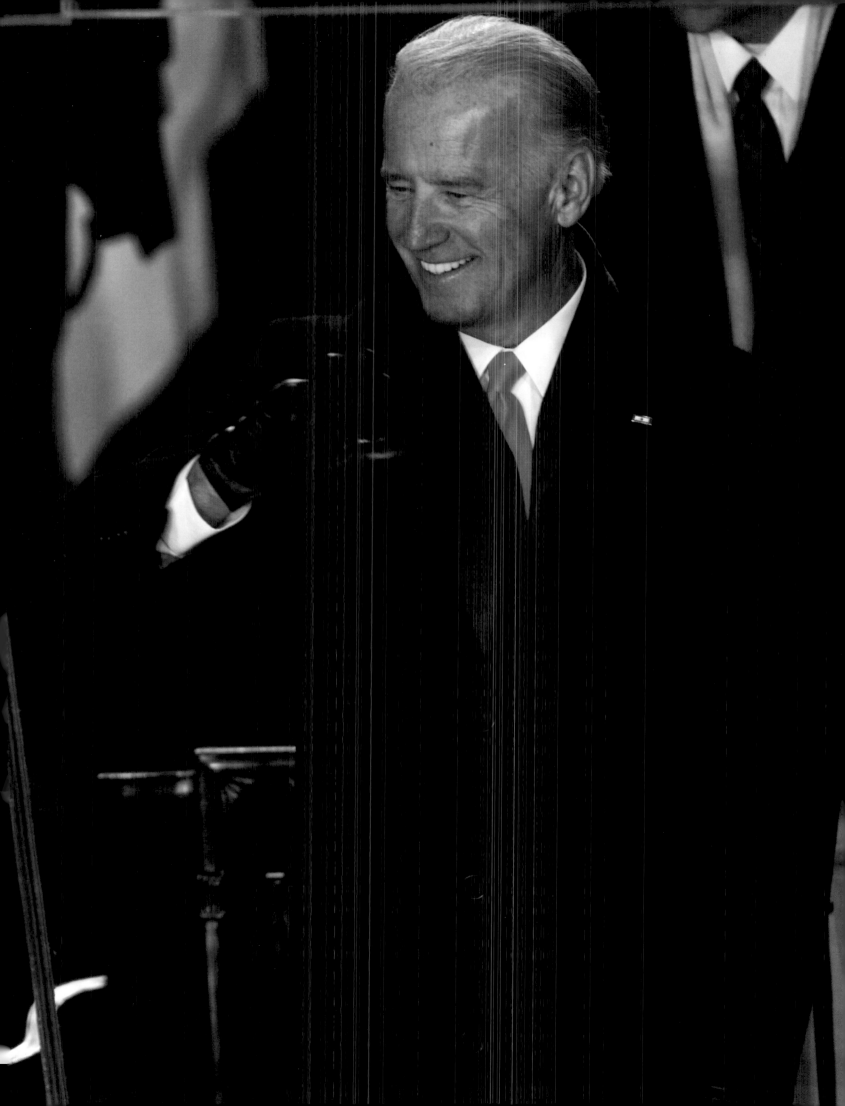

The inaugural parade draws smiles from the
First Lady, the President, and the Vice President.
More than 13,000 participants, including members
of this marching military unit, passed before the
presidential reviewing stand.

ABOVE
PHOTO BY DAVID HUME KENNERLY

RIGHT
PHOTO BY T. ADAMS/NATIONAL PARK SERVICE

PREVIOUS PAGE
President Barack Obama, standing next to the Vice President,
delivers one of his first salutes as commander in chief.

PHOTO BY KAREN BALLARD

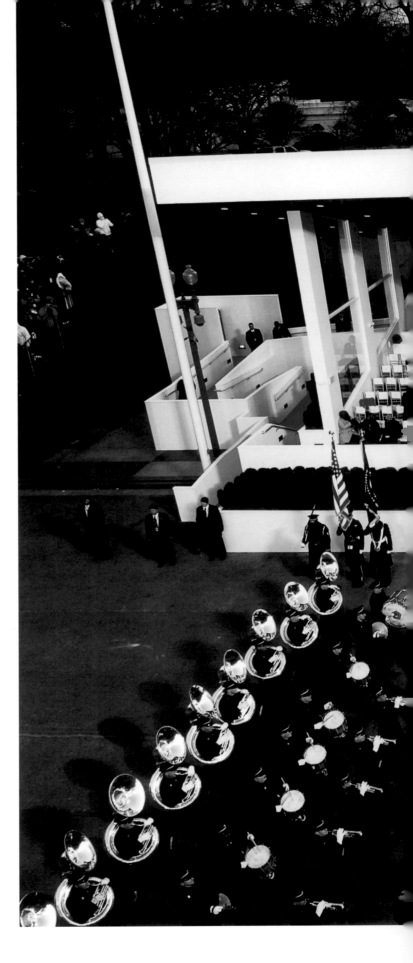

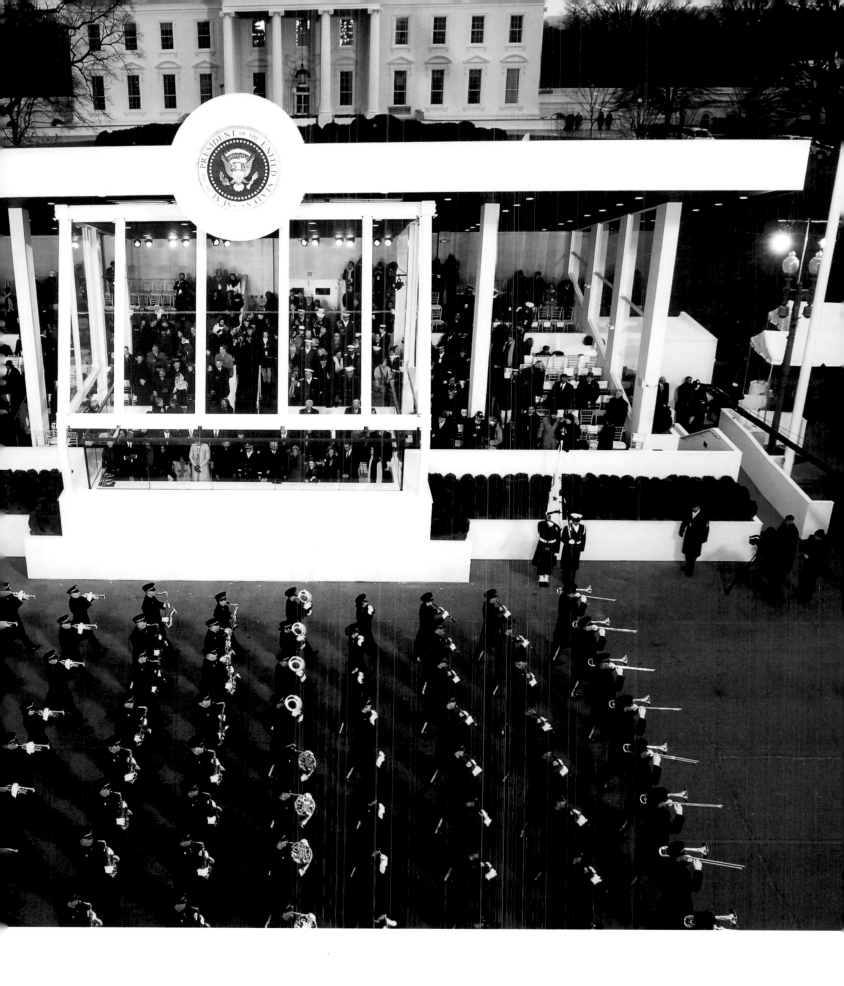

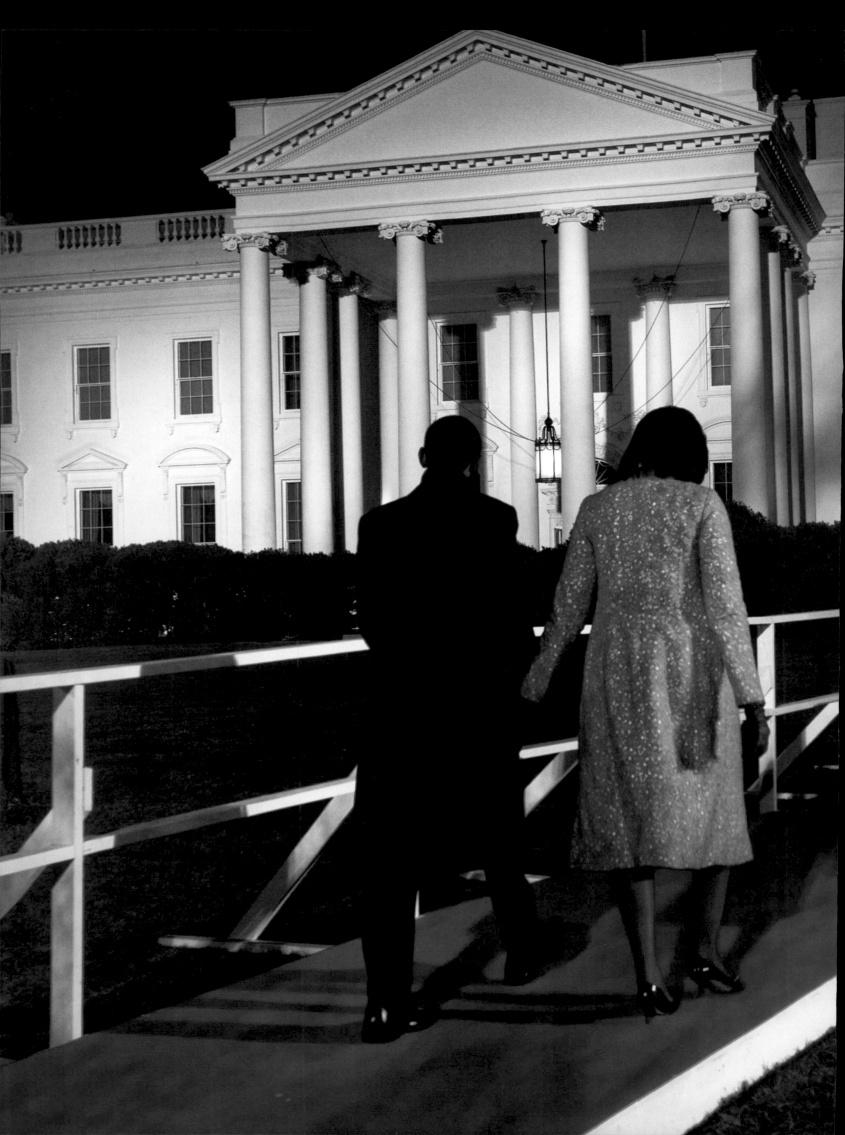

A long day behind them—and a long night of inaugural ball-hopping ahead of them—the President and First Lady head from the parade viewing stand to their new home in the White House.

PHOTO BY DAVID HUME KENNERLY

THE INAUGURAL BALLS

IMAGINE A PRESIDENT
and First Lady who dance
together like there is
no one else in the room.

At the Washington Hilton on their way to the Youth Ball, Barack and Michelle Obama pass their portraits already hung in a place of honor on the wall as the nation's President and First Lady.

PHOTO BY DAVID HUME KENNERLY

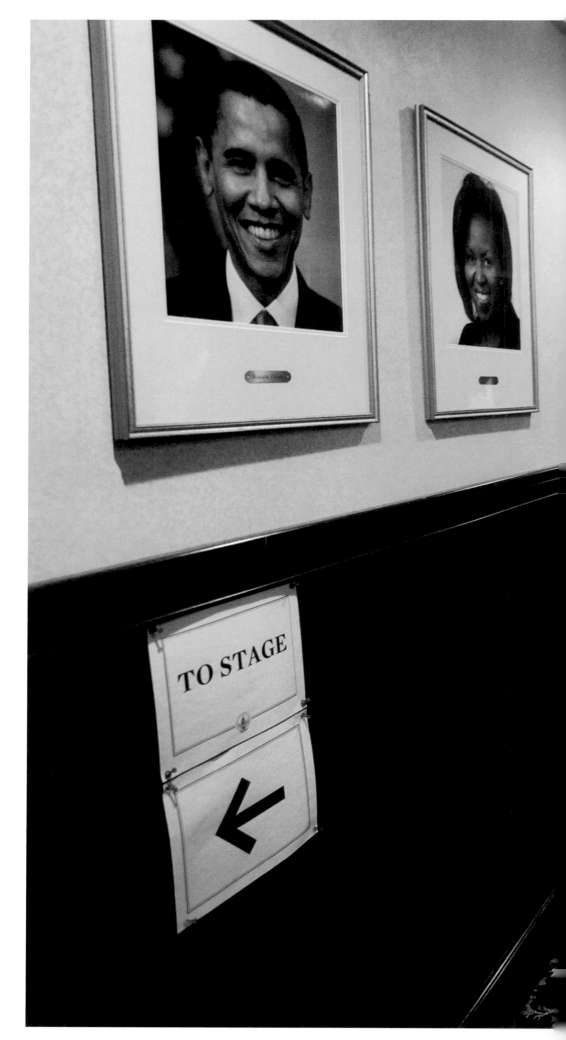

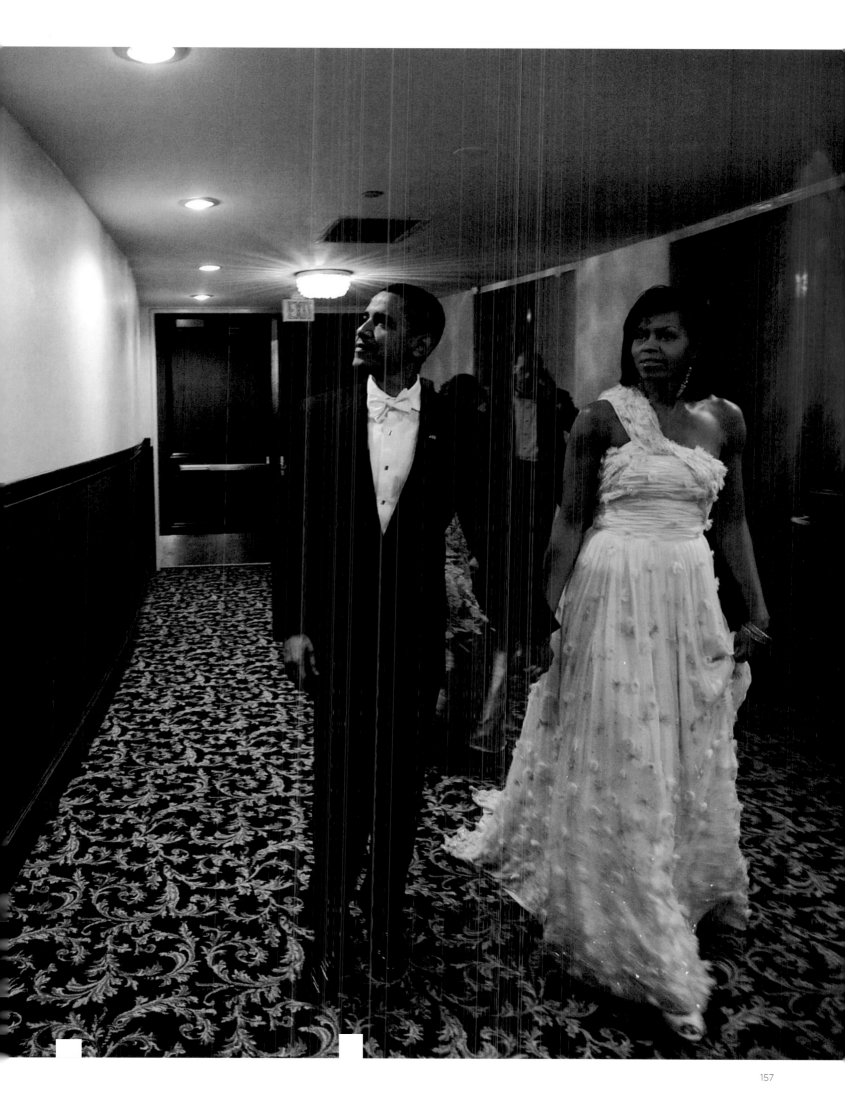

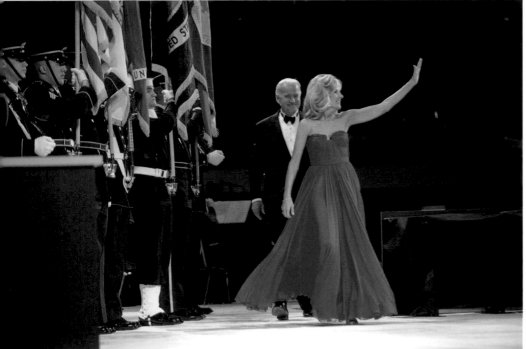

The Obamas make their first appearance of the evening at the Neighborhood Ball at the Washington Convention Center. A tradition since the 1809 inauguration of James Madison, the inaugural balls are a chance for the new president to celebrate together with the American people, but they have sometimes been seen as overly exclusive. Before the inauguration, Barack Obama declared the Neighborhood Ball—with free or affordable tickets reserved for Washington, DC, residents—to be different, saying, "This is an inauguration for all Americans."

ABOVE TOP AND RIGHT
PHOTOS BY DAVID HUME KENNERLY

ABOVE BOTTOM
PHOTO BY LUIGI CIUFFETELLI

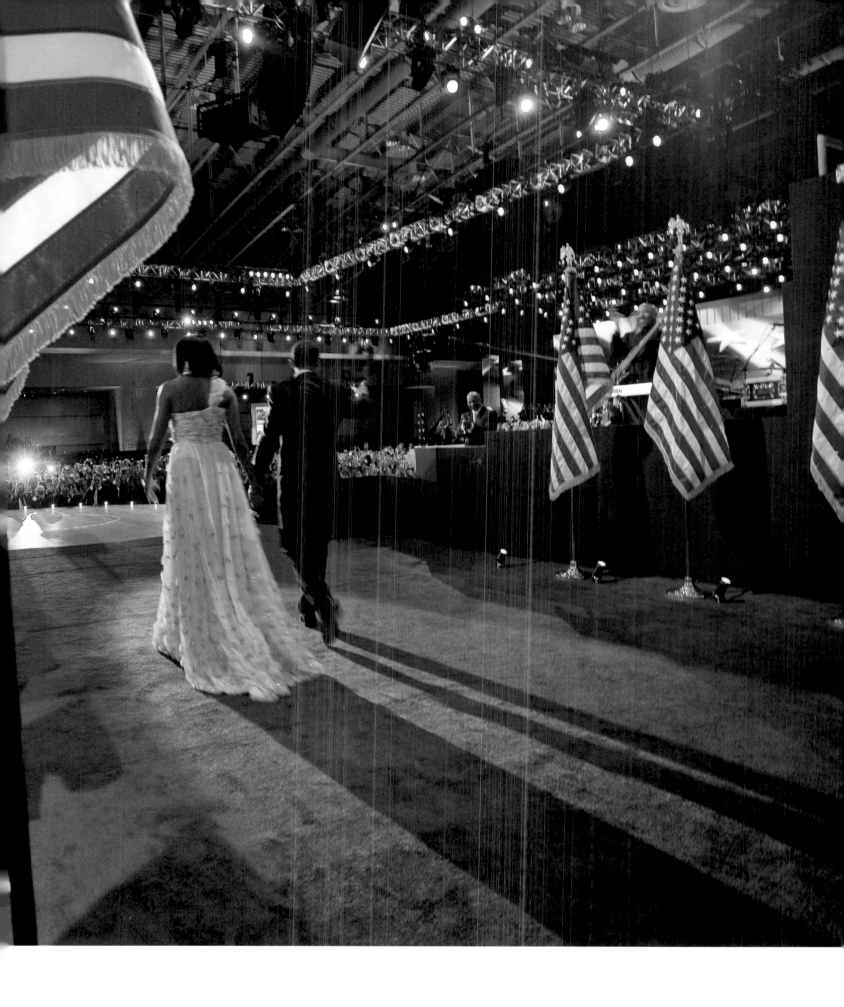

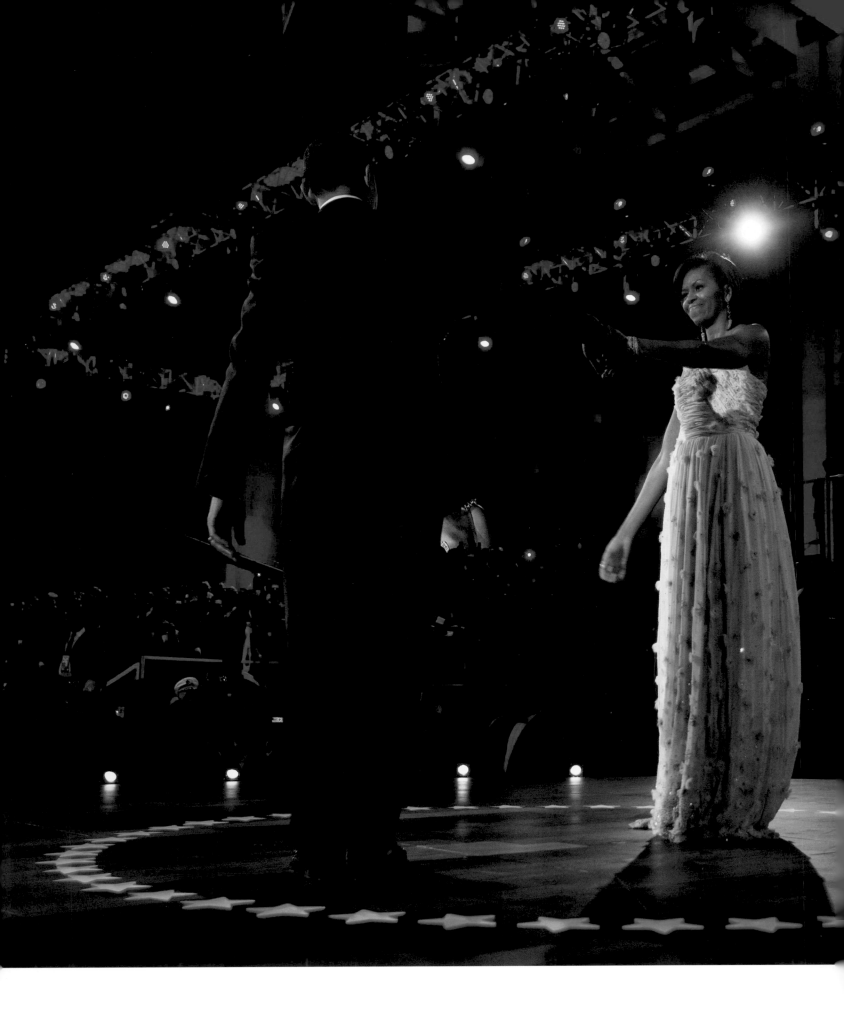

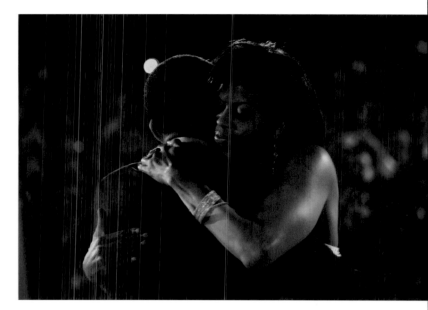

Broadcast live on ABC and watched by thousands in person throughout the night, the inaugural balls are anything but intimate. Yet somehow the new President and First Lady find tender moments, as during their first dance at the Neighborhood Ball—serenaded by Beyoncé, singing the Etta James classic "At Last."

PHOTOS BY DAVID HUME KENNERLY

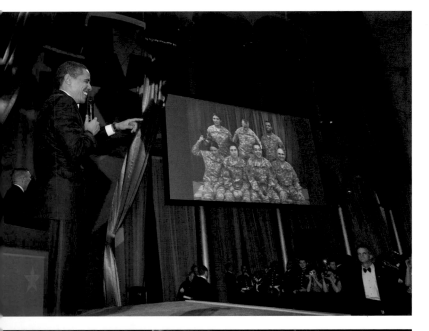

Continuing a tradition established in 2005 by George W. Bush, the Obamas attend the Commander-in-Chief Ball, held to honor the men and women of America's armed forces. The new president speaks by video link to members of the Illinois National Guard's 33rd Infantry Brigade, stationed in Kabul, Afghanistan. Then he and the First Lady dance with representatives of America's military, Army Sgt. Margaret Herrera and Marine Sgt. Elidio Guillen.

PHOTOS BY DAVID HUME KENNERLY

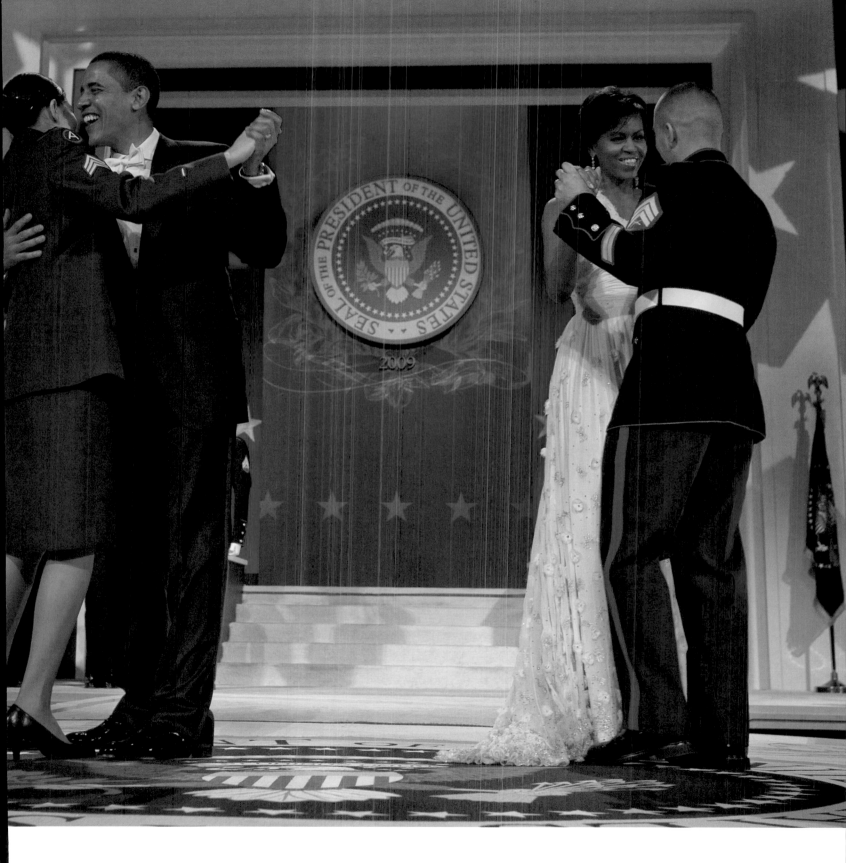

RENEWING AMERICA'S PROMISE

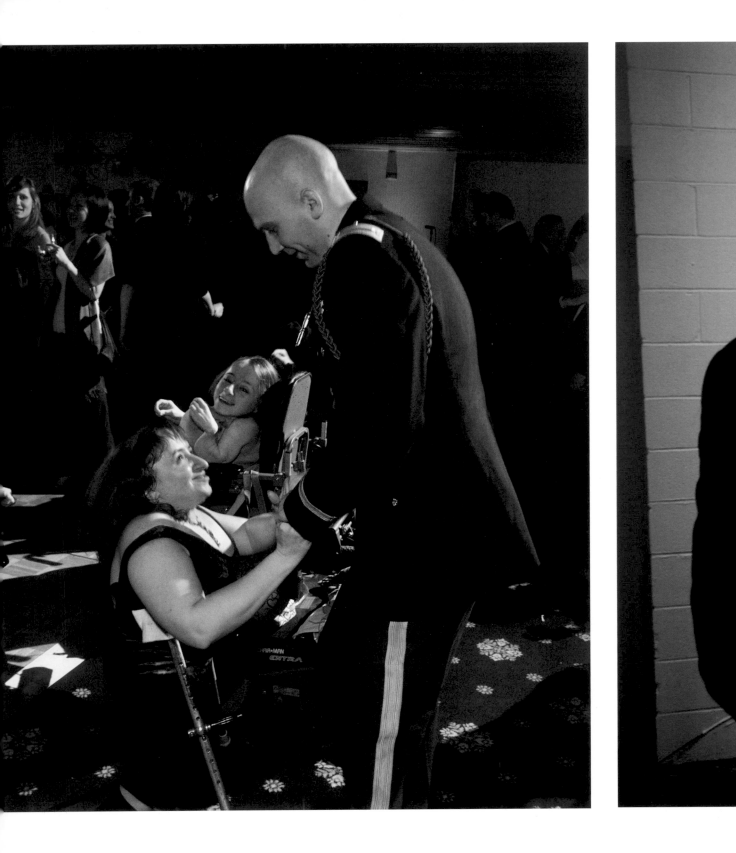

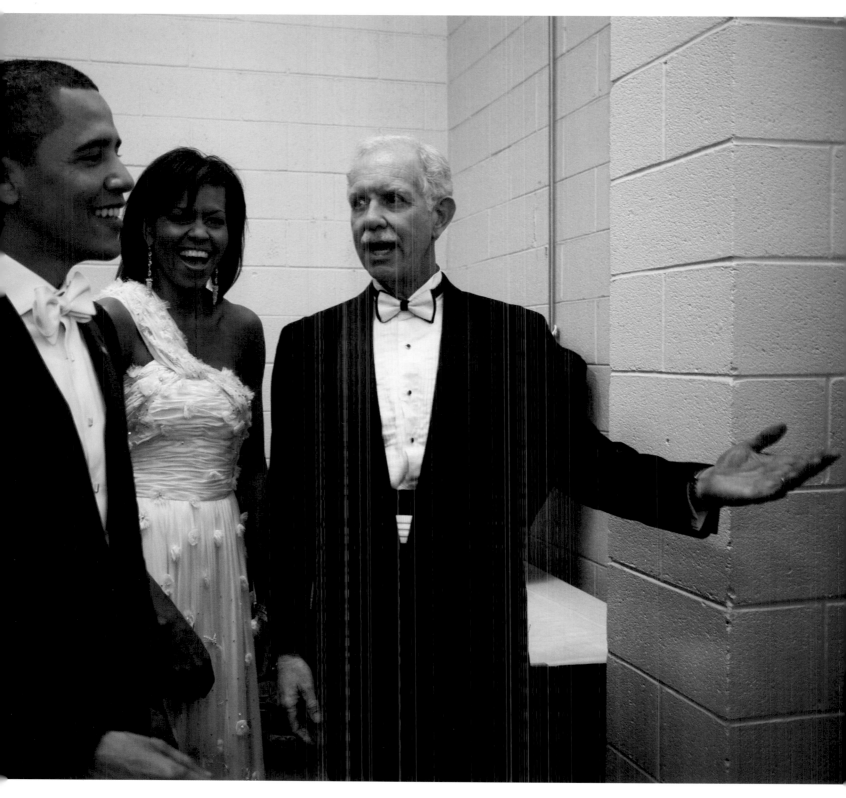

A constant theme throughout the week's inaugural activities was acknowledgment of America's heroes, both celebrated and unsung. The Obamas share a behind-the-scenes moment with Captain Chesley Sullenberger—now known to all as "Sully"—a week after the pilot successfully landed his disabled US Airways flight in the Hudson River, saving the lives of all aboard. An Iraqi war veteran at the Disability Ball (opposite) steps onto the dance floor for the first time after receiving a new prosthetic leg.

OPPOSITE
PHOTO BY THOMAS K. WALKER
ABOVE
PHOTO BY DAVID HUME KENNERLY

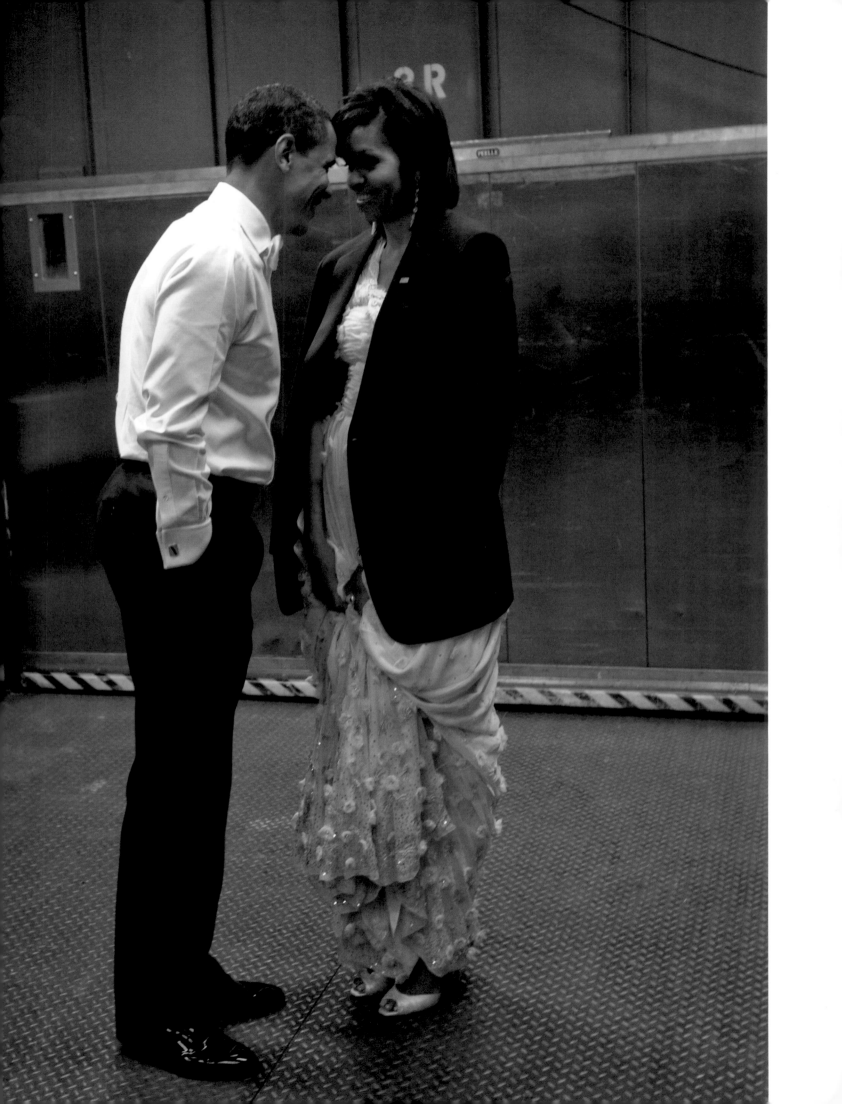

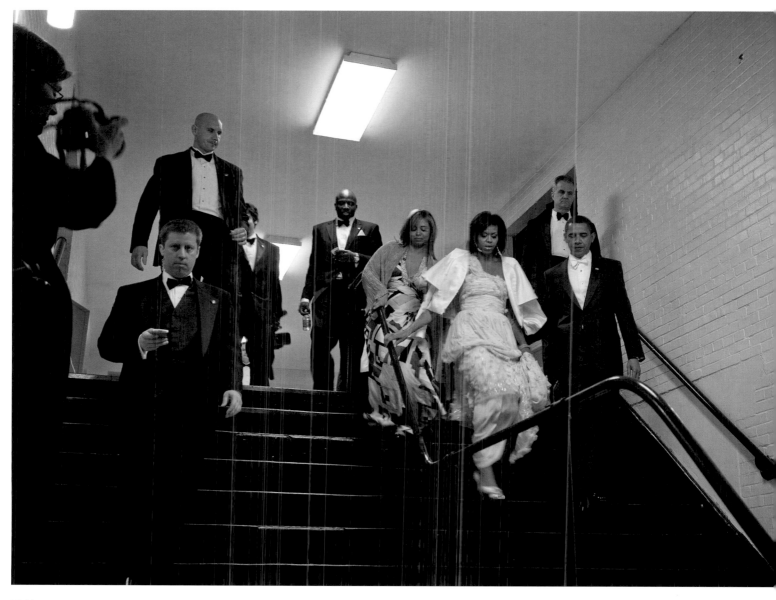

Making appearances at all ten of the official inaugural balls around Washington meant the new First Couple hustled from one gala to the next through the long evening. In the freight elevator of the Convention Center, however, the Obamas find a quiet moment (opposite).

PHOTOS BY DAVID HUME KENNERLY

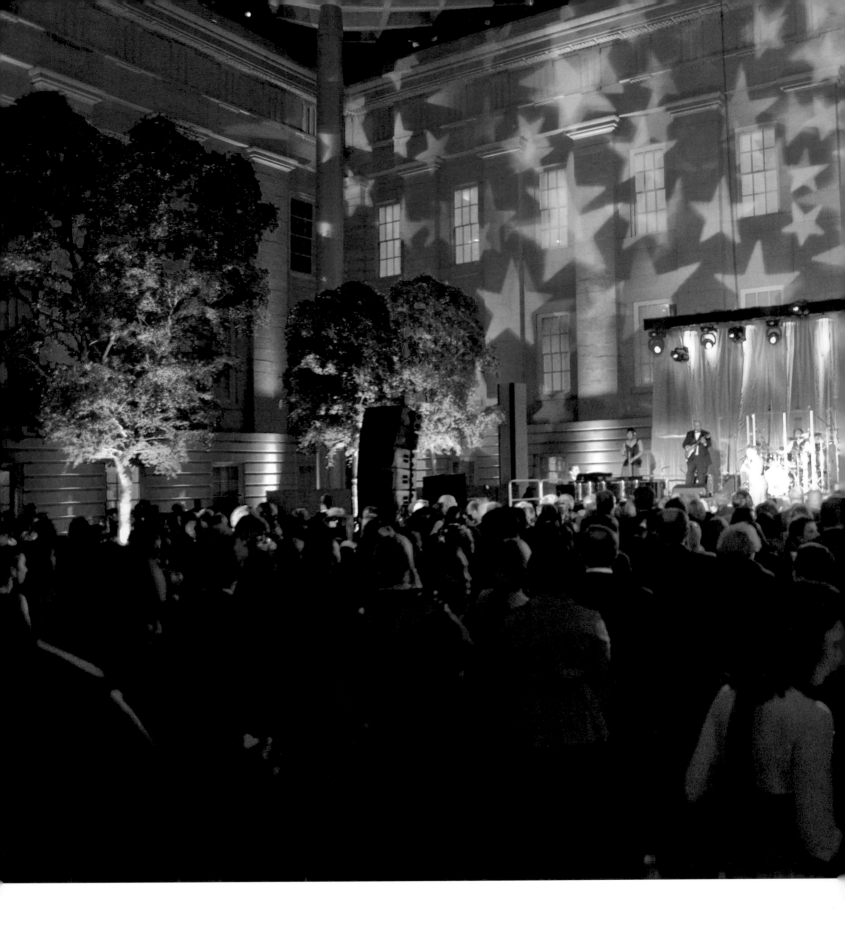

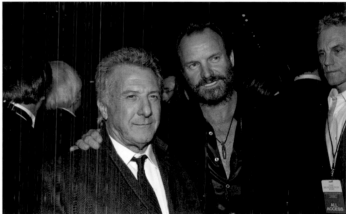

During the inaugural festivities of 2009, Washington rocked as it had never rocked before. At the ten official inaugural balls and a host of unofficial but still star-studded galas during the week (such as the Lincoln Ball, left), celebrities, politicos, and regular folks let their hair down to celebrate the fact that "Yes, we did!" At the HuffPost Inaugural Ball guests included (from top) Robert Deniro; Dustin Hoffman and Sting; and Democratic National Committee Chairman Howard Dean, along with hostess Arianna Huffington.

LEFT
PHOTO BY MIKE GENDIMENICO

ABOVE
PHOTOS BY MARK SENNET

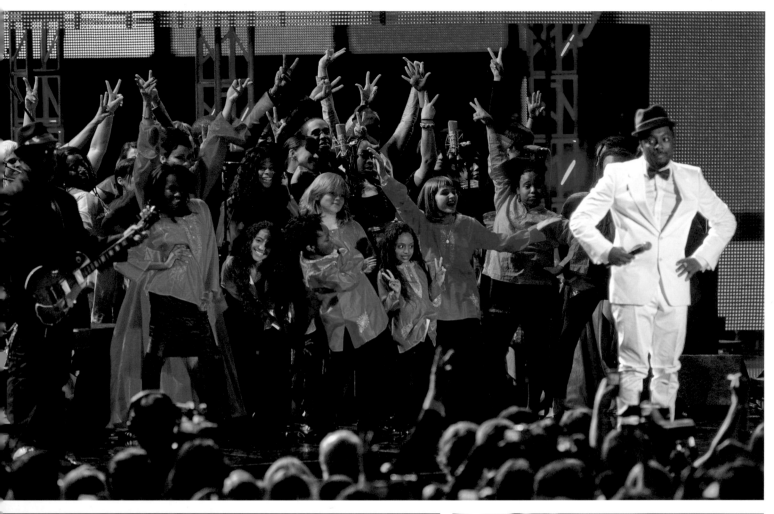

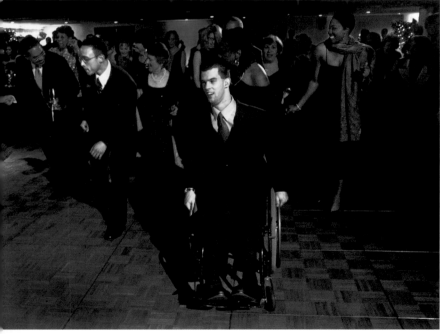

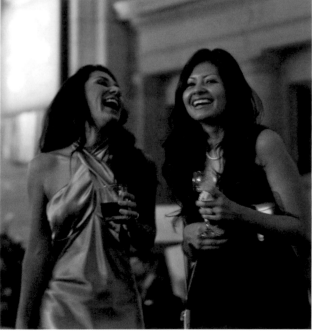

Inaugural galas rage into the night: Will.i.am (above top) entertains the crowd both onstage and off at the Neighborhood Ball. The parties also allowed ordinary Americans from all walks of life to celebrate, from the Disability Ball (bottom left, held on Sunday) to the Latino Ball (bottom right; opposite top left) to the Biden Home States Ball (opposite top right) to the Youth Ball (opposite bottom).

CLOCKWISE FROM TOP
PHOTOS BY DANIEL ROSENBAUM; HECTOR EMANUEL; THOMAS K. WALKER

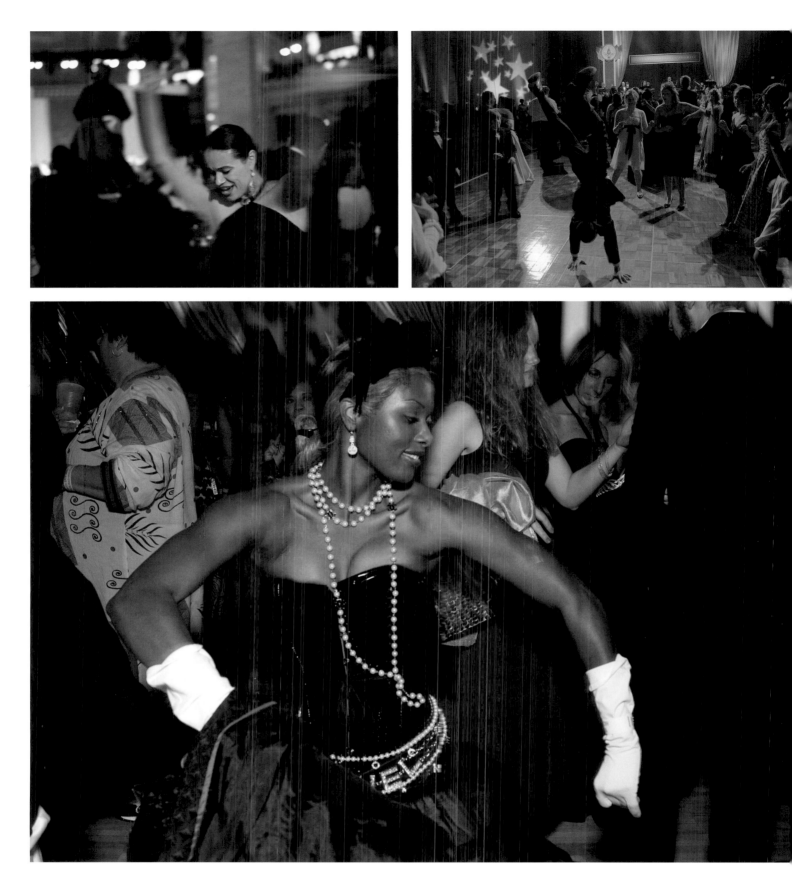

CLOCKWISE FROM TOP LEFT
PHOTOS BY HECTOR EMANUEL; DANIEL ROSENBAUM; ANNE DAY

The galas throughout the city lasted into the wee hours of the morning. The Washington City Council, in fact, allowed some bars to stay open until 5:00 A.M. for the occasion, giving revelers like these plenty of time to continue their celebration.

PHOTO BY HECTOR EMANUEL

With the clock about to strike 1:00 A.M.—appearances at ten official inaugural balls behind them—a wearied and elated Barack and Michelle Obama head upstairs to their new home in the White House.

PHOTO BY DAVID HUME KENNERLY

In times such as these, we the people need you, the leaders of this nation…to work for the common good, for the public happiness, the well-being of the nation and the world, knowing that our individual well being depends upon a world in which liberty and justice prevail.

THE REV. DR. SHARON E. WATKINS
SERMON AT THE NATIONAL PRAYER SERVICE
JANUARY 21, 2009

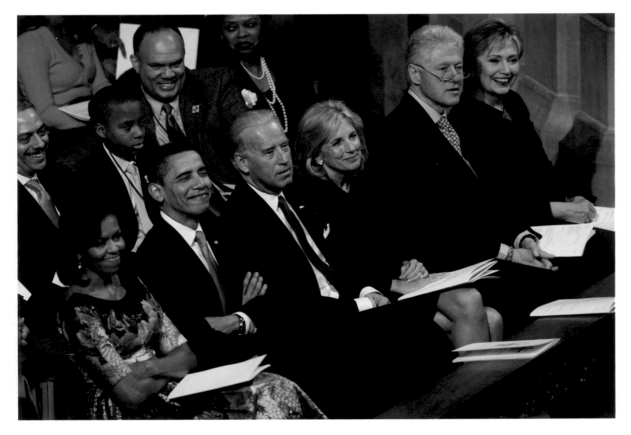

Following a tradition established by George Washington, who worshipped at St. Paul's Cathedral in New York City on Inauguration Day 1789, Barack Obama spends his first morning as president at the National Cathedral in Washington, listening to a prayer service that included two dozen clergy from various denominations.

PHOTOS BY JOHN HARRINGTON

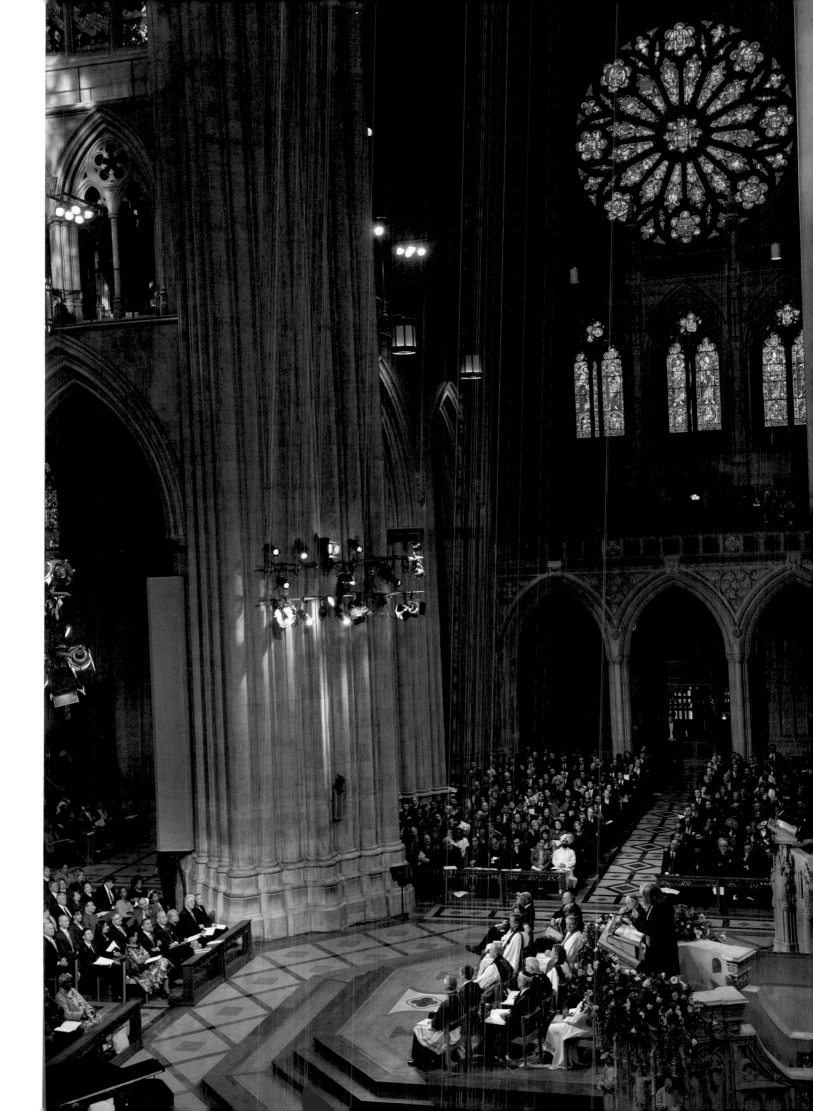

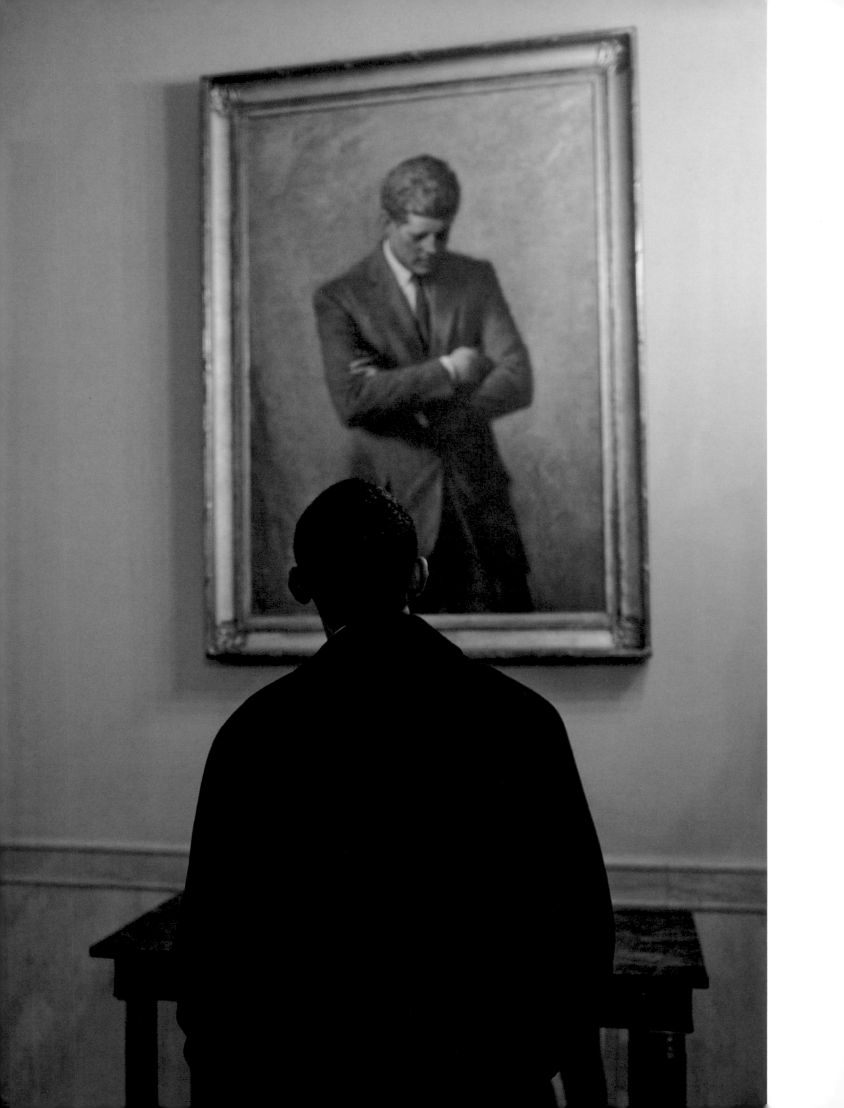

THE GLOBAL PRESIDENT

DOUGLAS BRINKLEY

"Obama, no matter how his presidency develops or the planet evolves, has already confirmed his place of greatness. For he didn't just write *The Audacity of Hope;* he actualized it.... His inauguration stands as the most uplifting public spectacle in contemporary American history since Neil Armstrong walked on the moon."

WHAT I MOST REMEMBER about Barack Obama's presidential inauguration are the warm smiles, a cold wind, a slight drizzle, and vendors selling T-shirts from hot-dog carts. A luminous light seemed to engulf Washington, DC, on that ethereal January day; everything seemed haloed and effervescent. Cameras were everywhere. Makeshift TV work holes had been assembled on platforms around the U.S. Capitol like cliff dwellings. When President-elect Obama placed his hand on the very bible Abraham Lincoln had used in 1861 and repeated the oath of office, thunderous cheers erupted from the bundled-up crowd of nearly two million. They were all witnesses to history.

The broad-beamed smile on the face of Barack Obama—an African-American who defied odds makers and transcended race to become the 44th president of the United States—personified a gold-star event. Soaking in the glory of the day, I couldn't find a single unhappy person. From a bird's-eye view, the National Mall crowd must have looked like one giant smile. The baton had been passed from Lincoln to the Roosevelts to the Kennedys and King to this man. And now the world's hopes rested squarely on the shoulders of the skinny kid with big ears who had seldom made a false move during one of the most grueling presidential campaigns of our time. A new generation had risen, chanting "Yes We Can," believing that America's star-spangled, high-voltage days were yet to come. Yes, the economy was in tatters and U.S. troops were mired in Iraq and Afghanistan. But there was no sense of gloom on January 20, 2009—only a consensus conviction that *right* was winning over *wrong.* The United States had done something extraordinarily uplifting by inaugurating Barack Obama. We had a chance to reset anew.

America seldom makes its poetry with words; direct action is our national forté. The crucibles are usually actual events, not those imagined by intellectuals. For all the

philosophical finery of the Declaration of Independence and *Common Sense,* our country was actually born when General George Washington endured the harsh winter at Valley Forge. Everyone knew Barack Obama was a great orator. But it was the reality of Obama *winning* the presidential election by a mandate that rocked the world. When the campaign began, in fact, pundits had doubted whether America was ready for a black president. But on November 4, 2008, the surge and thunder of history spoke. The forecasters had to reevaluate their hollow estimates. The past no longer seemed as heavy as old sandbags; the future, on that January 20, held the promise of an evergreen in winter.

Ruminating on what the Obama inauguration means to America in the long term is like whittling in the dark: Our national destiny remains unclear. But at this moment, we can allow ourselves to believe that every so often the People's Will erupts, that prejudice is given the back of the hand, and fairness holds court. While Obama is sui generis as a politician, his election was paradoxically the triumph of the common man. "We the People" had the courage to elect this talented individual for the most difficult job in the world. Somehow, as if by magic, we slipped Obama into the White House just in the nick of time. There is an old mountain-climber saying that heroism is endurance for "one moment more." Fair enough. But there is no smart calculus for when an individual like Barack Obama seems to float over an abyss. That, my friends, is when a world-beat character enters the global folklore realm.

Obama's Inaugural Address, while beautifully written, didn't contain an obvious repeatable refrain like Kennedy's "ask not" evocation. (Although *Bartlett's Familiar Quotations* will doubtless manage to shoehorn a couple Obama riffs into its next edition—most probably lines about a "new era of responsibility" based on "mutual interest and mutual respect.") But to my mind, the real public achievement of the speech was its antidemagogic tone. Obama deftly used the historic occasion to tamp down unrealistic expectations. Over and over again he reminded us that change wasn't going to be easy. For all the comparisons

to Martin Luther King, Jr.'s "I Have a Dream" speech, Obama exuded a Puritan work ethic that festive afternoon. He counted on us—*all* of us—to do some heavy lifting. The message was crystal clear: The new management in town wouldn't tolerate laziness or rudeness or duplicity. An adult hour had arrived in the nation's capital. The new president would address the citizenry as equals. The prevailing global sentiment was: Why not give Obama a chance to put his words to deeds?

TURNING POINTS IN HISTORY are sometimes tricky to detect. Perhaps the greatest event to follow the Second World War was Dr. Francis Crick and Dr. James Watson discovering DNA; it barely registered with the national press. But Obama's inauguration was different. By definition it was historic—like Robert E. Lee surrendering to Ulysses S. Grant at that Appomattox courthouse amongst the slender elms. Ever since the 9-11 terrorist attacks, Washington, DC, had been in mortuary mode. Ugly cement barricades surrounded the White House while a hideous Fence was being built along our border with Old Mexico. If you wanted to see the Declaration of Independence at the National Archives, you had to show your ID two or three times.

Fear dominated our collective emotional life from 2001 to 2008, and the Bush administration sought to capitalize on it. WMD. Anthrax. Gitmo. Abu Ghraib. Homeland Security. The never-ending War on Terror. There was a repressive aura about life in Washington during the Bush years that unfortunately demoted our most cherished civil liberties to luxuries of the past. A kingdom of fear had been constructed in the United States, every day an orange alert. Our national rhythm had been hijacked. The pendulum, however, started to swing back when Obama won the Democratic caucus in largely white Iowa. Now, almost a year later, Obama's presidential inauguration was the lifting of the veil— a return to the politics of hope.

President Obama has already begun to revitalize American politics. While I believe pundits overplayed

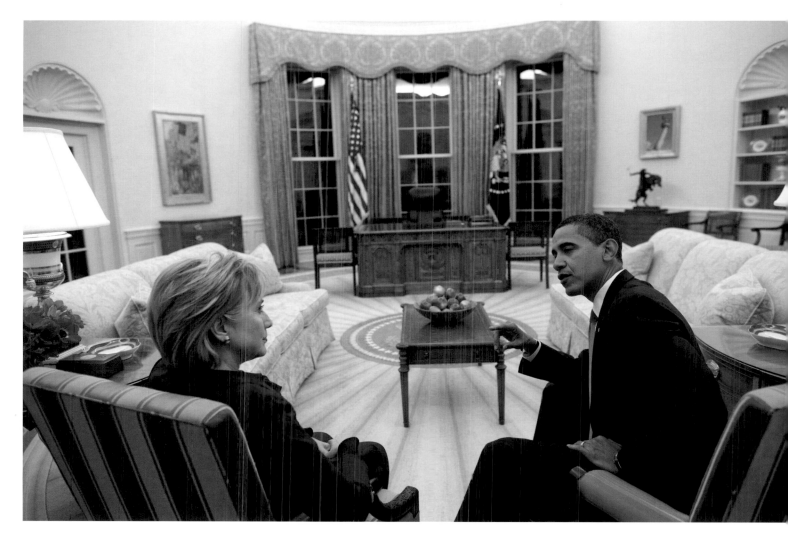

PHOTO BY PETE SOUZA

Obama's linkage to Lincoln, there is a shared humility between these two touchstone figures. And Obama isn't just postracial: He really is America's first global president. Yes, back in 1906, Theodore Roosevelt was embraced by Europe and South America and Africa as a world-class leader after he won the Nobel Peace Prize for mediating the Russo-Japanese War. FDR was the champion for half the world—that is, the "democracies"—during the Second World War. John F. Kennedy's picture is still proudly hung next to the Pope and Jesus in far-flung villages in predominantly Catholic countries.

But it is due to the reach and immediacy of the Internet that Obama is the first true global president. Even on the most remote South Pacific atoll or Himalayan hillside, his story is celebrated. I expected that European countries would champion the election of the Illinois senator as a ray of light in a muddle of global despair, that the *International Herald Tribune* would swoon about America "leaping" across the color line. But the accolades went far beyond that: In Germany, Obama's election was called "astonishing," while a French newspaper deemed it "transcendent." The Arabic daily *Ai-Chourouk*, published in Tunisia, proclaimed flat out that Obama was the "President of the World."

UPON REFLECTION, there is nothing surprising about Obama's global appeal. While America has long boasted of being a melting pot, Obama is a one-man composite bridge of cultures. Half black, half white, and all-American,

he personifies the very idea of democratic meritocracy. A double-Ivied academic, he is the first president to come of age after the cold war, a child of globalization with ties to Indonesia and Kenya; Obama's BlackBerry knows no borders. Hawaii, his home state, in fact, epitomizes the polyglot society of varied ethnicities. Obama's grace notes build upon, to my mind, Muhammad Ali in his fight against Parkinson's disease and Nelson Mandela after his release from prison in 1990. Obama, in other words, is post the fury of My Lai, Montgomery, Selma, Johannesburg, and Rhodesia-Zimbabwe. In his story, there is no defying the Vietnam War draft like Ali did in 1967. No getting beaten by police in apartheid South Africa like Stephen Biko a decade later. Obama isn't, in the traditional sense, a revolutionary. He is the supernova beneficiary of the global freedom struggle. Barack Obama's destiny isn't to be fingerprinted and jailed, but to be photographed for the cover of *Vanity Fair* and *People*. He is bigger than Elvis, more recognizable than Pope Benedict XVI.

But to denigrate him as a "celebrity" president (an ironic designation, given Ronald Reagan's previous résumé) is to lose sight of the primary accomplishment, of his ascendancy: Obama's inauguration turned celebrity

PHOTO BY PETE SOUZA

culture on its head. His fame is based on true accomplishments, like heading up the *Harvard Law Review* and helping out the poor in Chicago's Southside. And unlike many other politicians of the past decades, Obama exudes family values. For once, the tabloids are selling *positive* stories about a well-known figure who is a wonderful husband and father. He even loves his mother-in-law. He has managed to set an example for our young people that it is actually *cool* to be thoughtful, fair-minded, judicial, kind, honest, and dignified.

A photograph of Obama smiling—which you'll find a lot of in this book—is as much a global event as a trophy case with a Nobel Peace Prize. He has become the world's great hope—quite a burden to carry. Every mother in the world, whether in a remote village or a forgotten corner of urban sprawl, can tell her sons and daughters, "Yes, you can grow up to be like Barack Obama. Oh, Yes You Can!"

It is not rhetoric to say that a huge battle is being waged between the forces of light and darkness in the world. Obama is one of the brightest flames the human-rights movement has seen since Mahatma Gandhi took up his loom and marched to the sea. This doesn't necessarily mean his stature will hold up through the ages. History is known to play cruel tricks on its main-stage participants. There are trapdoors around every bend. Good intentions aren't enough in a hypertechnological world where lobbing a dirty bomb the size of a can of California peaches can take out a big chunk of New York City, and glaciers in Antarctica are losing 114 billion tons of ice a year due to global warming. But Obama, no matter how his presidency develops or the planet evolves, has already confirmed his place of greatness. For he didn't just write *The Audacity of Hope*; he actualized it on the campaign trail of 2008. His inauguration stands as the most uplifting public spectacle in contemporary American history since Neil Armstrong walked on the moon.

THE DATE OF JANUARY 20, 2009, will live in history—and not in infamy like December 7, 1941, or September 11, 2001. It was one of those rare days when a Great Wave broke; but this time, the surfer wasn't

bowdlerized by the impact. Many spectators were filled with angst, wondering if he would make it. But Obama (the master political surfer with a Zen aura) crested calmly onto the Washington, DC, shore with a reassuring smile on his face and has so far emerged unscathed. That's Obama's story. He was at one with the Great Wave of 2008, and on Inauguration Day, he paddled out to sea for another historic ride. Someday the wave might crash on Obama: His economic policies could sputter; his poll numbers could drop to anemic levels. But I don't think so. Occasionally the world produces metaphoric Zen masters—Tiger Woods in golf, Gabriel García Márquez in literature, Bob Dylan in music—and only a fool would bet against them.

Obama is one of those rare talents who doesn't have to get in the zone, because he is the zone personified. That is what he represents to the American political theater: the utter masterhood of statecraft. It wasn't Obama's inaugural speech, per se, that I'll always remember about being in Washington, DC, on January 20, 2009. It was the way Obama's personal chemistry transfixed the entire city in the belief that *positive change* was *a-comin'*. Even Obama's "mistakes"—like the botched oath when Chief Justice John Roberts misspoke the words—seemed to glow.

Just watching President Obama walk down Pennsylvania Avenue with First Lady Michelle on his arm in the inaugural parade was a national catharsis. Only someone numb or dried-up to life couldn't feel the drama. All the old Jim Crow–era civil-rights legislation combined couldn't equal the galvanizing impact of Barack and Michelle Obama moving into the White House. Ronald Reagan's inauguration in 1981 had been a triumphant occasion—for the Republican Party. Bill Clinton's inaugural in 1993 ushered in an era of New Democrats. The election of Obama, however—due in part, but not wholly, to the race component—was triumphant for America. The sixties hope of "We Shall Overcome" had become a universal chant of "O-ba-ma! O-ba-ma!" It was the refrain heard all Inaugural Day, and it came directly from the human heart. It was a day of love and duty and honor and pride and elevation. There was

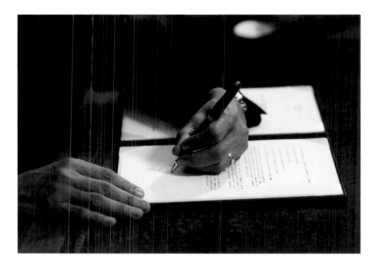

ABOVE AND FOLLOWING PAGE: PHOTOS BY PETE SOUZA

no bell-ringing of fear in the crisp air. At the largest public gathering in DC history, nobody was arrested for disorderly conduct or mugging an elderly person. Or for anything, in fact—a small miracle that bears out the prevailing spirit of that day.

Boiled down to its crux, Obama's inaugural message was one of hard work and endurance and sacrifice and the continued need for civility in public discourse. His address was devoid of fire-and-brimstone appeal. Wisely, Obama understood that rhetoric is always an insufficient substitute for action. His inaugural was our *world's* inaugural. The hundreds of millions of people who listened to him speak—from Albania to Zaïre and, most important, here at home—embraced his once inconceivable journey as their own personal odyssey. January 20, 2009, is now one of the pillars in which the world recognizes its own universal humanity. As emotional storms go, the inaugural was framed around the grand theme of the individual conquering fate. This is the cornerstone of our heroic American tradition, where Horatio Alger–like personal biography intersects with our future dreams. "Yes We Can!" has become "Yes We Did!" The pendulum of history has once again swung. The remaking of America is upon us.

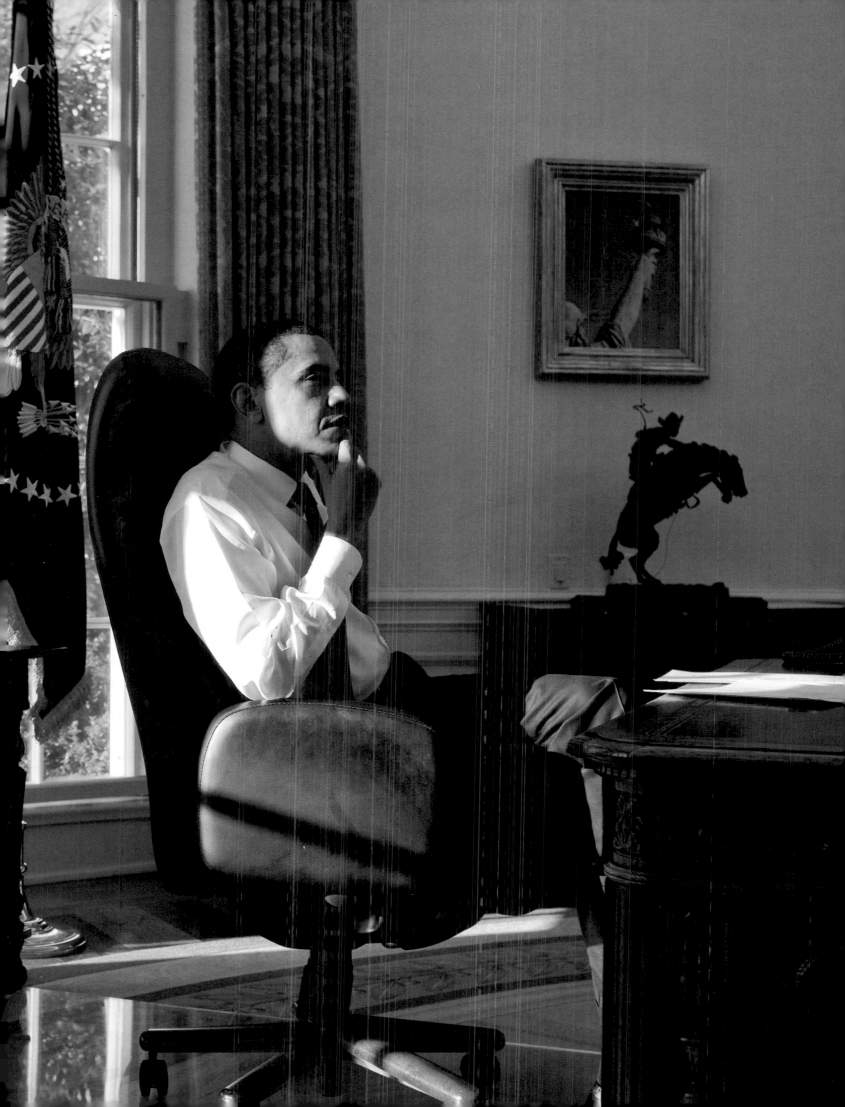

PHOTOGRAPHER
AND AUTHOR BIOS

DAVID HUME KENNERLY
Producer and Photographer

Kennerly won the 1972 Pulitzer Prize for his photos of the Vietnam War, and two years later was appointed President Gerald R. Ford's personal White House photographer. *American Photo Magazine* named him "One of the 100 Most Important People in Photography." Kennerly has published several books of his work, including *Shooter, Photo Op, Seinoff: The Final Days of Seinfeld, Photo du Jour,* and most recently, *Extraordinary Circumstances: The Presidency of Gerald R. Ford.* Kennerly is on the Board of Trustees of the Gerald R. Ford Foundation; the Atlanta Board of Visitors of the Savannah College of Art and Design (SCAD); and the Advisory Board of the Maybach Foundation. His archive is housed at the Center for American History at the University of Texas, Austin.

BOB McNEELY
Producer and Photographer

McNeely's love of photography began when he bought his first camera while serving in the Army in Southeast Asia. His love of politics began when he worked as the staff photographer for George McGovern's 1972 presidential campaign. Since then he has pursued both loves by photographing politics and the political process around the world. He was a staff photographer in the Carter White House from 1976 to 1979 and Bill Clinton's personal White House photographer from 1992 to 1998, which led to his book *The Clinton Years.* His "Photo 2000" project, a black-and-white documentary of the American political process during the 2000 election cycle, was exhibited at galleries in New York and Washington, DC; at *Visa pour l'Image* in Perpignan, France; and in an award-winning thirty-page portfolio in *Fortune* magazine. He continues to photograph for clients, history, and himself.

MATTHEW NAYTHONS
Producer and Photographer

After graduating from medical school, Naythons combined E.R. medicine with an award-winning career as an international photojournalist for *Time* magazine, covering the fall of Saigon, the Nicaraguan Revolution and the Jonestown massacre among other stories. After covering the exodus of Cambodian refugees from the genocide of Pol Pot, he formed and led International Medical Teams, which provided medical care to refugees along the Thai border. He is currently the president of Epicenter Communications, a company dedicated to high-quality photography books and exhibitions, as well as a founder of Argonaut-Ventures. Epicenter has produced the past five official inaugural books, for Presidents Clinton, Bush, and Obama. His photographic archive is housed at the Center for American History at the University of Texas, Austin.

THOMAS K. WALKER
Creative Director and Photographer

Walker's creative background bridges the worlds of design and photography. Over the past 17 years he has been responsible for the design and photo editing of the "Day in the Life" photographic book series, including *A Day in the Life of America,* the Soviet Union, Spain, Japan and Africa. His other photo-illustrated books include *Christmas in America, The Power to Heal, From Alice to Ocean, The Who's Tommy, the Musical,* and *Passage to Vietnam.* His most recent project is a collaboration with David Hume Kennerly titled *Extraordinary Circumstances: The Presidency of Gerald R. Ford.*

INAUGURAL BOOK PHOTOGRAPHERS
KAREN BALLARD

Award-winning photographer Karen Ballard has a diverse career with assignments in news, portraiture, travel, and major motion pictures. Her photography has been featured in major magazines and newspapers around the world, as well as on movie posters, including Steven Spielberg's *Munich* and Edward Zwick's *Defiance.* She most recently was the main unit photographer for the James Bond film *Quantum of Solace.* Before she began shooting movies, Ballard traveled to Baghdad six times, photographing subjects that included Saddam Hussein's arraignment, and she landed in Baghdad with General Tommy Franks one week after the fall of the city. Her initial foray into production photography took her to the battlefields of Afghanistan in 2002, where she was the photographer for ABC's *Profiles from the Front Lines.* Ballard also spent time shooting and living at Bagram Air Base outside Kabul and sailed in the Persian Gulf aboard the aircraft carrier USS *John F. Kennedy* during combat operations.

ANDRÉ CHUNG

Chung's 20 years of experience as a photojournalist started at the *Chicago Sun-Times.* He then moved on to the *Baltimore Sun,* where he spent over a dozen years. His work has won many awards, including the George Polk Award in 1999, the Robert F. Kennedy Journalism Award in 2000, and the Sigma Delta Chi Award in 2005. The *Baltimore Sun* nominated his work for the Pulitzer Prize on five separate occasions. A founding member of the Iris Photo-Collective, which is dedicated to documenting people of color and their relationship to the world, Chung now works independently on the stories that are close to his heart.

DANIEL CIMA

Cima was senior staff photographer for the Red Cross for eighteen years, photographing disasters throughout the world. Cima's work has taken him to many countries, including Kenya, Chad, Benin, Uganda, Ethiopia, Central Africa, Russia, El Salvador, and he has exhibited his work in

Argentina, France, Mexico, Armenia, Geneva, Switzerland, the former Yugoslavia, Japan, and the United States. Cima works as a freelance photographer and is a founding member of Metro Collective, a photographers' agency based in Washington, DC. He was recently awarded first place in the France Px3 2009 photo competition.

ANNE DAY

Now based in Connecticut and New York, Day has photographed stories in South Africa, Haiti, France, Spain, Japan and the former Soviet Union in addition to the United States. Her work has appeared in *Time, Newsweek, The New York Times, The Washington Post, Fortune, Vogue* and many other publications. Featured in seven of the *Day in the Life* book series, Day was the principal photographer for four books about classical architecture published by W. W. Norton and has also now photographed three presidential inaugurations for the Official Inaugural books. She was named an Olympus Visionary in 2003 and is still active in the program.

HECTOR EMANUEL

Peruvian-born photojournalist Emanuel won a Best of Photojournalism award from the National Press Photographers Association and was recognized by the World Press Photo Foundation for his documentation of the civil conflict in Colombia. His photographs have been widely exhibited, and he regularly contributes to outlets including *Time, Newsweek, Men's Journal, Washington Post Sunday Magazine,* and *The Washingtonian,* as well as to NGOs such as the American Red Cross, Greenpeace, and Amnesty International. Emanuel also holds a master's degree in physics.

JOHN FRANCIS FICARA

Ficara has covered the White House for *Newsweek* through five presidential campaigns and four administrations, producing thirty-eight cover images for *Newsweek* as well as covers for a variety of other domestic and international magazines. He won a Desi Award for his *Newsweek* cover photograph of Pope John Paul II in the Philippines, a 1992 National Headliners Award for feature photography for his Persian Gulf coverage leading up to the war, and he has received awards from World Press Photo, the National Press Photographers Association, and the White House News Photographers Association. His book *Black Farmers in America* was selected by the American Institute of Graphic Artists as one of the top fifty books of 2006.

GIL GARCETTI

Garcetti—who served as the Los Angeles County District Attorney from 1992 to 2000—is an award-winning photographer who has authored five photo books since 2002: *Iron: Erecting the Walt Disney Concert Hall, Frozen Music, Dance in Cuba, The Closer,* and *Water Is Key.* He has had solo exhibitions at

the United Nations; the Millennium Art Museum in Beijing, China; the National Building Museum in Washington, DC; and many other institutions and galleries. Named one of the country's four master photographers in 2003 by *American Photo* magazine, he has been profiled in *Time* magazine, on TV's *CBS Sunday Morning*, and on National Public Radio.

JOHN HARRINGTON

Harrington was a recipient of the 2007 United Nations Leadership Award from the International Photographic Council. A photographer for more than two decades, his work has appeared on National Geographic television and in *Rolling Stone*, *Life*, and international magazines including *Paris Match* and *Der Speigel*. Harrington was commissioned to produce three books for the Smithsonian's National Museum of the American Indian, and his work has also appeared in two of the *America 24/7* books. In addition, his book *Best Business Practices for Photographers* remains a best seller.

SAM KITTNER

Kittner's portrait and scene-setting photographs have appeared worldwide in publications such as *Time*, *Newsweek*, *The Washingtonian*, *Business Week*, and *People*. He is commissioned regularly by foundation, university, tourism, association, and corporate clients for marketing publications and Web sites, and his documentary and fine-art images have been displayed widely in gallery exhibits and published in the journal *Aperture*. Kittner's new panoramic work was featured prominently in an April 2008 *Washingtonian* article and recently received recognition in the 2008 PIX Digital Imaging Awards from leading commercial photography trade publication *Photo District News*.

PETE MAROVICH

Award-winning photojournalist Pete Marovich has been a professional photographer for 25 years, since starting as a staff photographer at a daily newspaper in Indiana and a stringer for the Associated Press. From 1986 to 1999, Marovich worked as a contract photographer for major golf publications while following the professional golf tours. He returned to newspaper photojournalism in 2001 and is now the director of photography at the *Daily News-Record* in Virginia. Pete is cocreator of *American-Journal Magazine*, for which he serves as principal photojournalist and photo editor.

GREG MATHIESON

Mathieson began his 37-year career chronicling the lives of America's men and women in uniform, celebrities, and the administrations of five U.S. presidents as an Army photographer. He served for ten years, chronicling activities at West Point, traveling with General Alexander Haig in Europe, and covering the White House. Upon leaving the Army, he chronicled the history of Iran Contra from the jungles of Nicaragua to the doors of Congress and the federal courts. Over the last 17 years, he worked extensively in Iraq, which culminated in his selection by NBC News to be videographer on a five-member covert team traveling into Iraq two months before the 2003 war.

PAUL MORSE

Morse had a firsthand view of politics as deputy director of photography at the White House from 2001 to 2007. He has been published in *Sports*

Illustrated, *Time*, *U.S. News & World Report*, *Men's Journal*, and *The New York Times Magazine*, and his photographs have illustrated the covers of many books on subjects such as the Los Angeles Lakers, Air Force One, and the Oval Office. Prior to working at the White House, Morse worked at the *Los Angeles Times* as a staff photographer for six years, covering sports, news, and the entertainment industry. His images are on display in the Smithsonian Institution, and he is an adjunct professor at the Corcoran School of Art.

DANIEL ROSENBAUM

Rosenbaum covers Washington for newspapers including *The New York Times* and was a staff photographer at the *Washington Times* for twelve years. During his stint at the *Washington Times*, Rosenbaum was a Pulitzer Prize finalist in 2003 for his work covering the DC-area sniper killings. Among those that have recognized his work are the White House News Photographers Association, Pictures of the Year, the Society of Professional Journalists, and the Associated Press.

MARK SENNET

Sennet spent 25 years as a Time-Life photojournalist. He is known for his candid photographs of the most famous faces of our times, from rock stars to politicians. His exclusive behind-the-scenes moments are legendary, from Mick and Bianca Jagger on their honeymoon to a postmortem Howard Hughes to John Lennon on the steps of a New York City courthouse after his marijuana bust in 1973. One of the five original photographers who launched *People* magazine, his images have appeared on the cover of that publication more than 150 times. Sennet is now a critically acclaimed producer of film and television projects.

PETE SOUZA

Souza is the chief official White House photographer for President Obama, and the director of the White House photo office. He has worked as an official White House photographer for President Reagan, a freelancer for *National Geographic*, and the national photographer for the *Chicago Tribune* based in its Washington bureau. Souza's book, *The Rise of Barack Obama*, was published in July 2008 and includes exclusive photographs covering the senator's rise to power. Souza extensively documented Obama's first year in the Senate and accompanied Obama to seven countries, including Kenya, South Africa, and Russia. The book was on the *New York Times* best-seller list for five weeks. Souza is currently on an extended leave of absence from Ohio University's School of Visual Communication, where he is an assistant professor of photojournalism.

BRUCE TALAMON

Talamon has been a contributing photographer to *People*, *Vanity Fair*, *Paris Match*, *Hello!*, *Rolling Stone*, and *Time* magazines. In 1984, he was assigned by *Time* magazine to cover the Reverend Jesse Jackson's bid to become the Democratic candidate for president. That began a journey which he says has now come full circle with his work documenting the inauguration of America's first African-American president. In 1994, he published *Bob Marley: Spirit Dancer*, a photo memoir of his travels with the late reggae icon. He also works as a still photographer on major motion pictures, recently completing work on *Indiana Jones and the Kingdom of the Crystal Skull*.

CLARENCE WILLIAMS

Williams was a staff photographer for the *Los Angeles Times* from 1995 to 2003 and won a Pulitzer Prize for General Photography for images of the children of crack-addicted parents in 1998. He was also awarded the Robert F. Kennedy Photojournalism Award and won Journalist of the Year honors from the National Association of Black Journalists for the same series. His photos documenting government neglect in New Orleans in the wake of Hurricane Katrina were published by the *Miami Herald* in 2006 and nominated for another Pulitzer Prize. Since leaving the *Los Angeles Times* in 2003, Williams has been a founding member of the Iris PhotoCollective and is the Photojournalist in Residence at the University of Southern Mississippi. He divides his time between New Orleans and Philadelphia, where he operates a nonprofit photo school and workshop.

CONTRIBUTING PHOTOGRAPHERS
Luigi Ciuffetelli; Chief Electronics Technician James Clark, U.S. Navy; Tech. Sgt. Suzanne M. Day, U.S. Air Force; Mike Gendimenico; T. Adams/National Park Service; Daniel Kunstler; Master Sgt. Cecilia Ricardo, U.S. Air Force

AUTHORS

DOUGLAS BRINKLEY

Dr. Douglas Brinkley is a professor of history at Rice University. He has previously taught at Princeton University, the U.S. Naval Academy, and Tulane University. Five of his books have been chosen as *New York Times* "Notable Books of the Year." His most recent title—*The Great Deluge: Hurricane Katrina, New Orleans, and the Mississippi Gulf Coast*—won the prestigious Robert F. Kennedy prize. A member of the Council on Foreign Relations, Brinkley also serves as contributing editor to *Vanity Fair* and is the official historian for CBS News. He has received numerous honorary doctorates and book prizes for his work in U.S. historical studies. The *Chicago Tribune* has dubbed Brinkley "America's new past master."

TOM BROKAW

Tom Brokaw began covering the White House as a correspondent for NBC News in 1973 during the Watergate scandal. He was anchor and managing editor of *NBC Nightly News with Tom Brokaw* for almost 25 years, and also served as the anchor of NBC's *Today Show*. A native of South Dakota, Brokaw is the author of the bestseller *The Greatest Generation*. He has won virtually every major award in broadcast journalism, including a dozen Emmys and two Peabody Awards, and is a fellow in the prestigious American Academy of Arts and Sciences. He has been honored by West Point, the National Archives, and Rutgers University for his writing on World War II.

U.S. REPRESENTATIVE JOHN LEWIS

John Lewis was elected to Congress in 1986 and has served as U.S. Representative of Georgia's Fifth Congressional District since then. A leader in the American Civil Rights Movement, Lewis spoke at the 1963 March on Washington, became nationally known during the 1965 Selma to Montgomery marches, and played a key role in the struggle to end segregation. Much recognized both nationally and internationally, Lewis held several positions in the Carter administration and was influential in the Clinton administration.

CREDITS AND ACKNOWLEDGMENTS

PRODUCERS
DAVID HUME KENNERLY
ROBERT McNEELY
MATTHEW NAYTHONS
GARRETT WHITE

EPICENTER COMMUNICATIONS

CREATIVE DIRECTOR
THOMAS K. WALKER

EDITORIAL DIRECTOR
DAWN SHEGGEBY

ONLINE DIRECTOR
PETER GOGGIN

DIRECTOR OF PHOTO EDITING
ACEY HARPER

PHOTO EDITORS
PORTER BINKS
KAREN MULLARKEY

CAPTIONS
EZRA GALE

ASSOCIATE ASSIGNMENT EDITOR
KAREN GAINES

LOGISTICS COORDINATOR
SUDHAKAR KOSARAJU

LEGAL COUNSEL
DOUGLAS FERGUSON, ESQ

LITERARY AGENT
JOHN SILBERSACK,
TRIDENT MEDIA GROUP

COPY EDITOR
DANIELLE MAUPAI

PUBLICITY COORDINATOR
JEFF CHIARAVANONT

FIVE TIES PUBLISHING

PUBLISHER
GARRETT WHITE

ASSOCIATE PUBLISHER
NADIA STIEGLITZ

PROJECT MANAGER
GLORIA GERACE

ASSOCIATE EDITOR
GENEVIEVE CORTINOVIS

PROOFREADER
ANN JEFFREY

PHOTO RETOUCHING
MICHAEL FEMIA

PUBLIC RELATIONS
MICHAEL JENSEN,
JENSEN COMMUNICATIONS

PS NEW YORK

DESIGNER
PENNY HARDY

DESIGN ASSOCIATE
ELIZABETH OH

With special thanks to all those on the Presidential Inaugural Committee 2009, whose commitment, support, and enthusiasm helped make this project possible.

Epicenter Communications wishes to thank the following individuals and organizations: From Kodak, Leslie Dance, Jeff Hayzlett, Audrey Jonckheer, Karl Post, Mary Reed; from Photobucket.com, Geoffrey Cullins, Alice Lankester, and Scott Simas; The Lombardy Hotel (Washington, DC); The Newseum; from Skadden, Arps, Slate, Meagher & Flom LLP, Clifford Aronson and Barbara Perry; Alyssa Adams and Bathhouse Studios; Andrew Cooney; Sandra Eisert (The White House Photo Office); Mike Hawley; Thomas Hodgens; Daniel Kunstler; John Lacagnina; Paola Leyton; Christian Matthews; Callie Shell; Brandon Showers; Alan Siegel; and Gary Wood.

And to our supportive friends and family: Sophia, Nicholas, and Mary-Margaret Goggin; Lisa Green; Rebecca, Byron, Jack, and Nick Kennerly; Debbie McFadden; Mattie, Will, and Susan Naythons; Minh Chau Nguyen; Andrea, Molly, Kris, and Katie McNeely; Emerson, Noah, Carol, Michael, Rosalie, and Rosemarie Sheggeby; Atonios Spyropoulos; and Judith Thurman.

Also, in memorium, we remember our treasured friend and colleague, Martyn Harmon.

For their generous assistance in the completion of this project, the Publisher wishes to thank Farouk Chaouni, Timothy Cotton, Teresa von Roedelbronn, and Margaret R. Smith; Olivier Corpet; Jeremiah Courtney, and Manon, Iliade, and Mila Stieglitz-Courtney; Richard Denzer; Karen Gaines; Jeffrey Ho and Pamela Torres; Brenda Jones; Jack Lang; Kirk McAfee; Punita M. Patel; Merrill Ring; Austin Skaggs; Richard Sparks and Jenny Okun; Jay Stewart; Claire, Hélène, Paulo, and Paul Stieglitz; Emmett White; Gary L. and Yolanda White; and, for their tireless and invaluable efforts on behalf of Five Ties Publishing, Nadia Stieglitz, Gloria Gerace, Genny Cortinovis, Penny Hardy, and Elizabeth Oh.

Kodak

Kodak is the Official Imaging and Print Partner for the 2009 Inaugural Photographic Album and the Official Imaging Partner of the 2009 Inaugural Book.

ABOUT KODAK

Every day, Kodak helps more than a half-billion consumers, businesses, and creative professionals unleash the power of pictures and printing to enrich their lives. Our continued ability to create relevant, easy-to-use products that help people make, manage and move pictures keeps Kodak a trusted, respected brand today. To learn more, visit www.kodak.com and follow our blogs and more at www.kodak.com/go/followus.

photobucket

Photobucket is the Official Online Photo Site Partner for the 2009 Inaugural Photographic Album and the Official Online Photo Site Partner of the 2009 Inaugural Book.

ABOUT PHOTOBUCKET

Photobucket, www.photobucket.com, is the premier standalone photo and video sharing site, with over 42 million monthly unique users around the world sharing and linking billions of personal photos, graphics, slideshows and videos daily to hundreds of thousands of Web sites. In addition to linking content, the company actively moderates content to create a safe environment for its users, partners and advertisers. For the latest feature announcements and news, please visit the Photobucket blog at blog.photobucket.com.

ABOUT THE PROJECT—THE PEOPLE'S INAUGURAL

In the spirit of President Obama's campaign, for the first time photographers from across the nation were invited to join our distinguished photojournalists for this official book project. We asked them to submit photographs to us online (via our online photo site partner www.photobucket.com and www.obamaphotobook.com). And we asked them to surprise us— which they did. And in doing so, our team of amateur and professional photographers captured an inauguration at its most festive and candid, at its most familial moment.

Online photographers are identifiable by (Photobucket) next to their credit. Images from the following photographers were selected from tens of thousands of submissions:

Christopher Beecroft
Cecilia Costella
Sandy Choi
Bryan Dozier
Marta Evry
Andy Isaacson

Paul Loveland
Christor Lucasiewicz
Shriya Malhotra
Alex Pascover
Steven Rosenbaum

First Edition, 2009
FIVETIES PUBLISHING, INC., NEW YORK
www.fiveties.com

"Barack Obama" © 2009 by Tom Brokaw
"We the People" © 2009 by John Lewis
"The Global President" © 2009 by Douglas Brinkley

PRINTED BY
CAPITAL OFFSET COMPANY, INC.
Concord, New Hampshire
www.capitaloffset.com

BOUND BY
ACME BOOKBINDING COMPANY, INC.
Charlestown, Massachusetts
www.acmebook.com

This book was printed on Sappi LOE 100# Dull Text.
It contains 30% post-consumer waste.

Mixed Sources
Product group from well-managed
forests, controlled sources and
recycled wood or fiber
www.fsc.org Cert no. BV-COC-080420
© 1996 Forest Stewardship Council
FSC

Printed in the USA

ISBN 978-0-9794727-9-4